HYDROPLANE RACING IN DETROIT
1946–2008

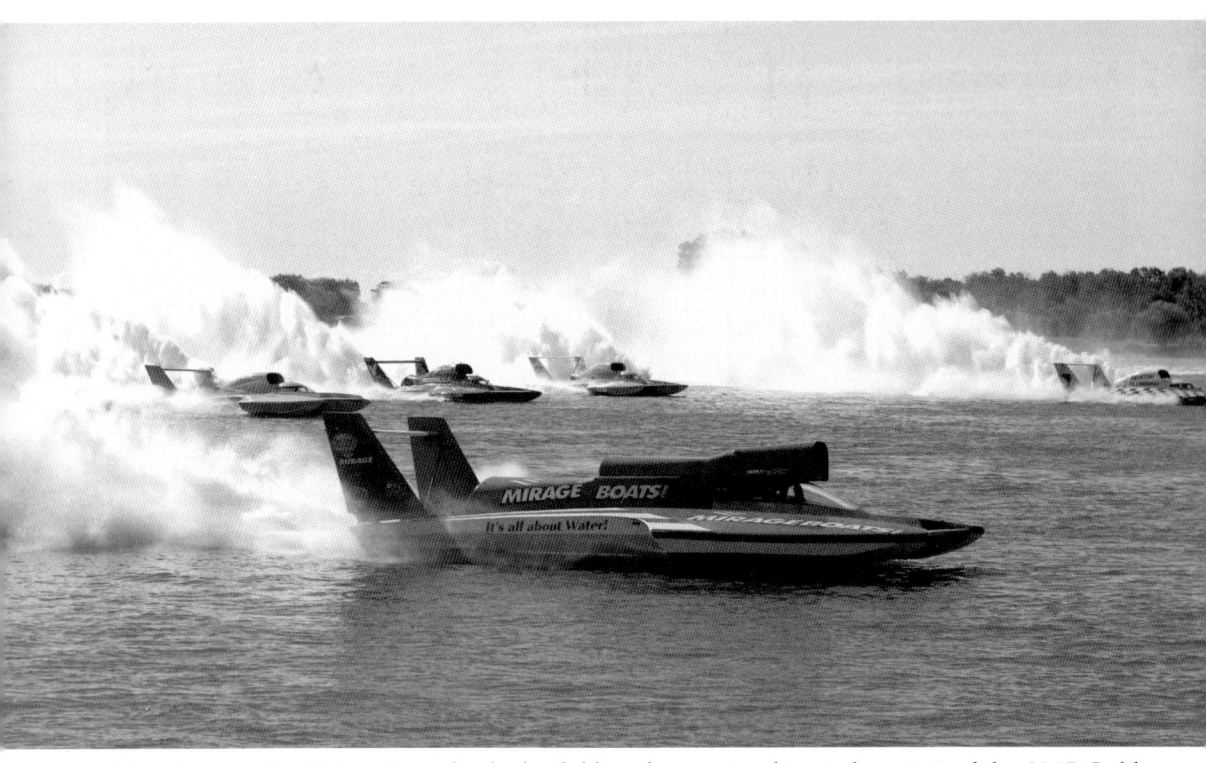

Greg Hopp in the *Mirage Boats* leads the field to the starting line in heat 1-A of the 2007 Gold Cup. (Photograph by James Crisp.)

On the front cover: *Miss Budweiser*, driven by Chip Hanauer, thunders through Detroit's Roostertail Turn on the way to victory in the 1993 Golden Cup. (Photograph by F. Pierce Williams.)

On the back cover: Chip Hanauer celebrates on the victory stand after winning the 1999 Gold Cup in Detroit. (Photograph by F. Pierce Williams.)

Cover background: The city of Detroit stands watch as Jack Schafer's *Such Crust II* speeds up the back stretch during the 1949 Silver Cup. (Courtesy of Bill Stroh.)

HYDROPLANE RACING IN DETROIT

1946–2008

David D. Williams and the Hydroplane and Raceboat Museum

ARCADIA PUBLISHING

Copyright © 2009 by David D. Williams
ISBN 978-0-7385-6086-1

Published by Arcadia Publishing
Charleston SC, Chicago IL, Portsmouth NH, San Francisco CA

Printed in the United States of America

Library of Congress Control Number: 2008943324

For all general information contact Arcadia Publishing at:
Telephone 843-853-2070
Fax 843-853-0044
E-mail sales@arcadiapublishing.com
For customer service and orders:
Toll-Free 1-888-313-2665

Visit us on the Internet at www.arcadiapublishing.com

CONTENTS

Acknowledgments		6
Introduction		7
1.	The Postwar Years: 1946 to 1949	9
2.	The Rivalry Years: 1950 to 1955	21
3.	The Golden Years: 1956 to 1962	35
4.	The Schoenith Years: 1963 to 1972	51
5.	The Years of Change: 1973 to 1983	67
6.	The Turbine Years: 1984 to 1990	83
7.	The Gold Cup Years: 1991 to 2002	95
8.	A New Beginning: 2003 to 2008	113
Appendix		125

ACKNOWLEDGMENTS

Usually an author will acknowledge one or two individuals who have inspired him in his work. I have to take a slightly different approach for this book and acknowledge two groups of several hundred people each who have devoted so much of themselves to keeping the great sport of unlimited hydroplane racing alive and flourishing in Detroit. First, I need to thank the Detroit River Regatta Association (DRRA) for their tireless work in putting on the race each year, and second, I wish to thank the members of Unlimiteds Detroit (UD), the most enthusiastic fan club any sport ever had! It is with great humility that I dedicate this book to the DRRA and UD!

Visit the Hydroplane and Raceboat Museum at 5917 South 196th Street, Kent, Washington, or on the Web at thunderboats.org.

Many of the photographs in this book were taken by the incomparable Bill Osborne. His talent for catching the beauty, power, and grace of unlimited hydroplane racing is unmatched. To see more of his work, log on to billophoto.com

Photographs that are not provided by Bill Osborne come from the extraordinary photography collection of the Hydroplane and Raceboat Museum. Over the last 25 years, tens of thousands of photographs have been donated to the museum. Some were clearly marked by the original photographer; many were not. In preparing this book, I have made every effort to identify and give proper credit to every photographer. I am continuing to research the origin of any unidentified photographer, and where possible they will be credited in future editions of this work.

Unless otherwise noted, all images are courtesy of the Hydroplane and Raceboat Museum.

INTRODUCTION

The story of hydroplane racing in Detroit started with two seemingly unrelated events in 1903. That was the year that an act of the New York legislature created the American Power Boat Association (APBA), a nonprofit corporation whose mission was to oversee powerboat racing in the United States. At roughly the same time Henry Ford founded the Ford Motor Company in Dearborn, a suburb of Detroit.

For the first decade and a half of the 1900s, American powerboat racing was dominated by a few wealthy families, living in Upstate New York. However, by the second decade of the 20th century, the wealth and mechanical know-how that Ford and the automobile industry brought to Detroit combined with the area's love of boating to turn Detroit into the powerboat racing capital of the nation.

The premier powerboat race in the United States is the APBA Gold Cup. Established in 1904, the Gold Cup is a 90-mile race that is divided into three 30-mile heats. One of the unique features of the Gold Cup at that time was that the winner of the race was allowed to choose where the following year's race would be held.

In 1915, a group of more than 200 Detroit powerboat enthusiasts formed the Miss Detroit Power Boat Association and entered the *Miss Detroit* in the Gold Cup on Long Island Sound, New York. Driven by Johnny Milot and riding mechanic Jack Beebe, *Miss Detroit* outlasted 12 other contestants to win the race. The following year, the race was held on the Detroit River in front of the Detroit Yacht Club, which was the largest yacht club in the world at the time. That race was won by *Miss Minneapolis*, and the race moved to Minnesota.

After the 1916 race, the Miss Detroit Power Boat Association sold the *Miss Detroit* to wealthy industrialist Gar Wood. Wood had made his fortune when he invented the hydraulic lift and installed it on a coal truck to make the world's first dump truck.

Wood also bought Chris Smith and Sons Boat Yard located in Algonac and asked them to build a new race boat. (Chris Smith built many of Wood's race boats until he started Chris Craft Boat Company in 1927.) In 1917, Wood took a brand-new *Miss Detroit II* to Minneapolis to challenge for the Gold Cup. Not only did Wood win the race and return the Gold Cup to Detroit, but he won it four more times and firmly established Detroit as the center of the powerboat racing universe. All totaled, Detroit would host 11 Gold Cups between 1918 and 1941.

Led by men like Col. J. G. Vincent, vice president of Packard Motor Car Company (Gold Cup winner 1922 and 1923); Horace Dodge Jr., heir to the Dodge automobile fortune (Gold Cup winner 1932 and 1936); and Herb Mendelson, heir to the Fisher Body/General Motors fortune (Gold Cup winner 1937), powerboat racing became a central feature in the social life of Detroit's rich and powerful. The elegant Detroit Yacht Club hosted many races on the Detroit River that runs from Lake St. Claire to Lake Erie. The river, which cuts between downtown Detroit and Belle Isle, offers prime viewing for thousands of fans. Winning the Gold Cup became a point of

civic pride that was equal in value to winning the World Series. In years when the Gold Cup was being run in another city, the Detroit Yacht Club would stage the Silver Cup or the Harmsworth Trophy Race.

When World War II started in 1941, gasoline rationing along with the fear that a large-scale sporting event would be a tempting target for terrorists prompted the APBA to cancel the Gold Cup for the duration of the war. When peace returned in 1946, racing followed soon thereafter and quickly returned to its prewar status as the most exciting game in town.

This book is the story of powerboat racing in Detroit from the end of World War II to the present time.

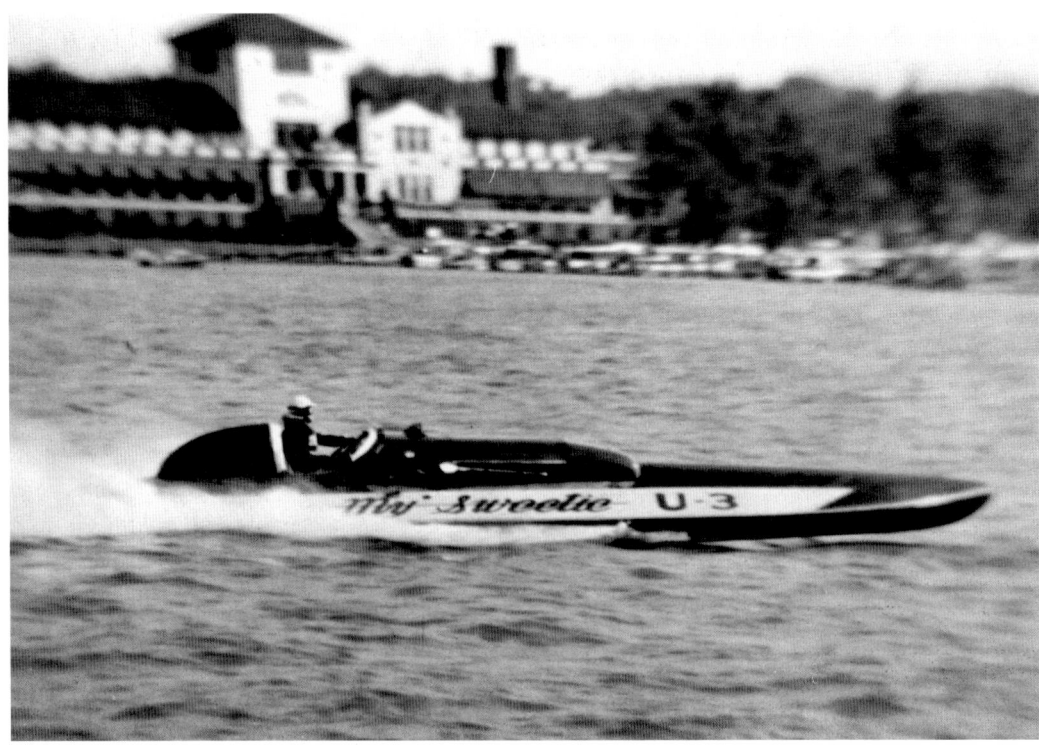

The 1949 Gold Cup winner *My Sweetie* speeds past the Detroit Yacht Club. (Courtesy of Bill Osborne.)

The Postwar Years

1946 to 1949

World War II formally ended with the Japanese surrender on September 2, 1945, onboard the USS *Missouri* in Tokyo Bay. One year later, to the day, the first postwar Gold Cup was held on the Detroit River, on September 2, 1946.

One of the unexpected benefits of the end of the war was the immediate surplus of tens of thousands of lightweight, high-horsepower Allison airplane engines. The Allison V-1710 was a 1,710-cubic-inch engine that put out 1,475 horsepower yet only weighed 1,595 pounds. Roughly 72,000 of the motors had been built for the Army Air Corps during the war to power its P-38, P-39, and P-40 fighters. The motors cost the U.S. government $19,000 each (equivalent to almost $250,000 in today's dollars).

The motors were being sold as surplus for pennies on the dollar, and boat racers were able to buy as many engines as they wanted for just a few hundred dollars each. Prior to World War II, there were two "big" classes of powerboat racing. The Gold Cup was run for Gold Cup–class boats, which were restricted to engines that were 732 cubic inches or less. The unlimited class, as its name implies, was open to motors of unlimited size. After the end of World War II, with the easy availability of the Allison, Gold Cup rules were changed to allow the much larger engines. Eventually the Gold Cup class was absorbed into the unlimiteds.

A total of 22 boats entered the 1946 Gold Cup, and 17 actually started the race. Five were full-fledged Gold Cup boats. Ten were 225-cubic-inch hydroplanes, and two were tiny 135-cubic-inch boats that were allowed to run with the larger boats. The odds on favorites were Guy Lombardo and the *Tempo VI*. Lombardo was a well-known musician who bought Zalmon Simmons's two-time Gold Cup winner *My Sin* for $6,001 and renamed her *Tempo VI*. *My Sin* had been built in 1937 by Ventnor Boat Works of New Jersey. The boat had a unique three-point design that allowed the boat to ride on two small supports protruding from either side of the hull near the bow, and a flat surface on the bottom, near the transom. *My Sin* was the first three-point boat to win the Gold Cup, taking home the trophy in 1939 and 1941.

Tempo's main competition came from a new California boat named *Miss Golden Gate III* that was designed, built, and driven by Dan Arena. *Miss Golden Gate III* was also a three-point design and was powered by a military surplus Allison engine. *Tempo* and the *Golden Gate* both won their elimination heats. By the start of the second heat, mechanical problems had cut the fleet down to only five boats. Arena and a wild-riding *Golden Gate* led the small field across the starting line, but Lombardo and the *Tempo* caught them by the end of lap 1 and cruised by to take an easy victory. In the third and final heat of the day, Arena finally got the *Miss Golden Gate* working properly and she rocketed out to a huge lead, setting a new lap record of 77.91 miles per hour (the prewar lap record had been 72.707 miles per hour). Unfortunately for

Arena, an oil line on the *Golden Gate's* Allison broke, ending her record-setting run two miles from the finish. Lombardo passed the broken-down *Golden Gate* and claimed an easy victory to become the first Gold Cup winner in the postwar era. The Silver Cup was held on the same day as the Gold Cup and was open to the boats that had not made it into the Gold Cup final. Lou Fageol's tiny *So-Long, Jr.* easily won the Silver Cup. Lombardo moved the Gold Cup to Jamaica Bay, New York, for 1947, but there would still be racing on the Detroit River. The Ford Memorial hosted by the Detroit River Racing Association was held in July, and the Silver Cup was put on by the Detroit Yacht Club in August. During the off-season, Fageol sold the larger of his two boats, *So-Long*, to Detroit businessman Russell Dossin. Dossin hired Danny Foster to modify the boat to accept an Allison and renamed her *Miss Pepsi,* to advertise his family's Pepsi distributorship. The American Power Boat Association (APBA) would not allow advertising on Gold Cup boats, so the boat's name was changed to *Miss Peps,* but the capital *P* had a long tail that swooped under the word Peps, and came up after the *s* to make it look like *Pepsi*. Dossin and Foster's ingenuity was rewarded with a stunning performance by the *Miss Peps V*. She won five races that year, including the Ford Memorial, the Gold Cup, the President's Cup, and the national championship.

Dossin brought the Gold Cup back to Detroit in 1948 for one of the most disappointing Gold Cups of all time. Twenty-two boats entered the race. Fifteen actually started, but only one, the old *Miss Golden Gate,* repainted and renamed *Miss Great Lakes,* was able to finish, and even she sank before she could return to the dock! There were two other races in Detroit that year. Lombardo's *Tempo VI* won the Detroit Memorial, and Harold Wilson won the Silver Cup in the *Miss Canada III*. Detroit hosted five major races in 1949, starting with the Gold Cup on July 2, which was won by "Wild Bill" Cantrell in Ed Schoenherr's *My Sweetie*. Two days later, on July 4, Stan Dollar won the Detroit Memorial in his revolutionary *Skip-a-long.* The all-aluminum *Skip-a-long* was a rear-engine, Allison-powered, three-point hydroplane with a fork-shaped bow. On August 1, *Skip-a-long* won again, taking both the international Harmsworth Trophy and the Detroit Marathon. Five weeks after that she won the Silver Cup.

Guy Lombardo was a successful bandleader who sold over 300 million records and made "Auld Lang Syne" a New Year's Eve classic. He was also a successful boat racer who won the first postwar Gold Cup on the Detroit River in 1946. (Courtesy of Bill Osborne.)

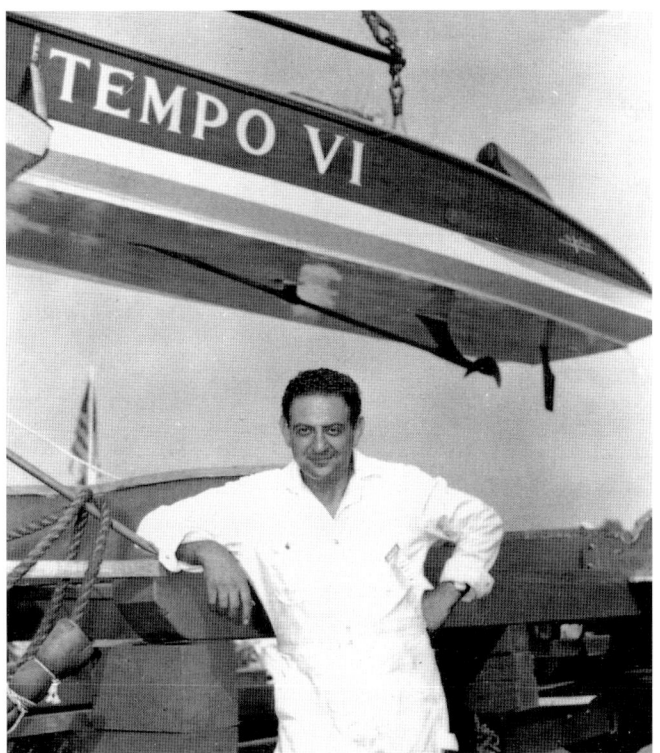

Lombardo's *Tempo VI* was built by Ventnor Boat Works in 1937 and was a classic example of the three-point design. Notice the two riding surfaces near the bow called sponsons. The third riding surface was the flat area behind the propeller. (Courtesy of Bill Osborne.)

The crew of the *Miss Golden Gate III* works on her Allison engine prior to the start of the 1946 Gold Cup. *Miss Golden Gate III* was the first Gold Cup boat to successfully use a World War II surplus Allison engine. (Courtesy of Dave Spear.)

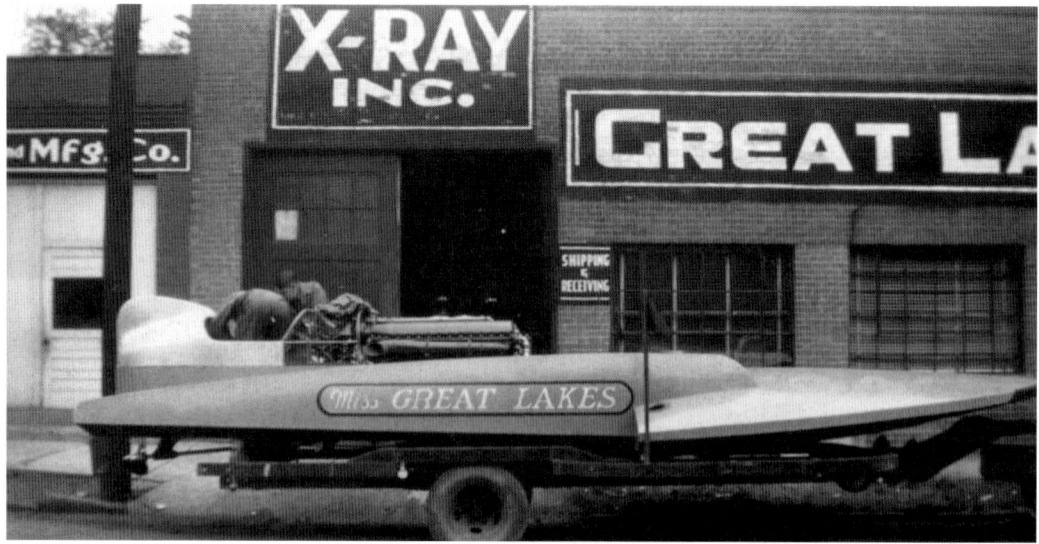

Shortly after the Detroit Gold Cup, Dan Arena sold the *Miss Golden Gate III* to Al Fallon, who renamed the boat *Miss Great Lakes*. (Courtesy of Bill Osborne.)

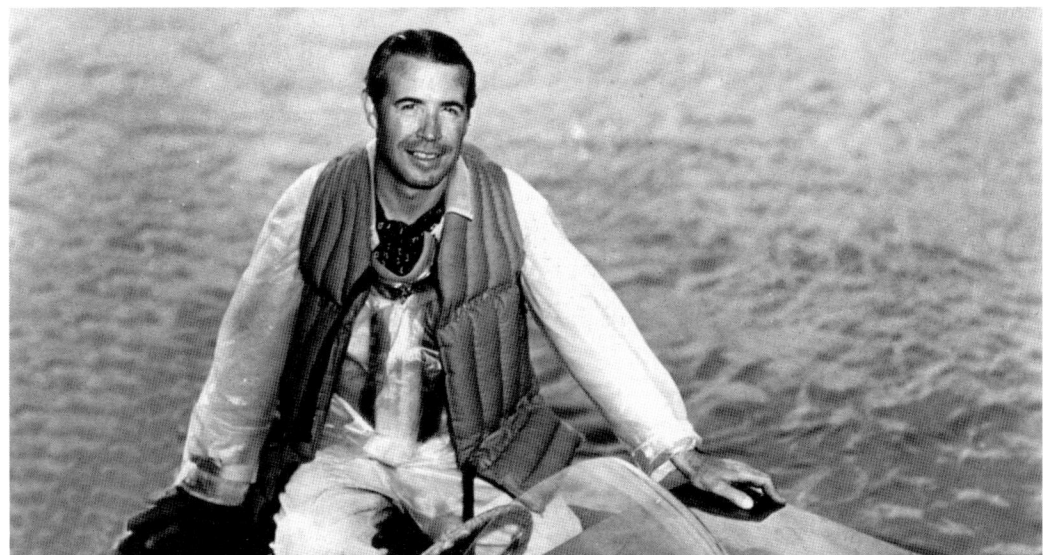

Lou Fageol drove his *So Long Jr.* to victory in the 1946 Silver Cup. Both Fageol and his larger boat, the *So Long*, would have distinguished Gold Cup careers, but not together. Fageol sold the *So Long* to the Dossin brothers, who put an Allison engine in the tiny boat, renamed her *Miss Peps V*, and won the 1947 Gold Cup. Fageol went on to drive for the *Slo-mo-shun* team and won the Gold Cup in 1951, 1953, and 1954. (Photograph by Ray Fageol.)

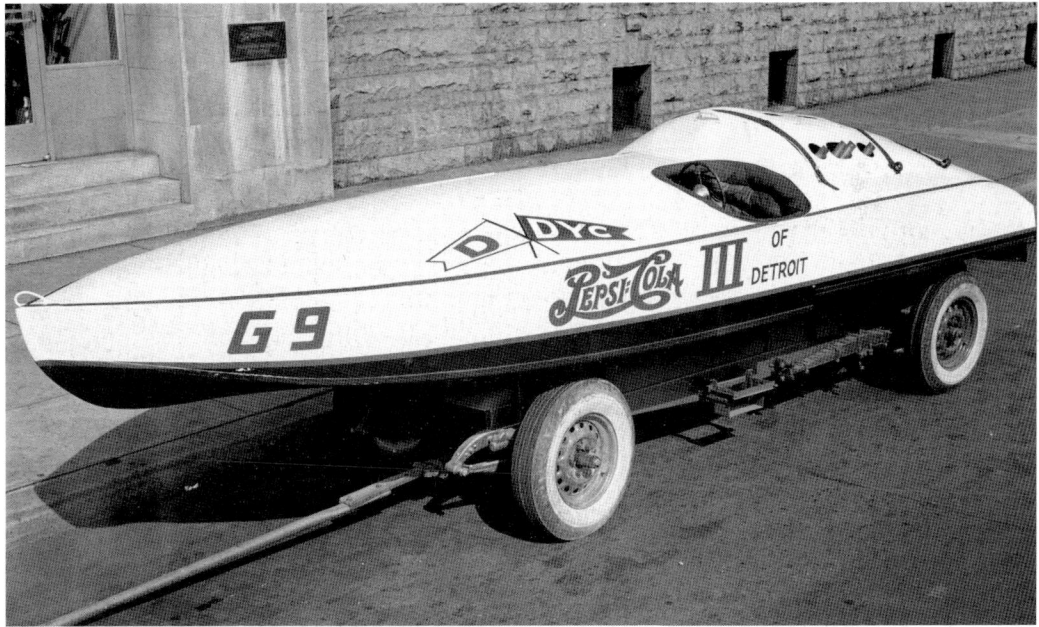

In 1946, Russell, Walter, and Roy Dossin of Detroit leased the G-9 *Dukie* from Bill Stroh and Whitey Hughes and called her *Pepsi-Cola III*. The boat only made it to one race and could only finish one heat, but it was a harbinger of great things to come for Pepsi and the Dossins! (Courtesy of Doug Dossin.)

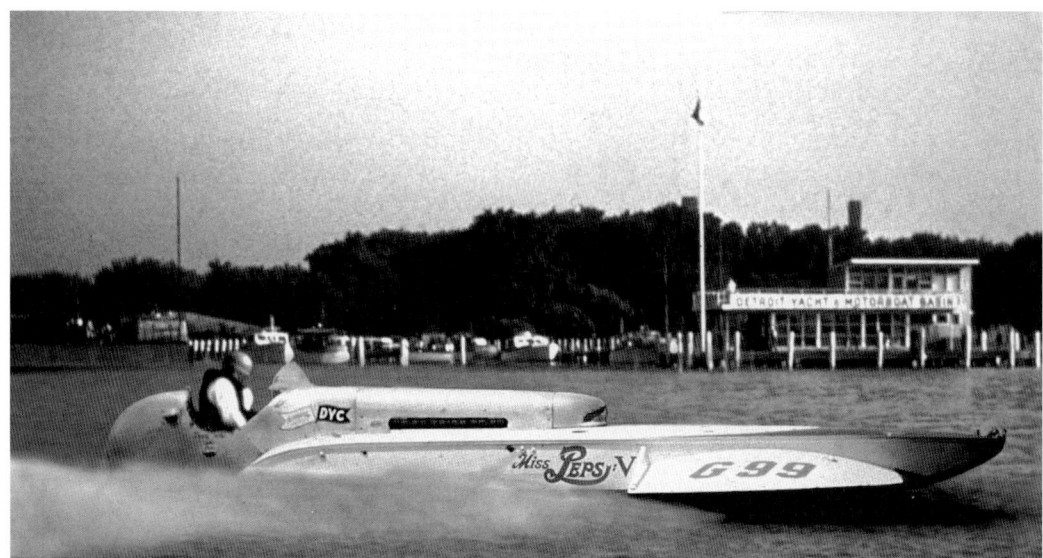

The Dossin brothers unveiled their new *Miss Pepsi V* at the 1947 Detroit Memorial, but chief referee Mel Crook was offended by the blatant commercialism of the name and demanded that the name be changed. The Dossins shortened the name to *Miss Peps V* but had the *P* painted on the boat with a very long tail that curled under the name and came up at the end to look like an *i*. Crook was incensed but allowed the boat to race. (Courtesy of Bill Osborne.)

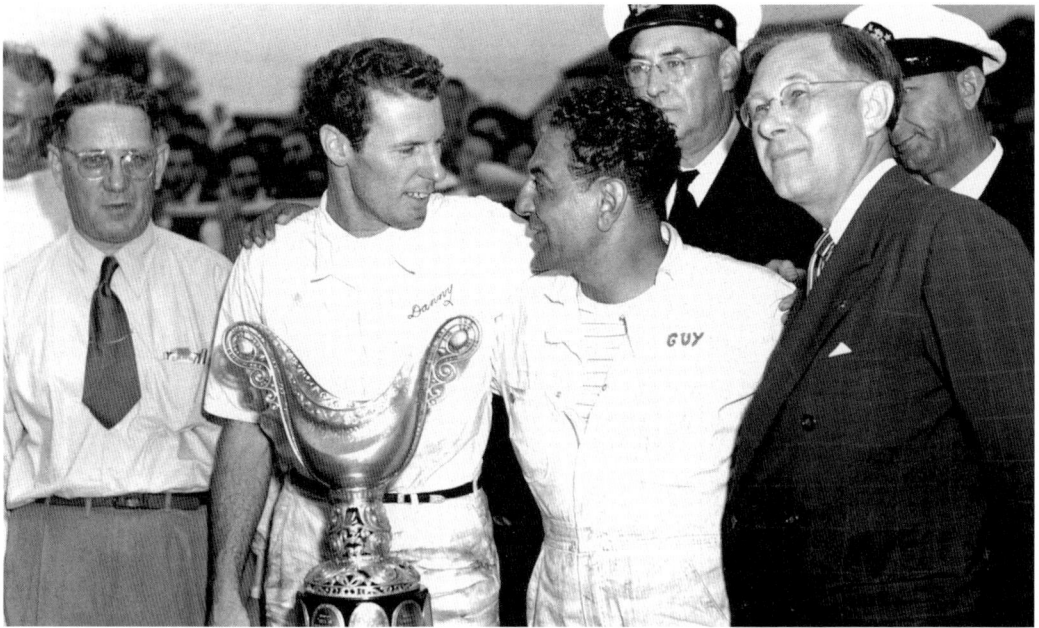

Danny Foster drove the Allison-powered *Miss Peps V* to victory in five out of the seven races he entered, including the Gold Cup and national championship. This photograph shows Foster (second from left) accepting the Gold Cup trophy and congratulations from 1946 winner Guy Lombardo. (Courtesy of Bill Stroh.)

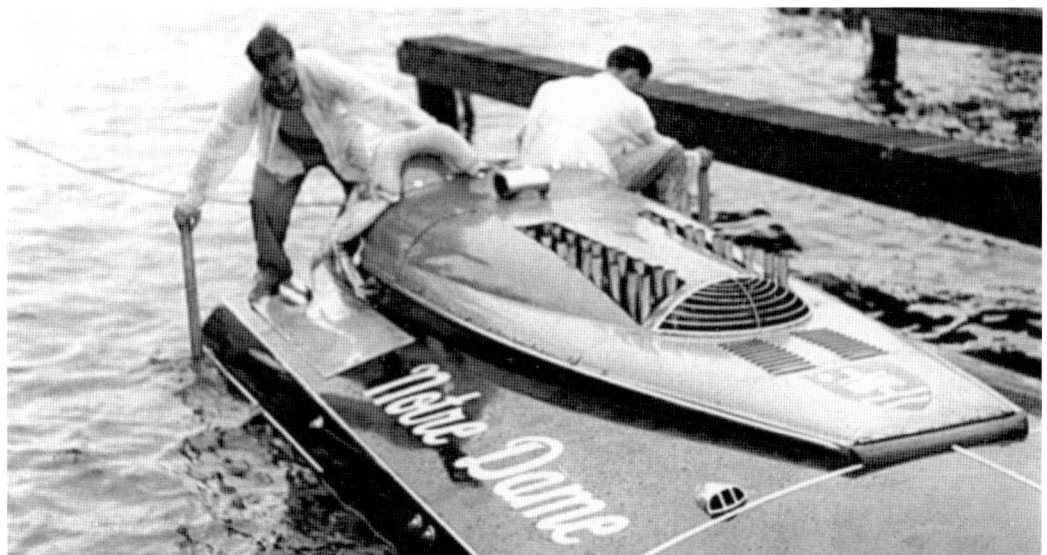

Prior to World War II, Herb Mendelson's Detroit-based *Notre Dame* team was a major contender and won the Gold Cup and President's Cup in 1937. *Notre Dame* was expected to be a major factor in postwar racing, but a family illness kept Mendelson from paying much attention to racing. The *Notre Dame* only went to three races after the war and won just one of them, the 1947 Silver Cup. (Courtesy of Bill Stroh.)

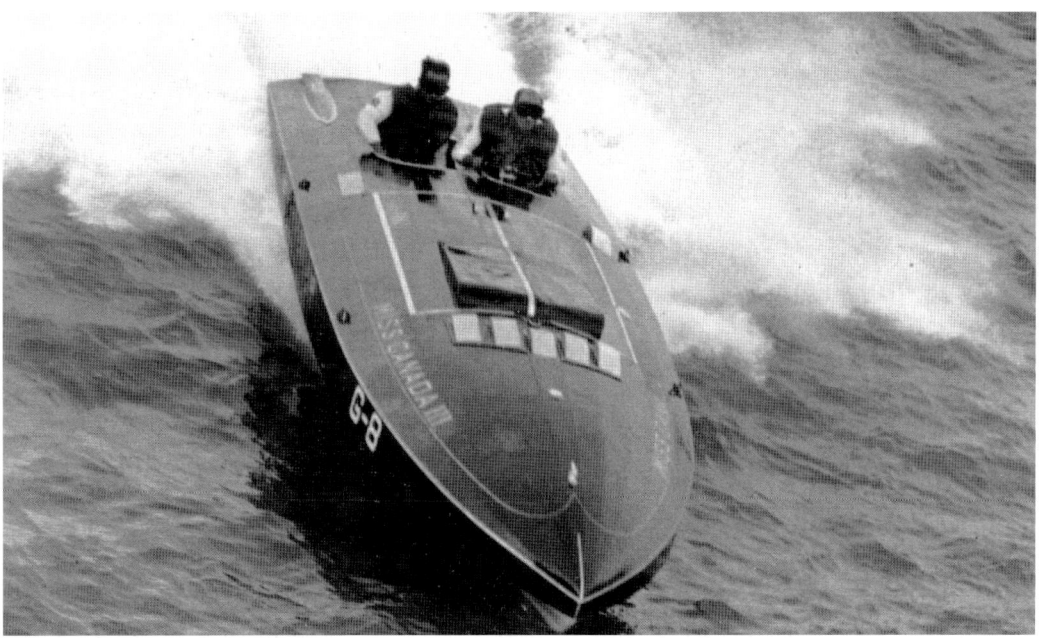

Ernest Wilson's *Miss Canada III*, driven by his son Harold, took second place at the 1947 Silver Cup. This feat marked the first time ever that a Rolls Royce Merlin–powered hydroplane successfully completed a race. In the years to come, the Merlin would dominate the sport from 1955 to 1983. (Courtesy of Bill Osborne.)

There was a building boom in 1948 with no less than 12 new boats showing up for the Detroit Gold Cup. The Dossins had a new *Miss Pepsi*, built by Clell Perry, seen here sitting in the boat's cockpit holding a bottle of Pepsi. The boat did not live up to expectations and was replaced in 1950 with the now-famous twin-engine *Miss Pepsi*. (Courtesy of Doug Dossin.)

Several of the new boats in 1948 were home-built by backyard inventors. Many, like Gerald Warren's *Miss-ter-ee*, failed to perform. (Courtesy of Bill Stroh.)

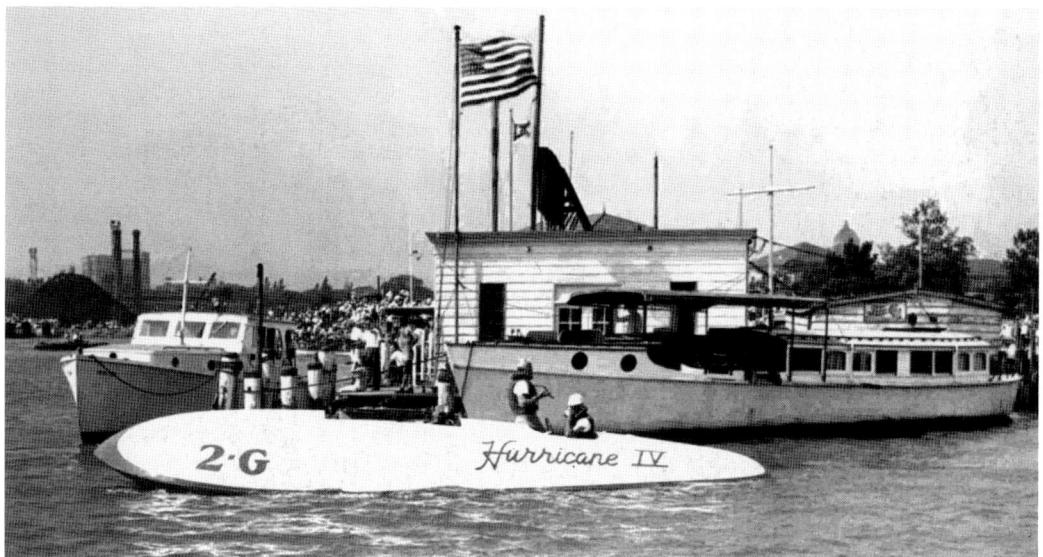

Morlan Visel's *Hurricane IV* lost its steering at the start of the first heat of the 1948 Gold Cup and veered in front of Guy Lombardo and the *Tempo VI*. Lombardo swerved to miss the floundering *Hurricane* but was thrown into the water and broke his arm. (Courtesy of Dave Spear.)

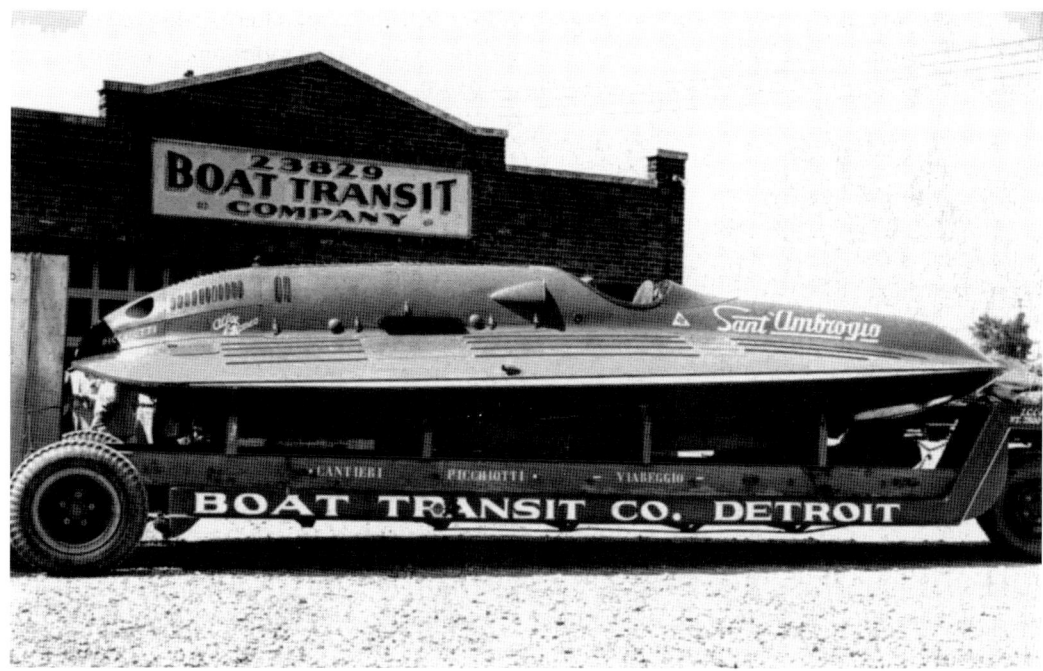

Achille Castoldi brought his Alfa Romeo–powered *Sant Ambrogio* all the way from Italy to compete in the Gold Cup, but the boat sank during her first heat on the river. (Courtesy of Bill Stroh.)

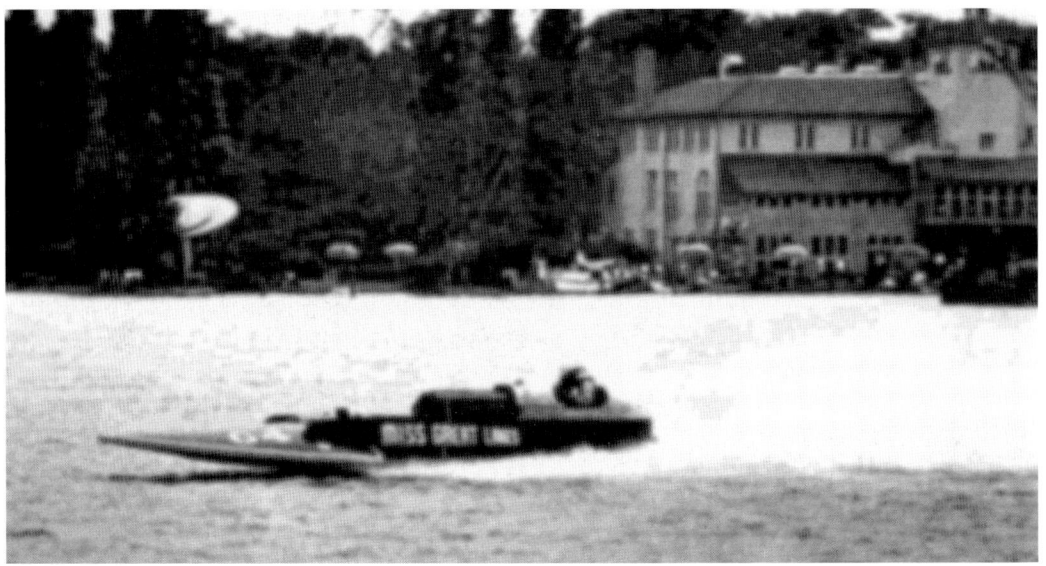

Over 200,000 fans showed up to watch the 1948 Gold Cup. The race was plagued by high winds and rough water. Of the 22 entrants, only the *Miss Great Lakes* and *Miss Frostie* were able to start the final heat. (Courtesy of Bill Stroh.)

When Danny Foster claimed the 1948 Gold Cup trophy, he became the first modern Gold Cup driver to win the cup two years in a row driving two different boats. (Courtesy of Bill Stroh.)

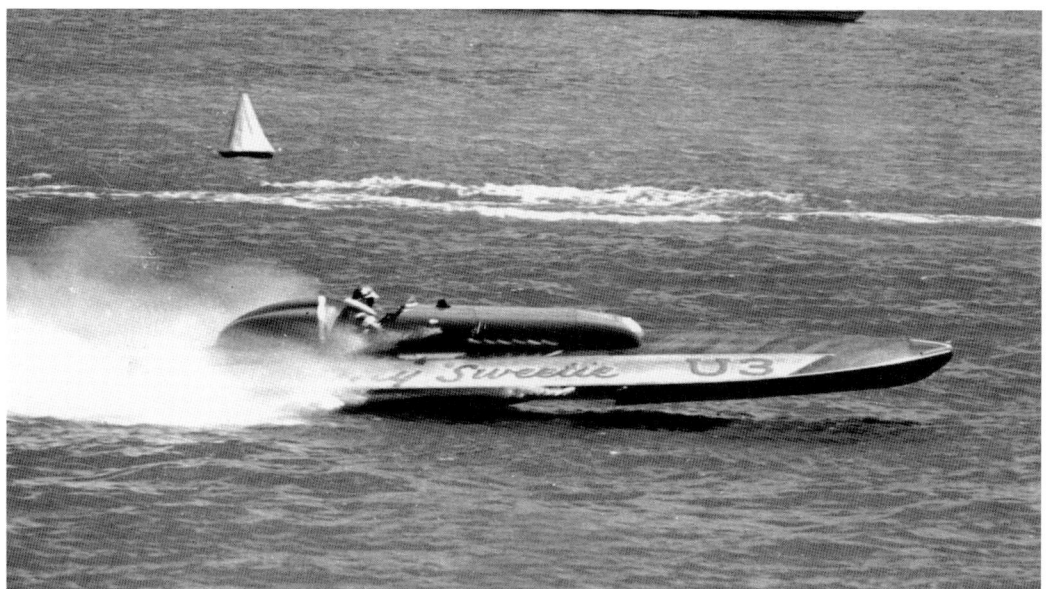

The first race of the 1949 season was the Gold Cup in Detroit. After the debacle in 1948, APBA officials mandated qualifications to prove that contestants were seaworthy. All participating boats had to average over 65 miles per hour for three laps around the Gold Cup course. Ed Schoenherr's U-3 My Sweetie driven by Bill Cantrell won the race. (Courtesy of Jim Higgins.)

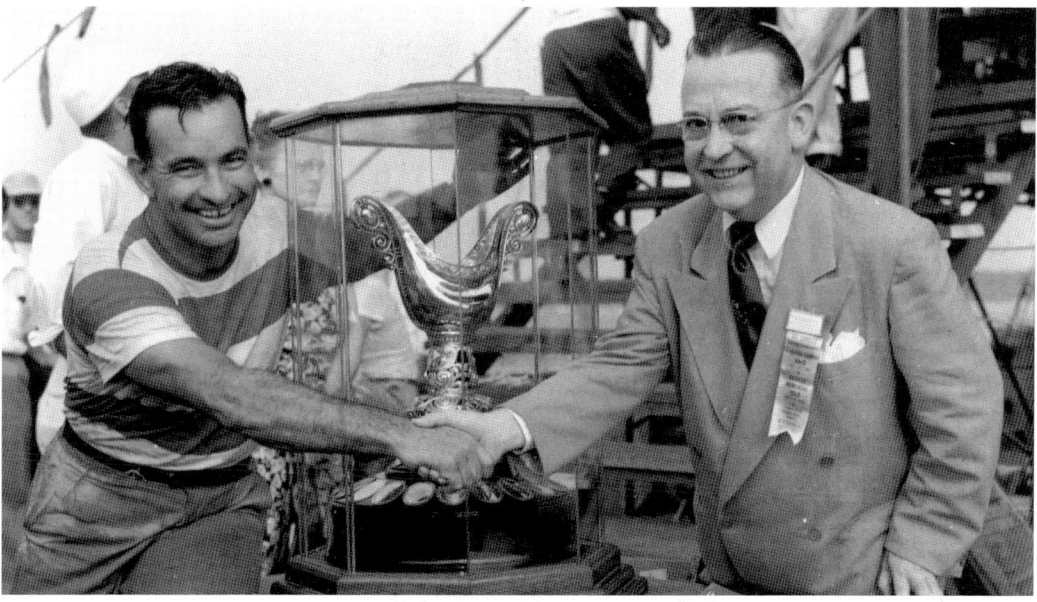

Before "Wild Bill" Cantrell earned fame as a Gold Cup–winning hydroplane driver, he raced outboard boats, limited hydroplanes, sprint cars, and Indy 500 cars and worked as a professional wrestler. During the first heat of the 1949 Gold Cup, the throttle linkage on the My Sweetie's foot pedal came off, so Cantrell reached under the dashboard and operated the throttle by hand and still finished the heat!

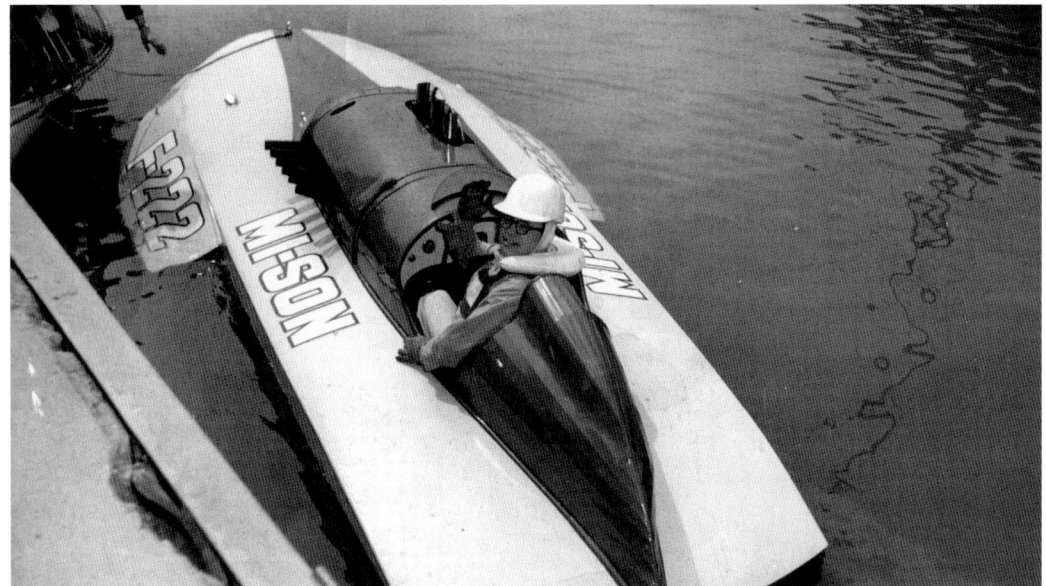

One of the boats that was unable to meet the 65-mile-per-hour qualification standard for the 1949 Gold Cup was a tiny 225 named *Mi-Son* driven by a young Detroit native named Bill Muncey. Muncey would go on to a long and distinguished career in racing and win more races than any other driver in the history of the sport.

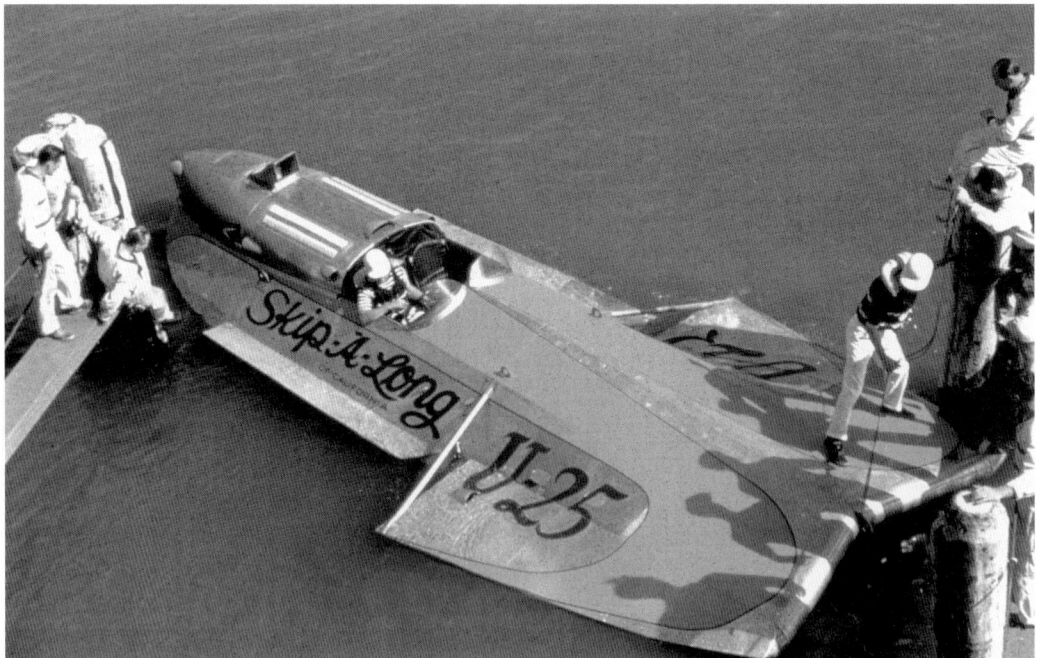

Stanley Dollar brought his radical *Skip-a-long* to Detroit in 1949. The all-aluminum boat took second place in the Gold Cup but then won four straight races, including the Detroit Memorial, the Harmsworth, and the Detroit Marathon. (Courtesy of Joe Meek.)

2

THE RIVALRY YEARS

1950 TO 1955

Unnoticed by most Detroiters, three visitors walked through the pits of the 1948 Gold Cup asking questions, taking photographs, and jotting down notes. The three men were Stan Sayres, Anchor Jensen, and Ted Jones. They returned to the Northwest and quietly began to build a new boat.

In the spring of 1950, Detroiters began to hear rumors of a speedy new craft being tested in Seattle. The world speed record for unlimited boats was 141.74 miles per hour, held by England's Sir Malcolm Campbell. The American record, held by Gar Wood, was only 124.91 miles per hour. Rumors that the mystery boat in Seattle was hitting 160 miles per hour were dismissed as idle gossip. Then on June 26, 1950, word came from Seattle that the mystery boat, identified now as the *Slo-mo-shun VI* set a new world water speed record of 160.3235 miles per hour! The Detroit establishment was shocked! Fans wondered what would happen when the *Slo-mo-shun* came to Detroit for the Gold Cup. Veteran racers quickly assured worried supporters that any boat that was light enough to go 160 miles per hour was too fragile to handle the rough Detroit River.

The *Slo-mo-shun IV* was a refinement of the familiar three-point principle. Unlike the Ventnor-style hydroplane, the rear of the *Slo-mo-shun* was lifted out of the water and rode on the propeller. This new concept, called "prop riding," had been tried with some success in smaller boats, but Sayres (the boat's owner), Jones (the designer), and Jensen (the builder) were the first to perfect the concept in an unlimited.

Seventeen boats, including the *Slo-mo-shun*, showed up for the 1950 Gold Cup. Detroiters were encouraged when Horace Dodge's *My Sweetie* qualified at 89 miles per hour, almost 2 miles per hour faster than the *Slo-mo-shun*. In the first heat of the race, the *Slo-mo*, driven by Jones, quickly took the lead. Jones continued to extend his advantage and was so far ahead that as the *Slo-mo* came out of the last turn on the last lap, he had caught the *Sweetie* and was ready to lap her. Jones says that he lost track of the *Sweetie's* position and was not sure if he was behind her or not, so rather than take a chance on finishing second, he pressed the throttle down and sped past the second-place *My Sweetie*, putting her a full lap down. Detroiters were outraged at what some considered poor sportsmanship. In that instant the seeds of one of professional sports' greatest rivalries were planted.

Sayres took the Gold Cup to Seattle, but the Detroit racers vowed to head to Seattle and win the trophy back. Seven boats, led by the Dossin brothers' new *Miss Pepsi* made the long trek to Seattle. Sayres unveiled a new *Slo-mo-shun V* less than a week before the race. The *Slo-mo-shun V* proved to be every bit as fast as her older sister and handily won the 1951 Gold Cup. The weary Detroit fleet returned from Seattle in time to run for the Detroit Memorial on September 1 and

the Silver Cup on September 3. The mighty *Pepsi* driven by Chuck Thompson won both races and went on to claim the national championship.

In 1952, the Detroit Memorial was held on July 4, a full month before the Gold Cup, to give the Detroit fleet a chance to "tune up" before it headed west. The *Pepsi* won again, making her a clear favorite for the Gold Cup. Only three Detroit boats made the 2,400-mile trip to Seattle. The *Slo-mo-shun IV* won again, and the *Miss Pepsi* took second but accumulated enough points during the rest of the season to capture her second national championship in a row.

The 1953 season started with the Detroit Memorial on July 4, which was won by Al Falon's *Miss Great Lakes II*. Five Detroit boats made the long journey to Seattle to fight for the Gold Cup, and again they were disappointed when the *Slo-mo-shun IV* won. Even though Detroiters were having a run of bad luck in the Gold Cup, they continued their stranglehold on the national championship, with Lee Schoenith and the *Gale II* winning the award in 1953.

Joe Schoenith unveiled his new *Gale IV* and *Gale V* at the start of the 1954 season. His son Lee won the Detroit Memorial and then led a fleet of seven Detroit boats west to do battle in Seattle. Once more the trip was in vain, as the *Slo-mo-shun V* won, giving Seattle five Gold Cup victories in a row! Lee Schoenith returned to Detroit and drove the *Gale V* to victory in the Silver Cup and claimed the national championship as well.

The *Gale IV* won the 1955 Detroit memorial in June, and spirits were high as the *Gale IV* and *Gale V* led a fleet of seven Detroit boats west on the now-familiar trek to Seattle. Aside from the two *Slo-mo* boats, Seattle had a new entry in to the hydroplane wars. The *Miss Thriftway* was designed by Ted Jones and driven by transplanted Detroiter Bill Muncey.

Seattle's hopes of victory took a serious blow when the *Slo-mo-shun V* flipped while qualifying and had to withdraw. On race day, the *Slo-mo IV* won the first heat and *Thriftway* won the second. In the final heat, the *Slo-mo* took the lead and Seattleites were confident that they were about to win a sixth straight Gold Cup. Then the unthinkable happened. With only two laps to go, the *Slo-mo* slowed to a stop, out of the race. *Miss Thriftway* assumed the lead, and the highly partisan Seattle crowd breathed a sigh of relief; with two firsts and a third, the *Thriftway* looked like a clear winner over the *Gale*, which had two seconds and a third. But the *Gale* had actually completed her heats 4.5 seconds faster than the *Thriftway*, so she was awarded 400 bonus points for the fastest elapsed time and thereby won the race. Seattleites were outraged; Detroiters were thrilled. The Gold Cup would finally return "home" to the Detroit River and the Detroit Yacht Club. Schoenith and the *Gale V* also won the national championship that year.

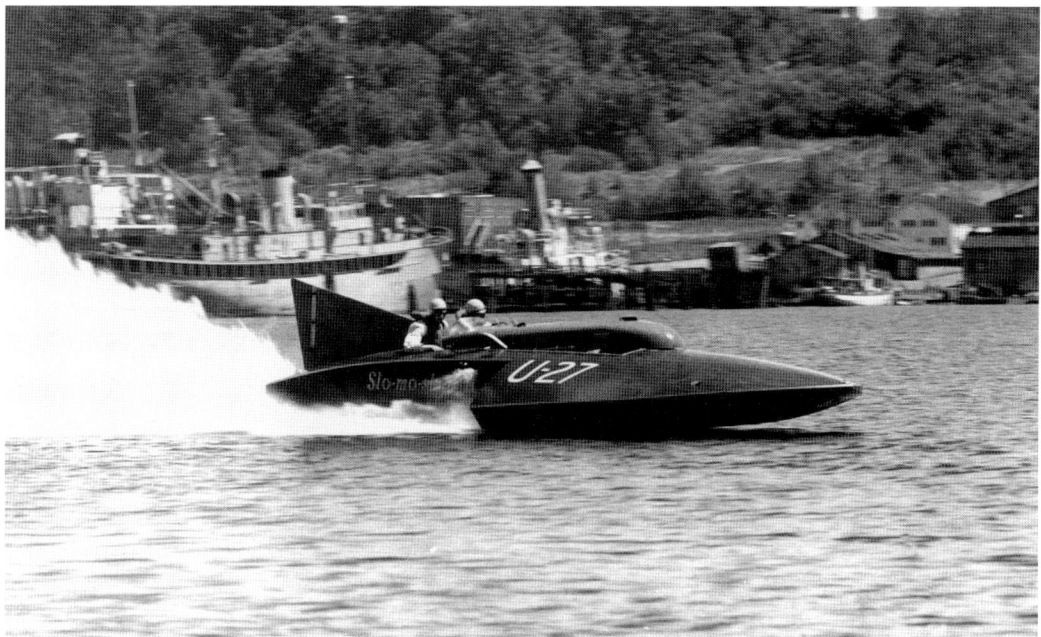

Stan Sayres's *Slo-mo-shun IV* shocked the Detroit racing establishment when she set a new world water speed record of 160.3235 miles per hour on Seattle's Lake Washington in June 1950. The new record bettered the previous American record held by Gar Wood by more than 35 miles per hour!

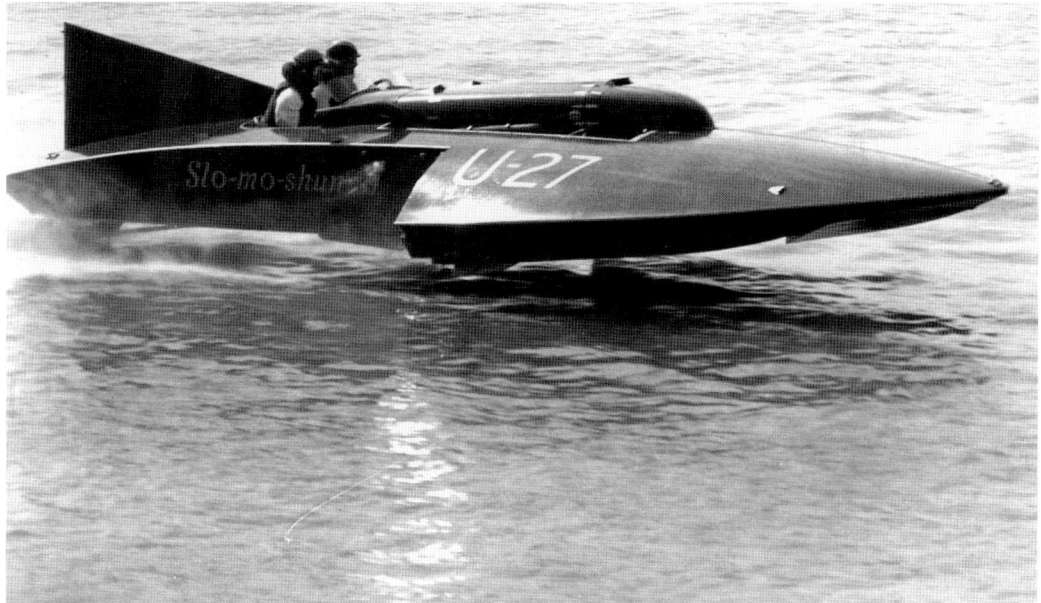

The *Slo-mo-shun IV* proved to be every bit around a turn as she was in a straight line. With Ted Jones at the wheel, the *Slo-mo* won the 1950 Gold Cup and took the Gold Cup out west to Seattle. (Courtesy of Jim Higgins.)

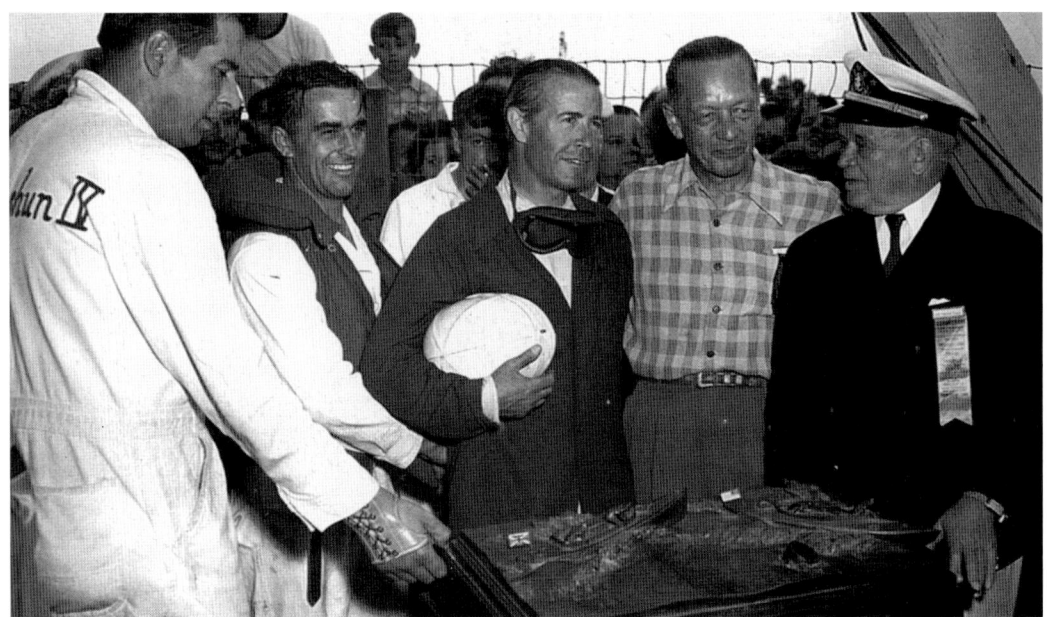

From left to right are Ted Jones, Mike Welsch, Lou Fageol, Stan Sayres, and unidentified. The Harmsworth Trophy was an international trophy that rivaled the Gold Cup for significance. The *Slo-mo-shun IV* was chosen to be one of the American defenders in 1950 and beat the *Miss Canada VI*. The *Slo-mo's* normal driver, Ted Jones, was unable to drive because of a broken hand received while roughhousing around in the pits, so Lou Fageol filled in. This started a long and successful relationship between Fageol and Sayers. (Courtesy of Jim Higgins.)

Jack Schafer owned the Schafer's Such Crust Bread Company in Detroit and won his first hydroplane in a poker game. He started racing Gold Cup boats in 1947 and by 1950 was a major force in the sport. (Courtesy of Bill Stroh.)

Schafer's *Such Crust* with Danny Foster driving won the 1950 Silver Cup. (Courtesy of Jack Schafer Jr.)

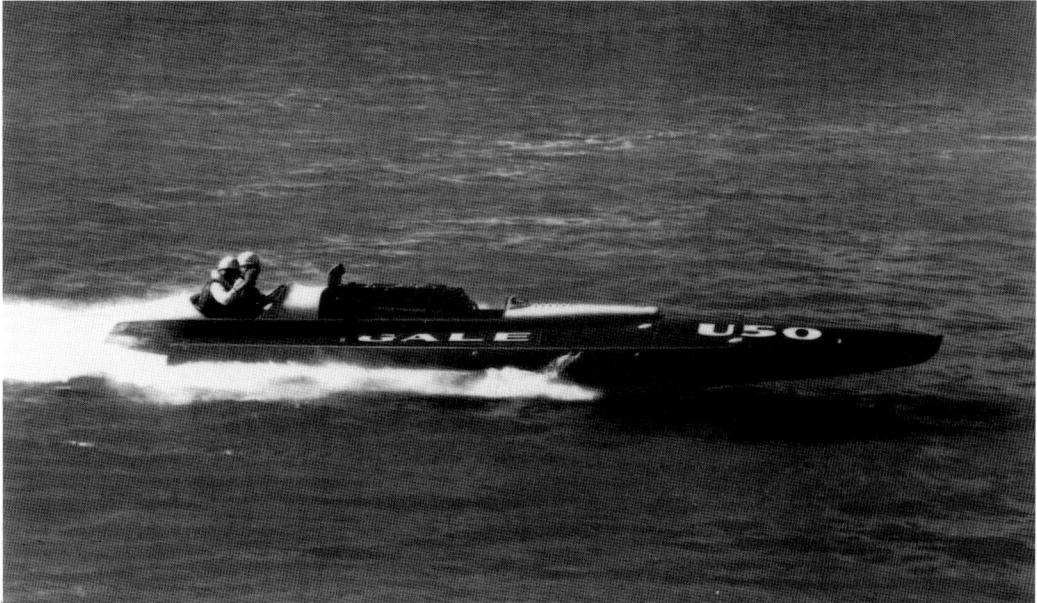

Joe Schoenith bought the old *Notre Dame* and renamed her *Gale* after the W. D. Gale Electrical Company that he owned. The boat failed to qualify for the Gold Cup and took sixth place in the Silver Cup, but in the years ahead, the team would grow to become the dominant force in Detroit hydroplane racing.

HYDROPLANE RACING IN DETROIT

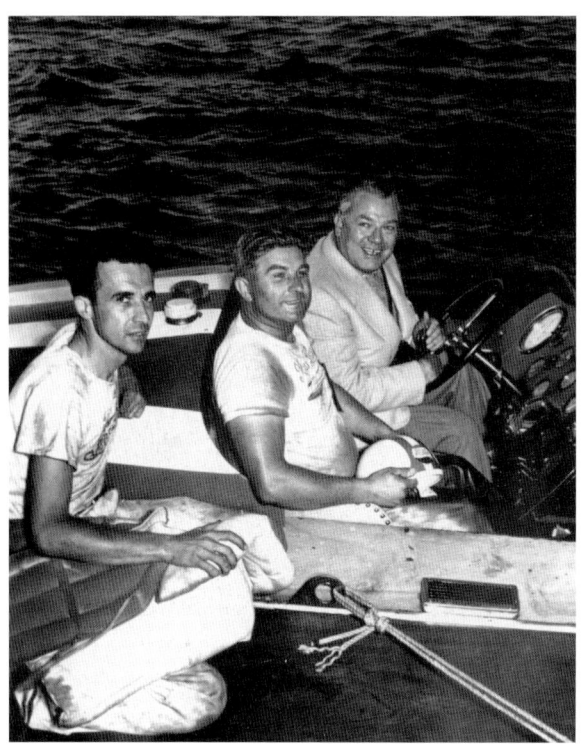

The U-99 *Miss Pepsi* won the President's Cup at the end of the 1950 season and followed that up with wins in the first two races of 1951. She looked like a clear favorite to win back the Gold Cup for Detroit at the race in Seattle. In this photograph, from left to right, Ernest J. Dossin II, Chuck Thompson, and local radio personality Johnnie Slagle pose in the cockpit of the boat. (Courtesy of Jim Higgins.)

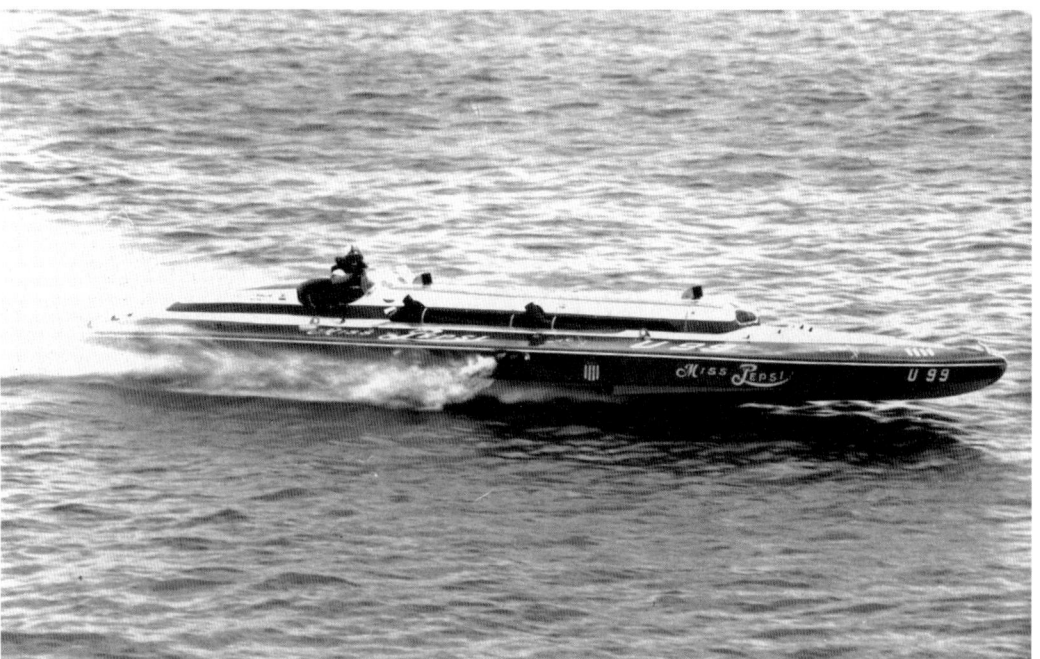

Despite a disappointing Gold Cup that saw Seattle retain the cup for another year, the *Miss Pepsi* won five races in 1951, including the Detroit Memorial and Silver Cup. The *Miss Pepsi* also captured the national championship. (Courtesy of Bill Osborne.)

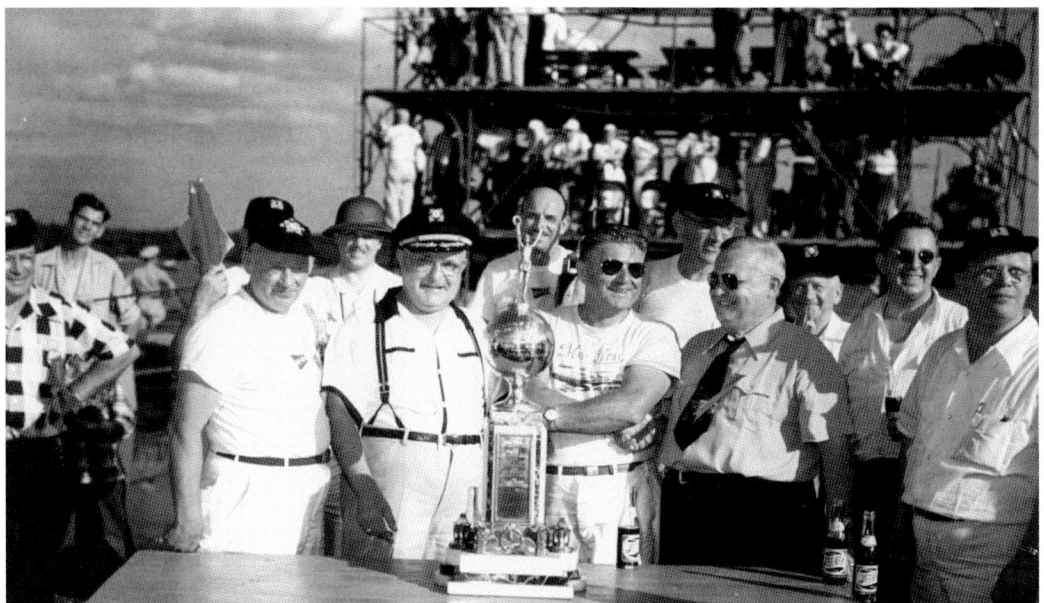

The *Miss Pepsi* continued her winning ways, claiming the 1952 Detroit Memorial before heading west for another try at the Gold Cup. In this photograph, from left to right, Walter, Roy, and Ernie Dossin pose with Chuck Thompson after winning the 1952 Detroit Memorial. (Courtesy of Jim Higgins.)

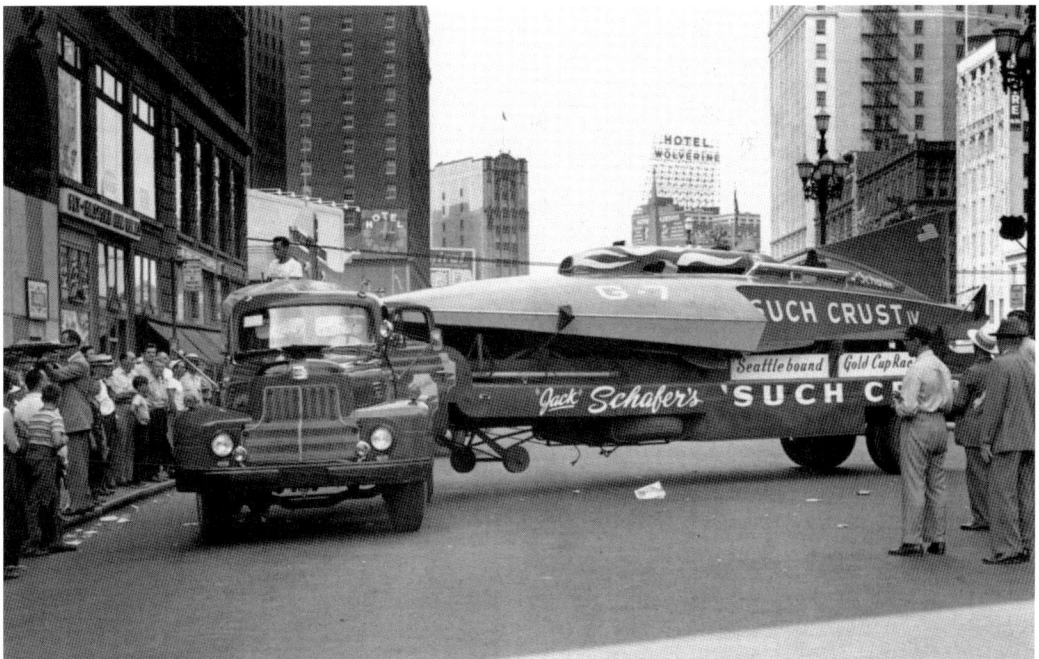

In 1952, the *Miss Pepsi*, *Such Crust IV*, and *Miss Great Lakes II* caravanned together from Detroit to Seattle. Here the boats receive a rousing send-off from local fans. The best Detroit finish in Seattle was the *Miss Pepsi's* second, so the cup stayed out west. (Courtesy of Doug Dossin.)

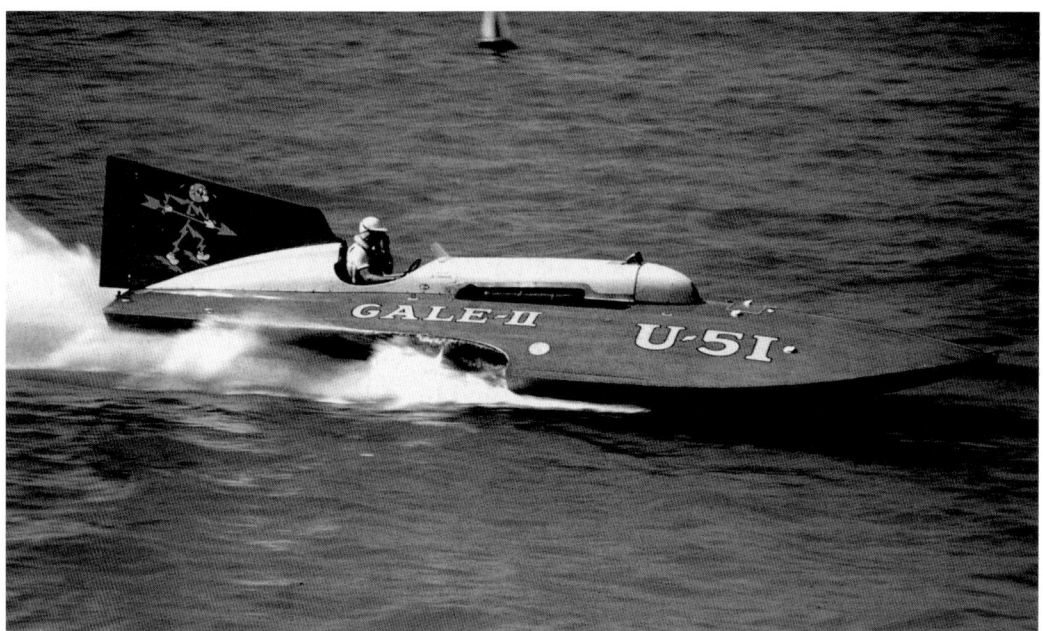

The *Gale* team's regular driver, Lee Schoenith, was drafted into the army and spent the 1952 season in Korea, so Danny Foster drove Joe Schoenith's *Gale II* in his absence. Foster steered the boat to a first-place finish in the 1952 Silver Cup. (Courtesy of Jim Higgins.)

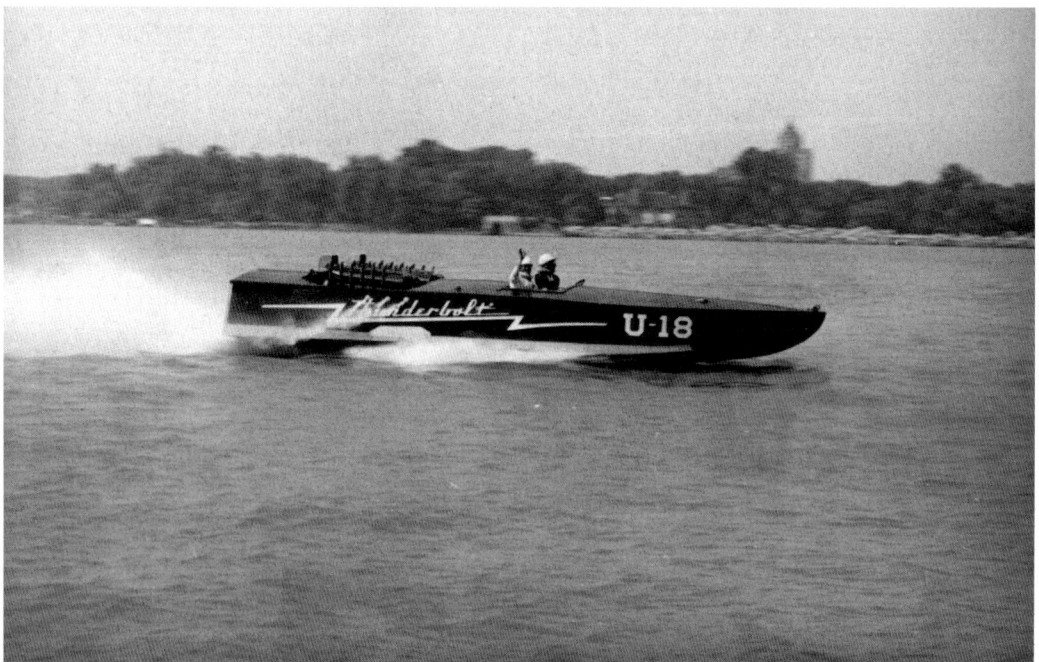

Backyard builders continued to try their hand at boatbuilding. The *Thunderbolt* owned and driven by George Zigas was powered by twin side-by-side Allisons. She was entered in the 1952 Silver Cup but failed to finish a heat. (Courtesy of Doug Dossin.)

Danny Foster drove Al Falon's *Miss Great Lakes II* to victory in the Detroit Memorial to kick off the 1953 season.

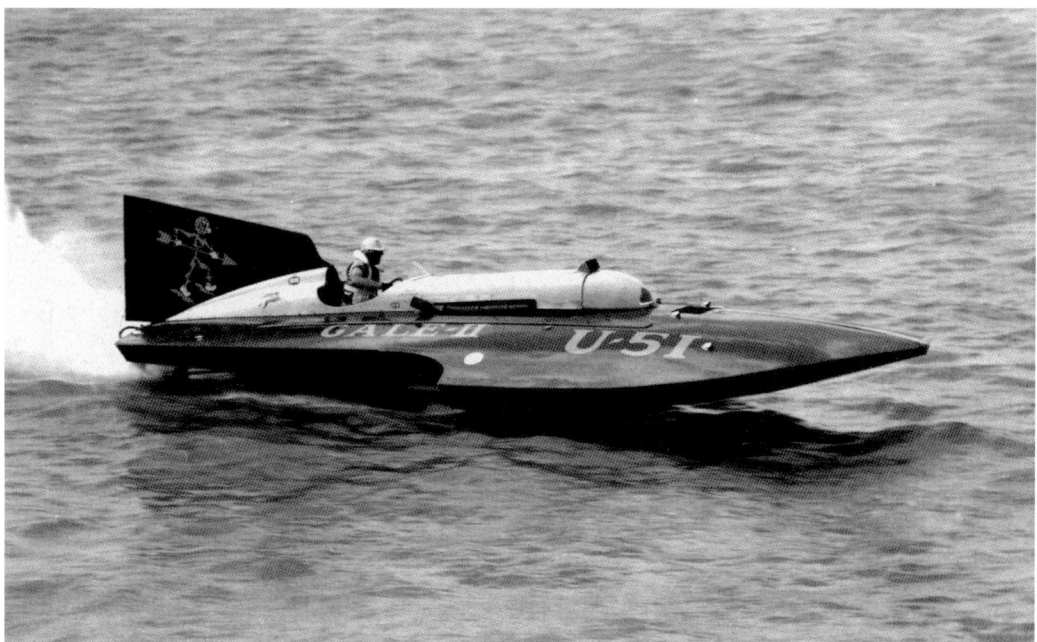

Lee Schoenith, back from a tour of duty in Korea, took second place at the Gold Cup in Seattle behind the *Slo-mo-shun IV*. The following month, he drove the *Gale II* to victory in the Silver Cup and won the national championship. (Courtesy of Jim Higgins.)

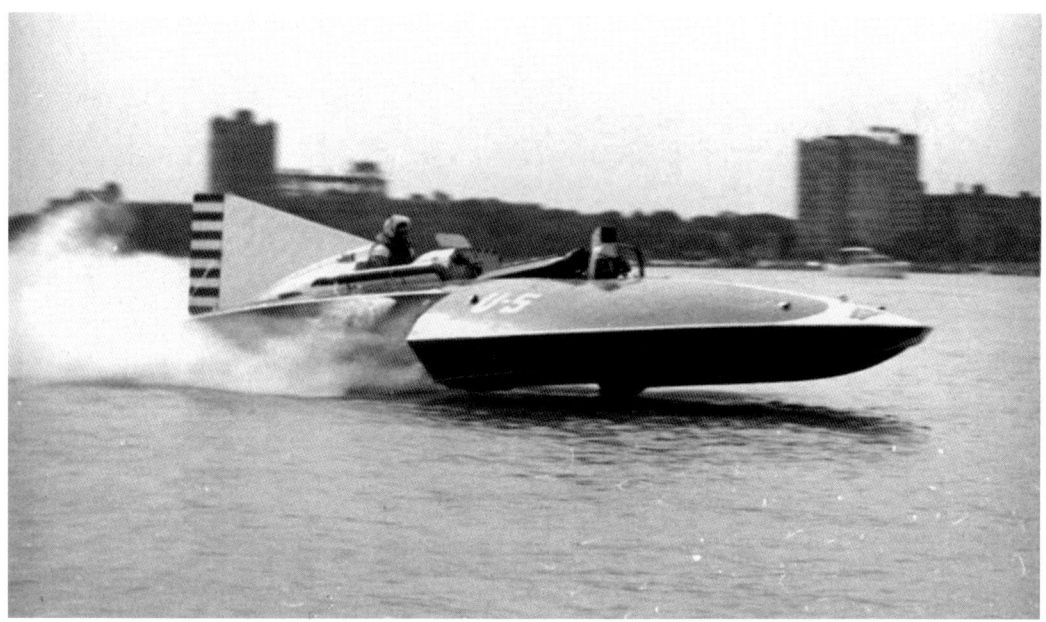

The *Such Crust V* with Bill Cantrell at the wheel took second place at the Detroit Memorial and second place in national high points. (Courtesy of Doug Dossin.)

The *Slo-mo-shun V* journeyed back to Detroit for the 1953 Silver Cup and only managed to take fourth place. (Courtesy of Doug Dossin.)

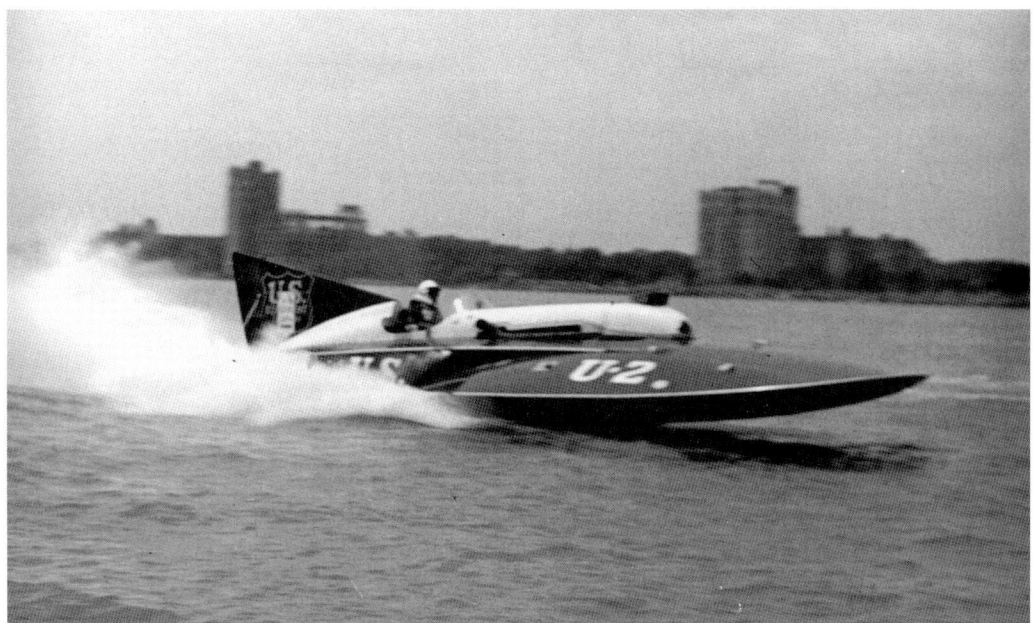

Detroit got another first-class team when George Simon, owner of U.S. Equipment Company, entered the hydroplane wars in 1953 with his Dan Arena–designed *Miss U.S.* The Allison-powered craft took fourth place at the Gold Cup. (Courtesy of Doug Dossin.)

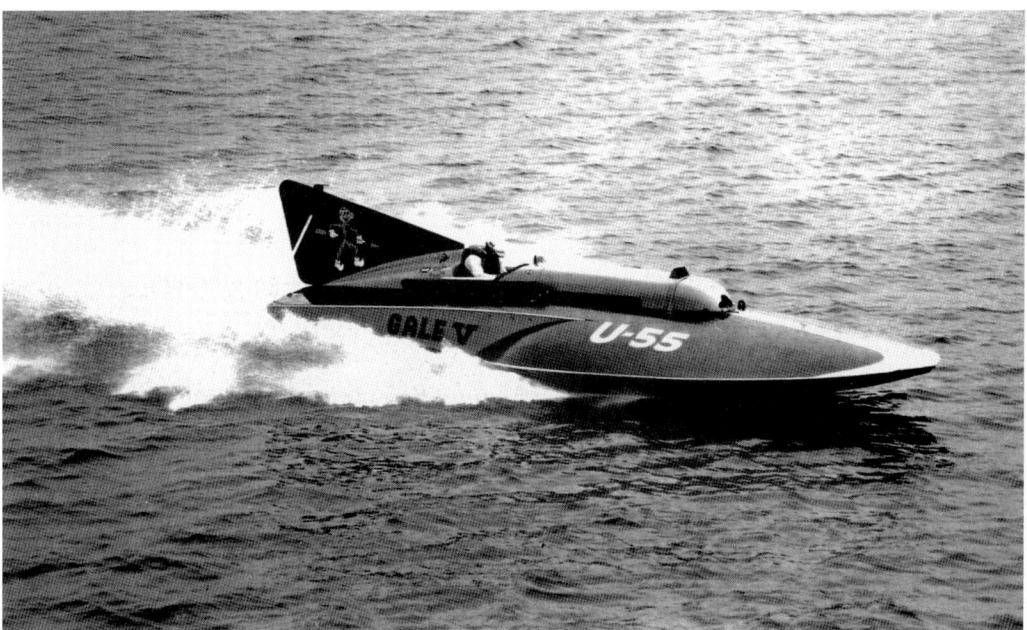

Lee Schoenith drove his father's new *Gale V* to victory in four races, including the Detroit Memorial in 1954 to earn his second straight national championship. However, the Gold Cup continued to elude the Detroit-based team, and the *Slo-mo-shun V* won the trophy again in 1954. (Courtesy of Bill Osborne.)

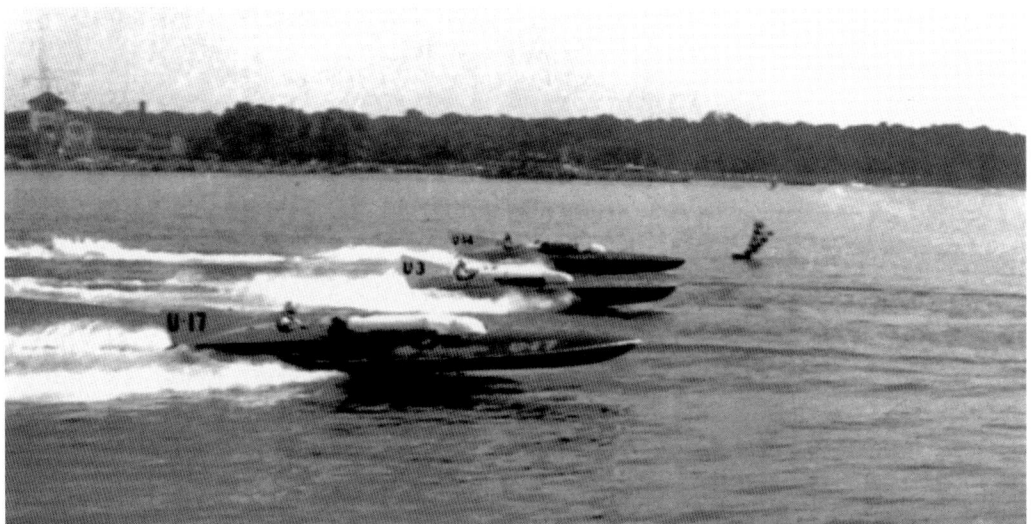

The 1954 Silver Cup was won by Horace Dodge's step hydroplane My Sweetie Dora. This would be the last time a step hull would win in Detroit, although Dodge did claim one final victory with the Dora in 1956 in Windsor, Ontario. Dodge was devoted to the old step hull design and continued to have step boats built long after the other Detroit teams switched to three-point hydroplanes. In this photograph, the U-14 My Sweetie Dora, U-3 My Sweetie, and U-17 My Sweetie John Francis cruise past the Detroit Yacht Club. (Courtesy of Bill Stroh.)

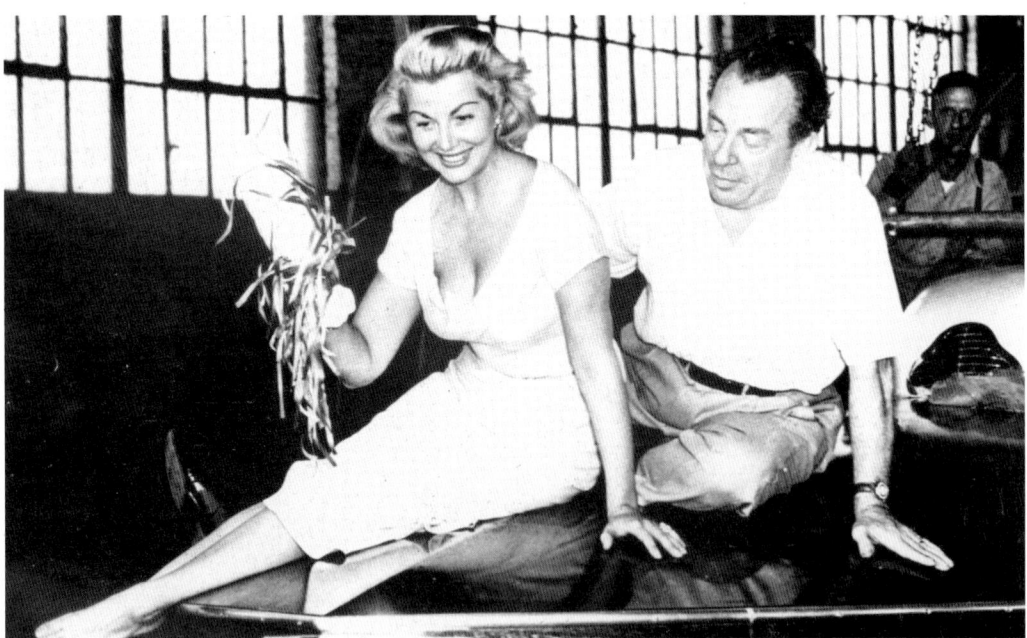

Horace Dodge and his fifth wife, showgirl Gregg Sherwood, christen the My Sweetie John Francis, named after their son. Dodge's marriage to Sherwood lasted nine years. After the divorce, Sherwood sued Dodge's mother, Anna, claiming that she sabotaged the marriage. (Courtesy of Bill Stroh.)

Bill Cantrell and the *Gale IV* won the 1954 Detroit Memorial. (Courtesy of Doug Dossin.)

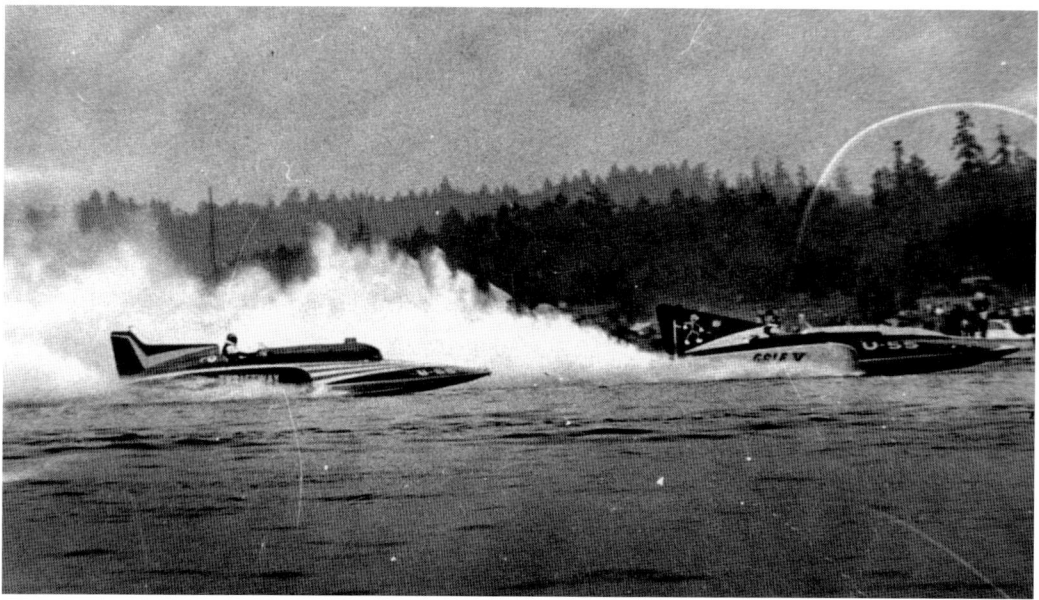

Detroit native Bill Muncey was hired to drive Willard Rhodes's *Miss Thriftway*. Leaving Detroit and moving to Seattle to drive for "the competition" was a difficult decision for Muncey. He appeared to win the 1955 Gold Cup, but the trophy was awarded to Muncey's good friend Lee Schoenith, driving the *Gale V*, in a very controversial decision by the officials. This photograph shows the *Gale V* leading the *Miss Thriftway* during the first heat of the 1955 Gold Cup.

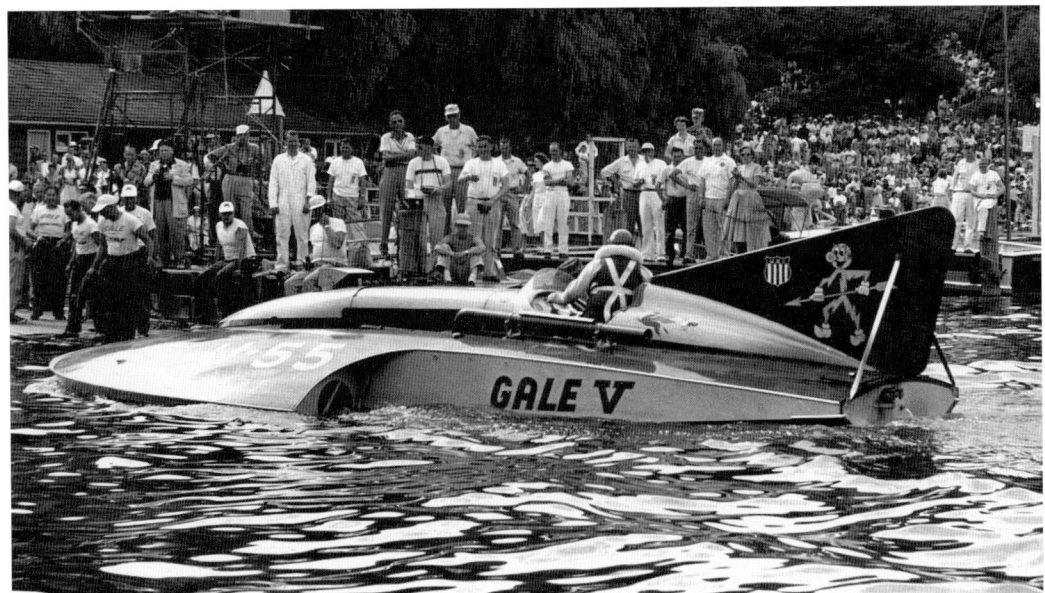

Lee Schoenith brings the Gale V back to the pits after the 1955 Gold Cup. Gold Cup scoring was complicated. The Miss Thriftway finished her three heats with two first and one third. The Gale V had two thirds and a second, but the Gale's total elapse time was 4.5 seconds faster, so she was awarded 400 bonus points and ended up winning the race.

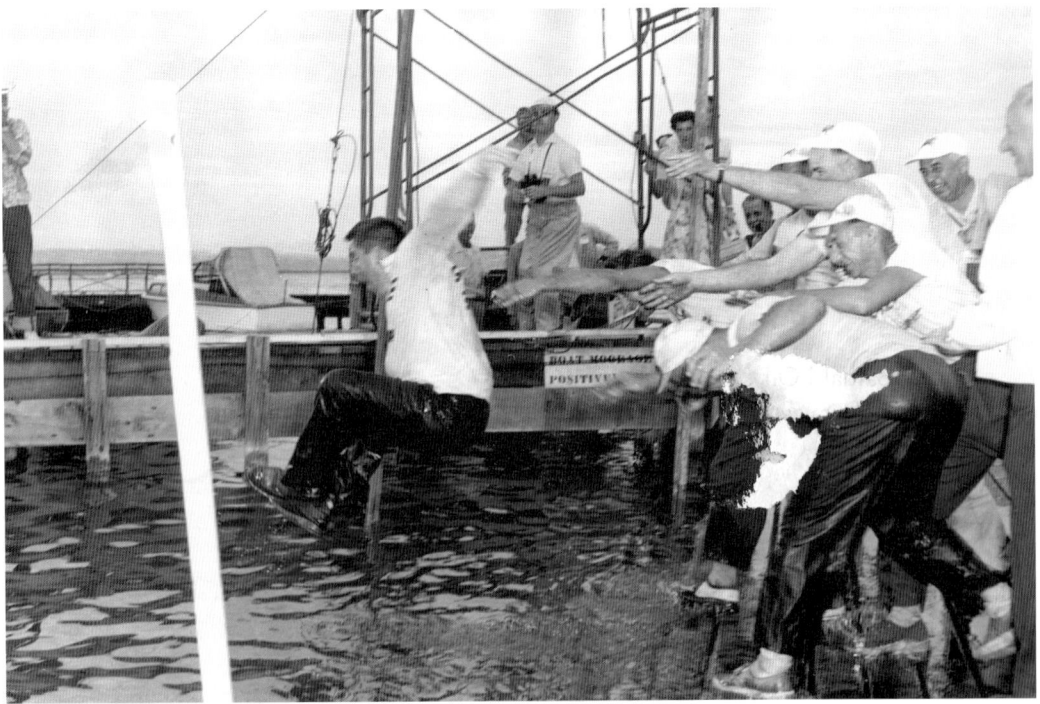

When it was announced that Lee Schoenith won the 1955 Gold Cup, his crew was ecstatic and celebrated by throwing him in Lake Washington.

3

THE GOLDEN YEARS

1956 TO 1962

There were three unlimited races in Detroit in 1956, starting with the Silver Cup on August 18, won by George Simon's *Miss U.S. II*, followed by the international Harmsworth Trophy race held on August 28, won by Bill Waggoner's *Shanty I*, and finally the Gold Cup on September 1. Eight boats came from the West Coast to try and wrest the Gold Cup away from Detroit. For the second year in a row, Bill Muncey and the *Miss Thriftway* appeared to win the race on the race course only to return to the pits and find out that it was not so. A turn judge ruled that the *Miss Thriftway* hit a buoy on her seventh lap, so she was disqualified. The penalty gave the victory to Chuck Thompson and the *Miss Pepsi*. Detroiters were elated. Seattleites were dejected. Armed will film from Seattle's KING TV that clearly showed the *Thriftway* passing the buoy without hitting it, Willard Rhodes, owner of the *Thriftway*, filed a formal protest. It took almost two months for a decision to be made, but finally on November 25 it was announced that Bill Muncey and the *Miss Thriftway* had won the race. Fans on both sides of the dispute complained, and the Seattle-Detroit trivially heated up considerably!

The Gold Cup controversy also pointed out the need for the unlimited class to have professional management, so in June 1957, the unlimited owners voted to form the Unlimited Racing Commission (URC), a separate commission within the APBA to oversee the sport. George Trimper, a former APBA president, was elected as the first URC commissioner.

The rest of the decade of the 1950s saw teams from Seattle and Detroit slug it out for hydroplane supremacy. There were three major Detroit-based unlimited race teams: Joe Schoenith's *Gale* team, sponsored by Gale Electric; George Simon's *Miss U.S.* team, sponsored by U.S. Equipment; and Jack Schafer's *Such Crust* team, sponsored by Such Crust Bakeries. Seattle was represented by Willard Rhodes's *Thriftway* team, sponsored by Associated Grocers; Ole Bardahl's *Miss Bardahl*, sponsored by Ford Company; and Edger Kaiser's *Hawaii Kai*. There were also a number of smaller teams from each city that took part in the race, but the main contenders were the six teams listed above.

The 1957 Detroit Memorial was held in June, and not a single Seattle boat made the trip east. Jack Schaffer's big *Such Crust III* won the race to claim the second victory in her career. Six Detroit boats made the trip to Seattle to fight for the Gold Cup. This time Bill Muncey and the *Thriftway* won with no disputes.

Only one Seattle boat made the long journey east to run for the 1958 Detroit Memorial, but one was enough. Former Detroit native Bill Muncey drove the second *Miss Thriftway* to her one and only victory on June 14, 1958, at the Detroit Memorial.

Miss U.S. and *Gale V* and *Gale VI* were the only Detroit boats to head to Seattle for the 1958 Gold Cup. The *Hawaii Kai III* won, with *Gale V* finishing fourth and *Gale VI* taking home fifth.

The 1958 Silver Cup was one of the greatest races of all time with *Gale V* and the *Maverick* staging a deck-to-deck duel that went on for 10 laps before Bill Stead and the *Maverick* pulled out a victory in the winner-take-all final heat.

Bob Hayward drove Canada's *Miss Supertest III* to victory in the 1959 Detroit Memorial. Later that summer, Bill Waggoner's *Maverick* won the Gold Cup in Seattle and the Silver Cup in Detroit. Waggoner elected to defend the 1960 Gold Cup on Lake Mead, outside Las Vegas.

Miss Thriftway won the 1960 Detroit Memorial, and Sam DuPont's *Nitrogen Too* captured the Silver Cup. Seven different boats won races in 1960, making the late-season Las Vegas Gold Cup look like it would be one of the most competitive races in Gold Cup history, but shortly after the first heat was run, the wind began to blow, making the water too rough to continue. Reluctantly the race was declared no contest. This created a problem because without a winner in 1960, there was no mechanism for determining the race location for 1961.

The URC decided to let all the race sites bid on the race, and the 1961 Gold Cup would go to the race site that offered the most prize money. Reno, Nevada, won the contest with a bid of $35,000.

There was not a single West Coast boat on hand when the *Gale V* won the Detroit Memorial to kick off the 1961 season. Later that year, the Reno Gold Cup was won by Bill Muncey in the *Miss Century 21*.

The Silver Cup was shortened to one heat after popular Canadian driver Bob Hayward was killed when the *Miss Supertest II* flipped during the first lap of heat 2-A. Ron Musson and *Miss Bardahl* were declared the winner.

In the off-season between 1961 and 1962, Lee Schoenith replaced George Trimper as the commissioner of the URC. Schoenith took immediate steps to make the sport more professional. He required that all race sites offer a minimum of $10,000 prize money. It was also decided that starting in 1963, the Gold Cup would be awarded to the race site that offered the most prize money. Due to the steep prize money requirements, several race sites dropped off the circuit, including the Detroit Memorial. For the first time since racing resumed after World War II, there would only be one race in Detroit, the Silver Cup. Bill Muncey and the *Miss Thriftway*, renamed *Miss Century 21* to promote the Seattle world's fair, won the 1962 Gold Cup, Spirit of Detroit Trophy, and national championship.

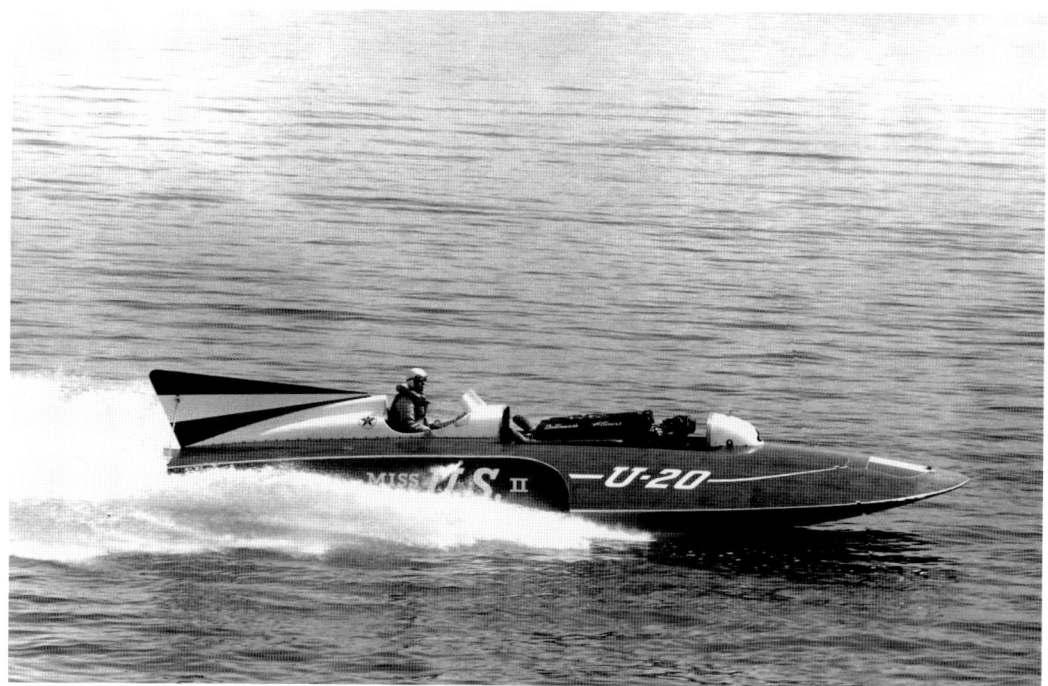

George Simon's new *Miss U.S. II* won the 1956 Silver Cup with Don Wilson driving. (Courtesy of Hal Stein.)

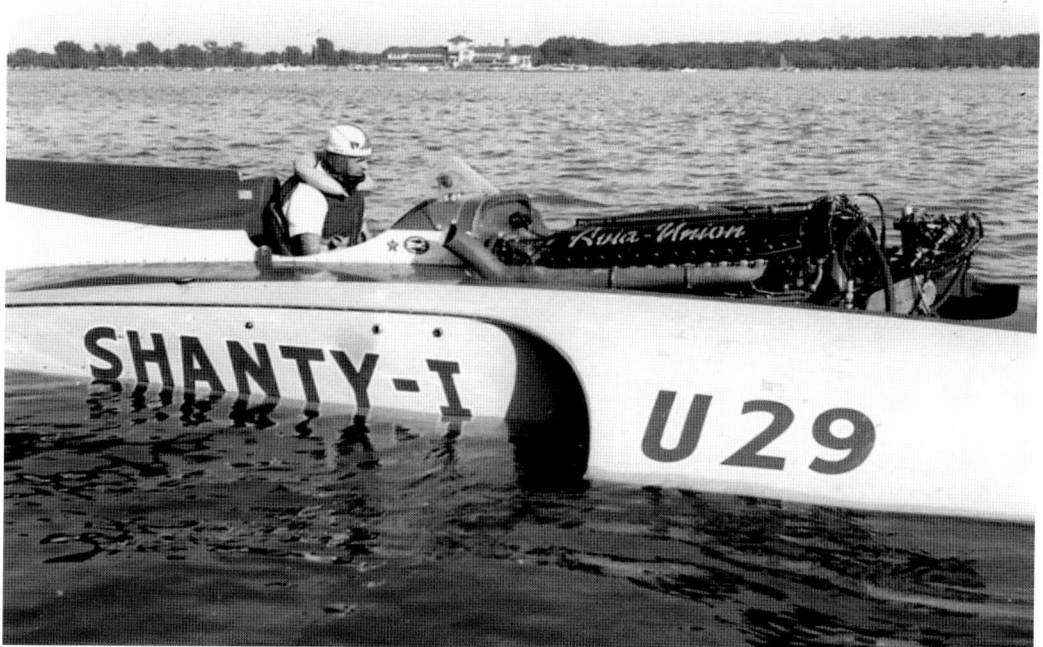

Col. Russ Schleeh won the Harmsworth Trophy Race in Detroit driving Bill Waggoner's *Shanty I*. Schleeh won three races in 1956, and that was enough to earn him the national championship.

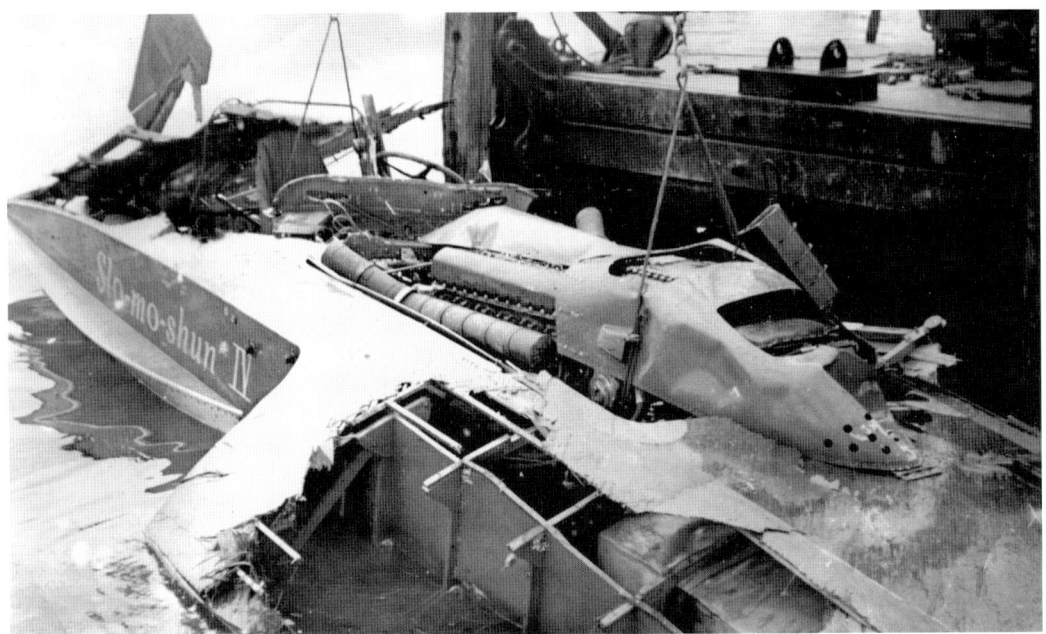

The *Slo-mo-shun IV* led the Seattle fleet that came to Detroit to try to win back the Gold Cup. In an early-morning test run, the *Slo-mo* hit the wake of a patrol boat and disintegrated. Driver Joe Taggart was seriously injured but recovered.

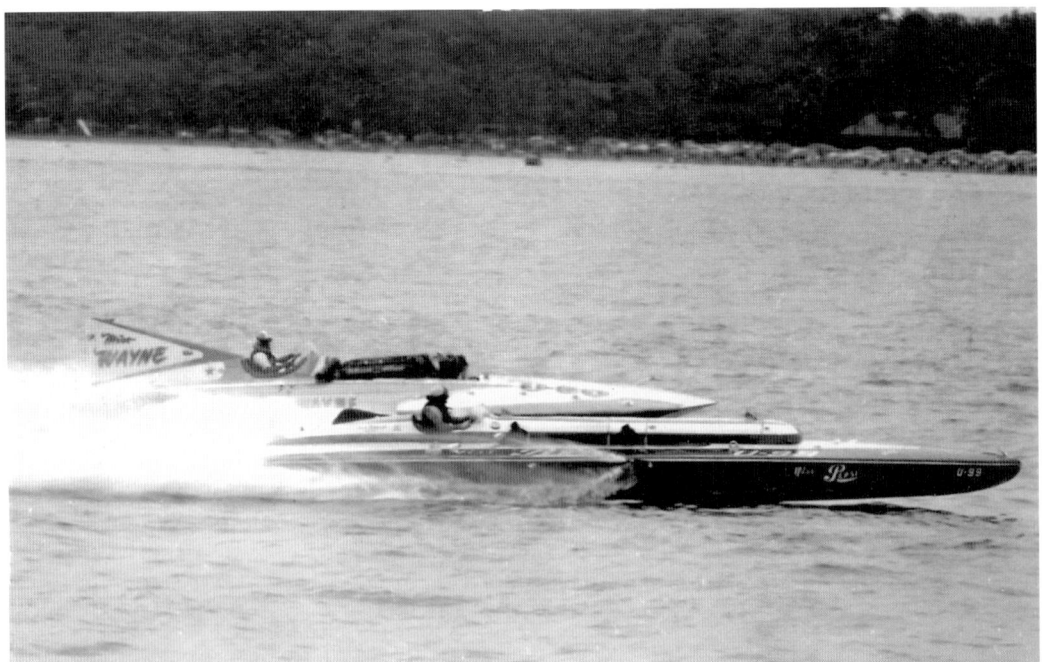

The Dossin brothers brought the *Miss Pepsi* out of retirement to take part in the Gold Cup. The old step hull qualified almost 10 miles per hour slower than the fastest three-point boats, but the huge wake that the *Pepsi* put up made her hard to pass. (Courtesy of Hal Stein.)

The *Miss Thriftway* was fast and light but suffered serious damage during her first heat. The *Thriftway* crew led by Ted Jones was able to repair the boat in time for the next heat. (Photograph by Sandy Ross.)

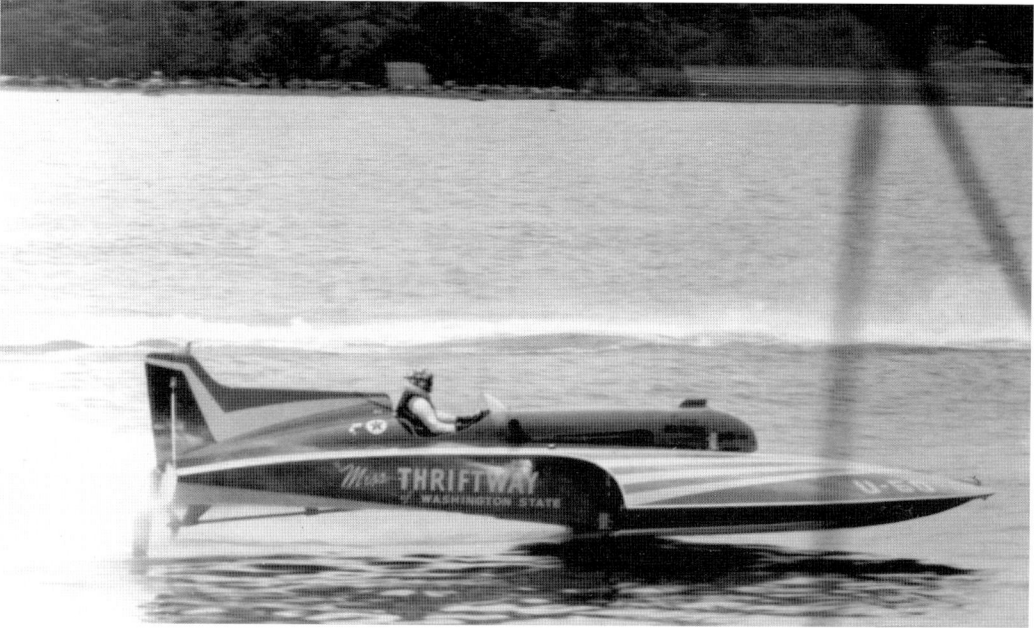

Bill Muncey won his first Gold Cup in front of his hometown crowd in 1956. But it took almost 90 days before the trophy was awarded. A dispute over whether or not the *Thriftway* hit a buoy and a lawsuit by Horace Dodge kept the trophy in limbo from September 1 until November 25! (Courtesy of Hal Stein.)

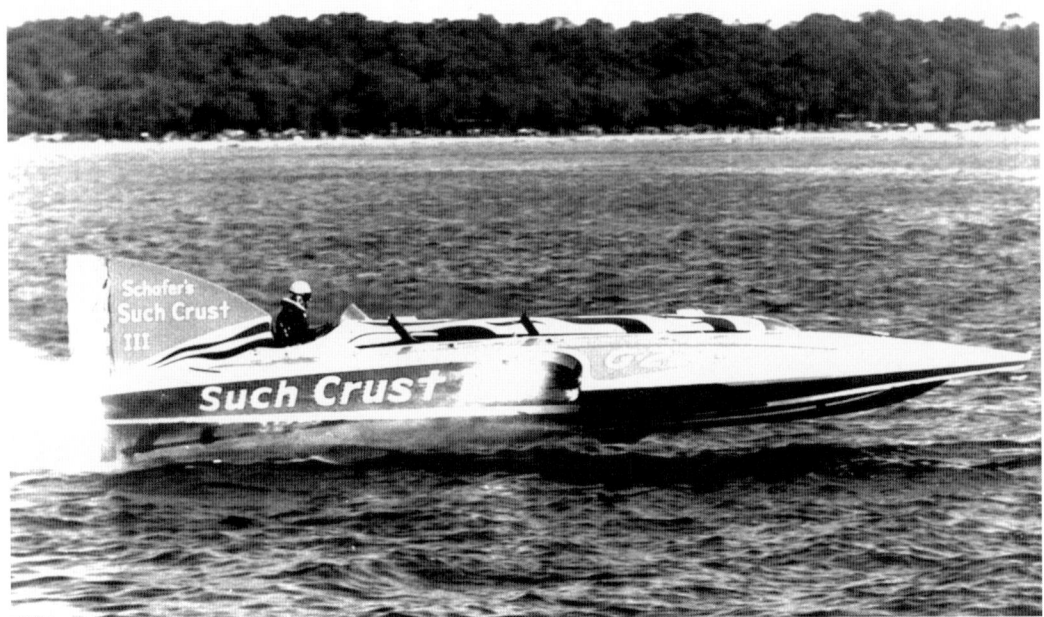

Fred Alter drove the big twin-engine *Such Crust III* to victory at the 1957 Detroit Memorial.

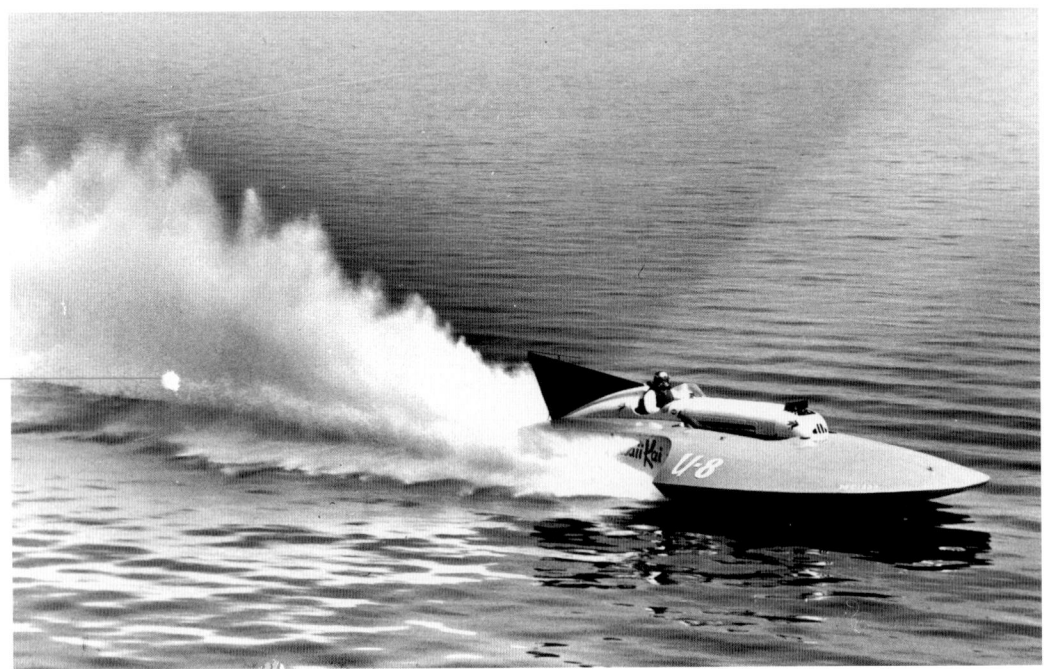

Edgar Kaiser was the owner of the *Hawaii Kai III*. When the *Slo-mo-shun IV* was destroyed, Kaiser turned the *Kai* over to the *Slo-mo-shun* crew. The *Kai* won the last two races of the 1956 season and went on to win five races in 1957, including the Silver Cup.

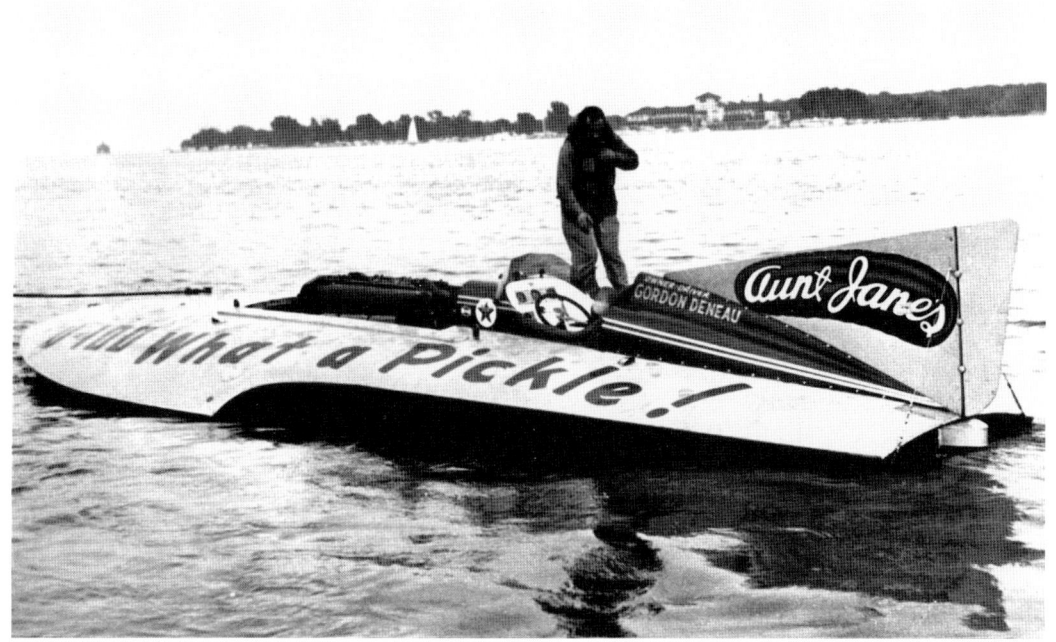

Gordon Deneau campaigned three different boats under the name *What a Pickle!*, sponsored by Aunt Jane's Pickles of Croswell. None of the boats performed very well. The boat in this photograph was originally built as *Miss Great Lakes II* in 1952.

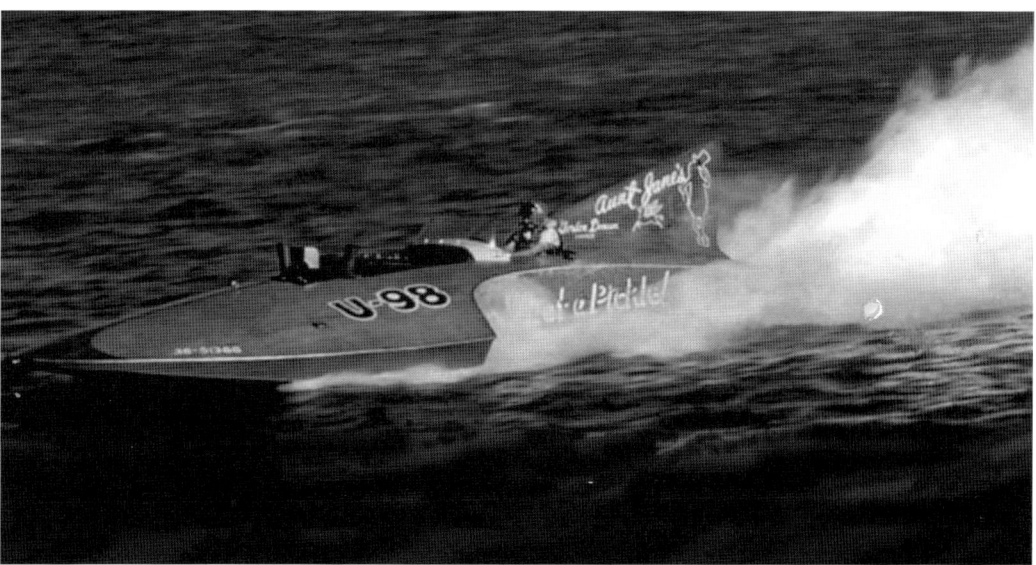

This extremely rare photograph shows the third *What a Pickle!* running in 1957. This boat was originally built in 1953 as the *Gale III* and featured twin counter-rotating props driven by one engine. The boat only appeared at four races in its entire lifetime. (Photograph by C. Marshall.)

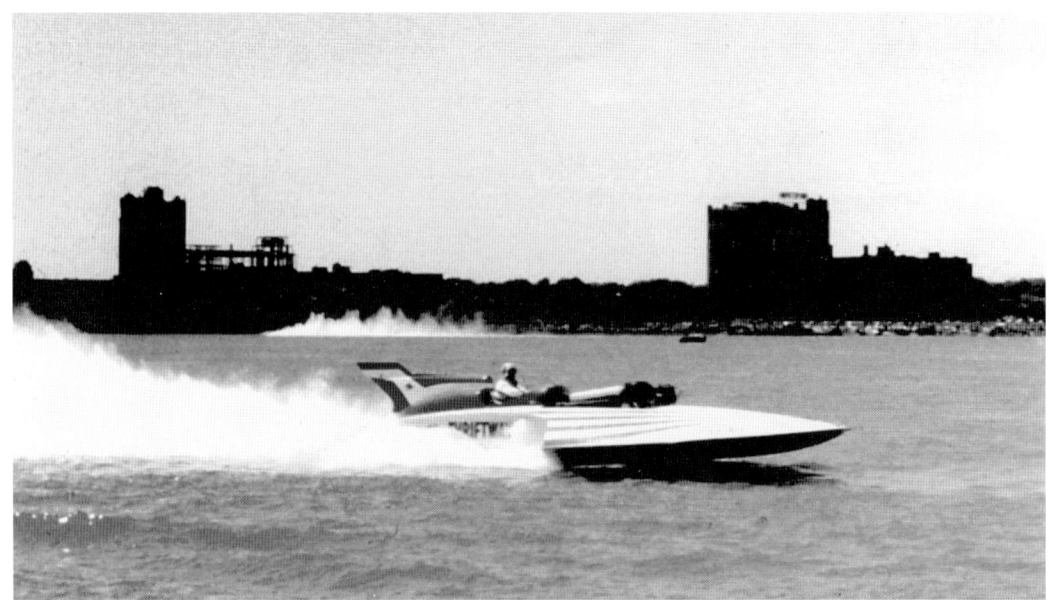

The first *Miss Thriftway* was destroyed in an accident in Madison, Indiana, in 1957. The second *Miss Thriftway* showed great promise when she won the Detroit Memorial in only the second race of her career. The boat was destroyed in a horrific accident during the Gold Cup in Seattle two months later. (Photograph by Sandy Ross.)

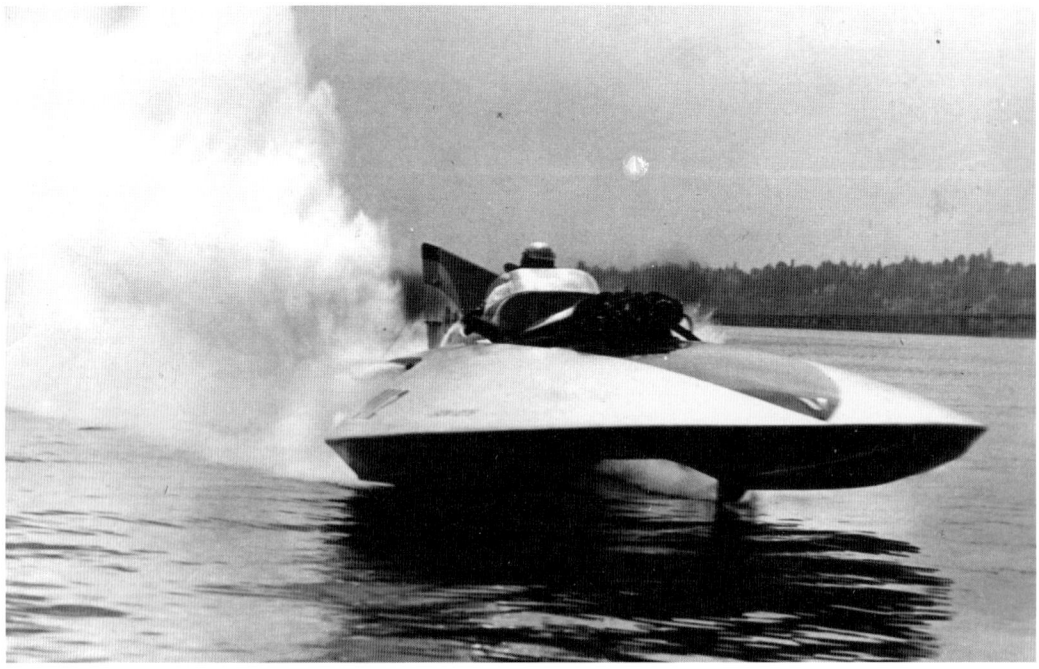

The *Maverick*, driven by Bill Stead, won the 1958 Silver Cup after a stunning deck-to-deck duel with Bill Cantrell in the *Gale V*. The *Gale's* average speed over the 10 laps final was 105.229 miles per hour; the *Maverick* averaged 105.481 and claimed the trophy by a fraction of a second.

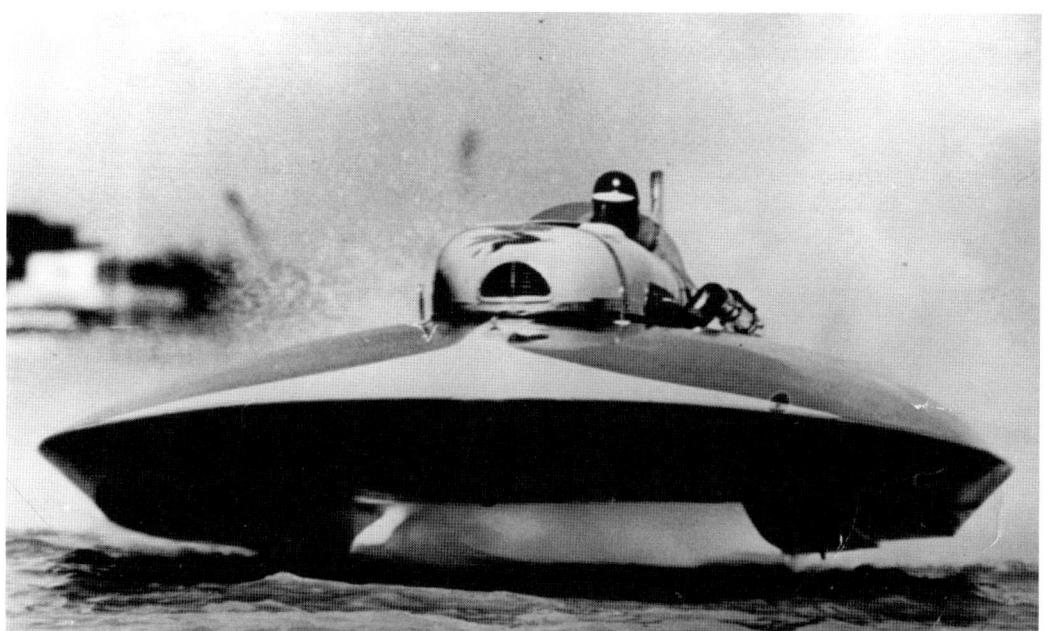

Joe Schoenith debuted a new *Gale V* in 1958, the third and final boat to be called *Gale V*. She was driven by Bill Cantrell and took seventh place in national high points that year. (Courtesy of Hal Stein.)

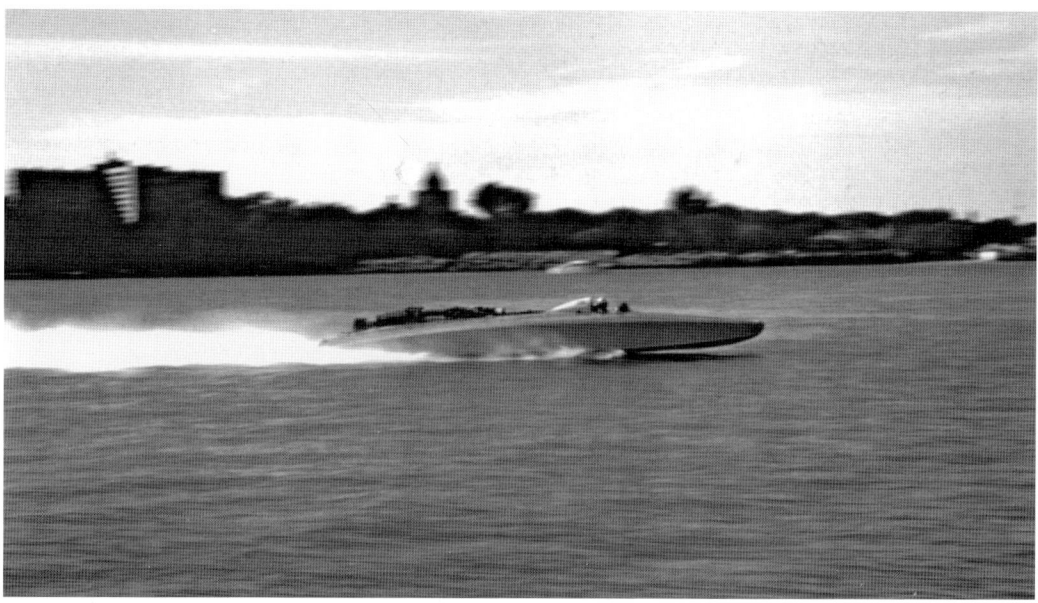

Lee Schoenith showed off the Schoenith team's brand-new jet boat with some exhibition runs between heats of the 1958 Silver Cup. The boat was designed, built, and driven by Les Staduacher and was intended to break the world water speed record for jet boats, held at that time by England's Donald Campbell. The boat never panned out, and the project was eventually abandoned. (Photograph by Sandy Ross.)

Bob Hayward drove Jim Thompson's brand-new Rolls Royce Griffon–powered *Miss Supertest III* to victory in the 1959 Detroit Memorial. (Photograph by Bill Stroh.)

The Schoenith family introduced a brand-new twin-engine *Gale VI* at the 1959 Detroit Memorial. The boat was driven by Fred Alter and could only manage a ninth-place finish.

Detroit-based *Miss U.S. I*, driven by Don Wilson, passes two Seattle boats (*KOLroy* and *Miss Bardahl*) in front of the Detroit Yacht Club during heat 2-A of the 1959 Silver Cup. *Miss U.S.* took second place overall in the race. (Courtesy of Hal Stein.)

Bill Stead and the *Maverick* won five races in 1959, including the Gold Cup and the Silver Cup. They also won the national championship. (Photograph by Sandy Ross.)

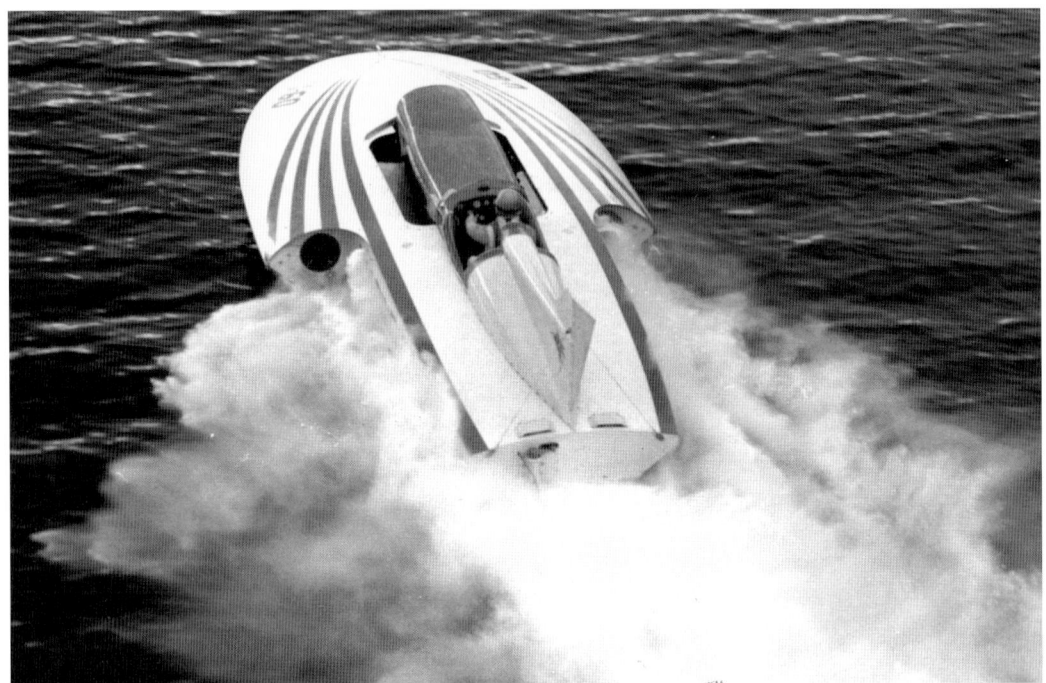

On February 16, 1960, Bill Muncey and the Miss Thriftway team set a new world water speed record of 192.001 miles per hour. The Miss Thriftway went on to win four races that year, including the Detroit Memorial.

Ron Musson drove Sam DuPont's Nitrogen Too to a first-place finish in the 1960 Silver Cup.

In heat 1-A of the Detroit Memorial, *Miss Bardahl's* rookie driver Jim McGuire lost control of his boat in the tight Roostertail Turn. (Photograph by Sandy Ross.)

The *Bardahl* slammed into Kean's Marina boat dock, knocking several spectators into the water. Miraculously, no one was injured. (Photograph by Sandy Ross.)

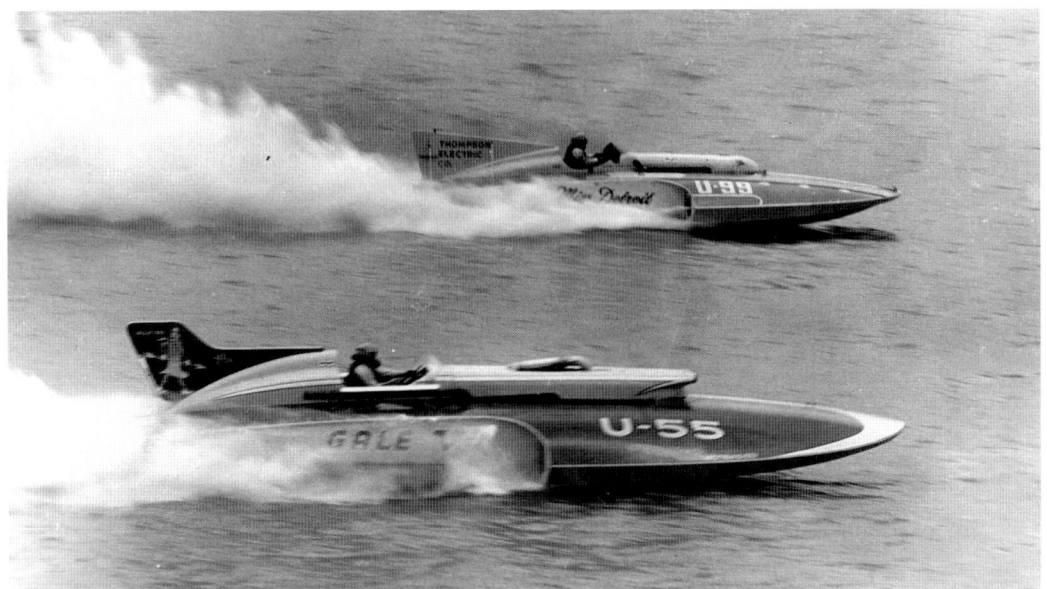

The weather was overcast and windy for the 1961 Detroit Memorial. The rough water gave Bill Cantrell and the heavy *Gale V* an advantage over the other boats. And Cantrell capitalized on it to win the *Gale* team's only race that year. Chuck Thompson and the *Miss Detroit* run alongside Cantrell and the *Gale* in heat 1. (Photograph by Hal Stein.)

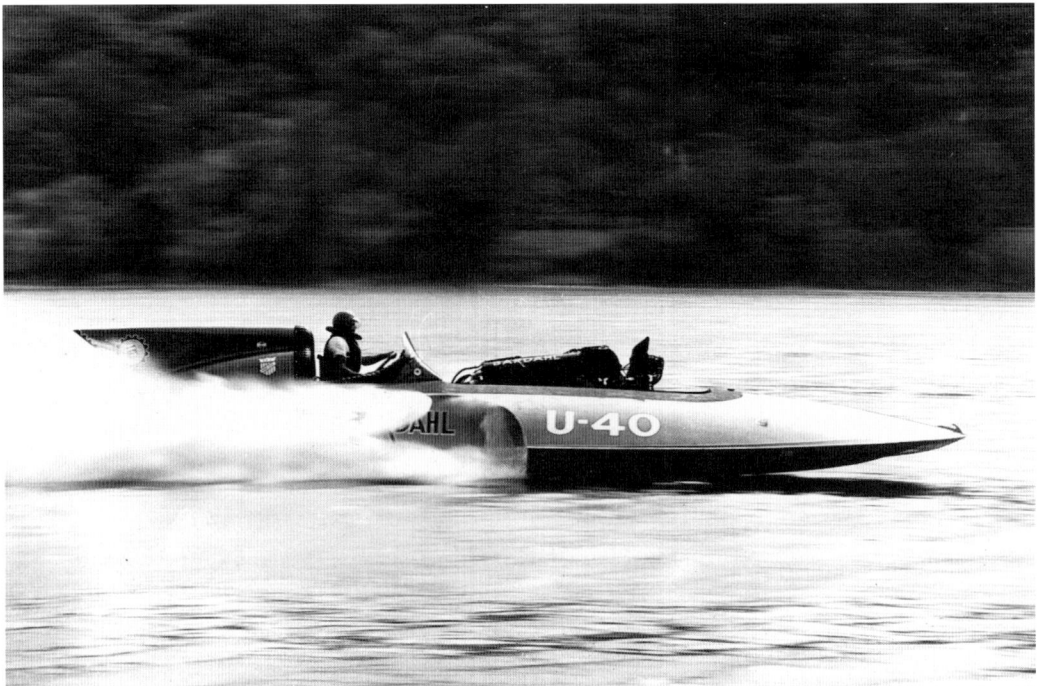

Ron Musson and the *Miss Bardahl* won the accident-marred 1961 Silver Cup. The races were halted after only one set of heats, when Canadian driver Bob Hayward was killed.

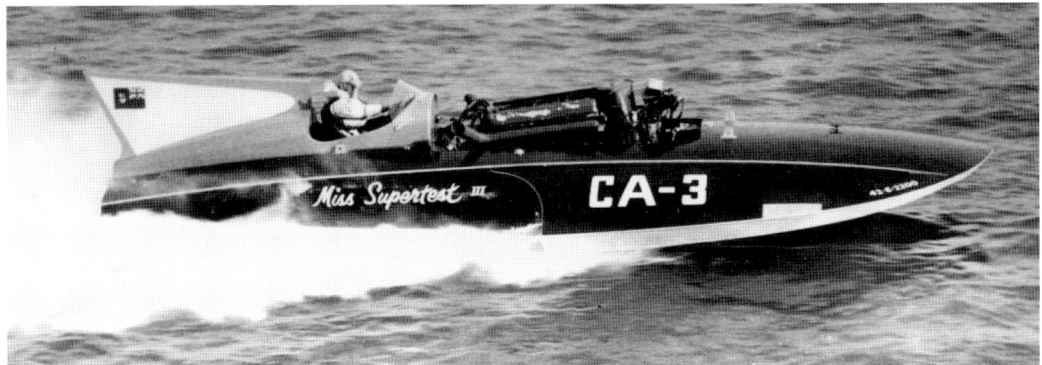

The *Supertest* team ran two boats. The Rolls Royce Griffon–powered *Miss Supertest III* shown in this photograph was built primarily for Harmsworth competition and won every race it entered. The *Supertest II* was used for most other races.

In heat 2-A of the 1961 Silver Cup, Bob Hayward ran hard into the first turn and the boat flipped over, killing Hayward. It was the first fatality in modern hydroplane racing on the Detroit River. Unfortunately, it would not be the last.

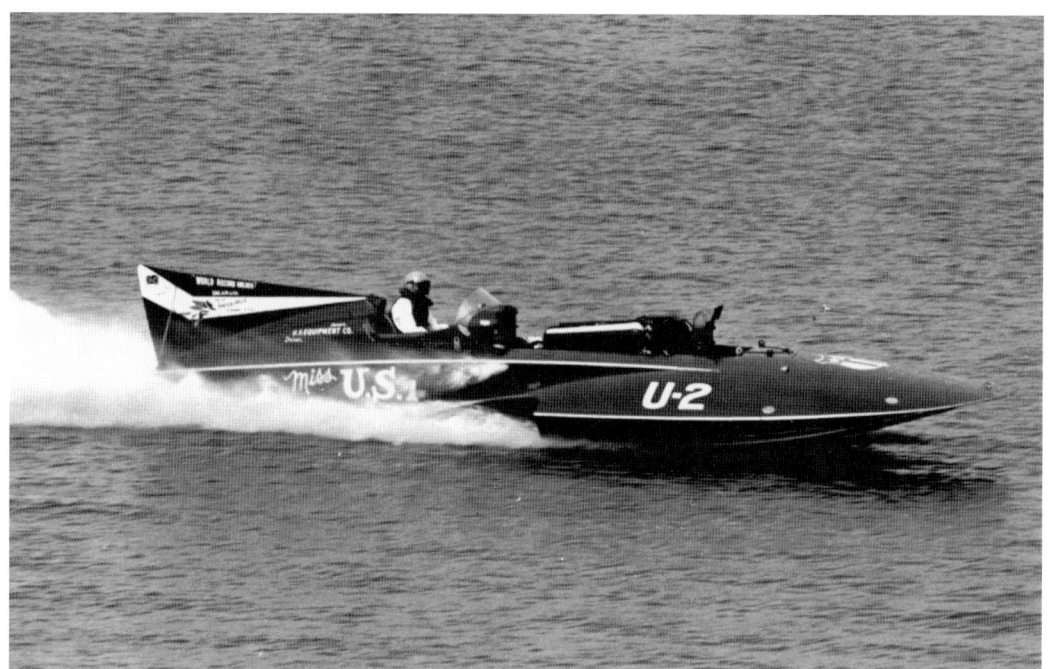

Prior to the start of the 1962 season, Roy Duby drove George Simon's *Miss U.S. 1* to a new world water speed record of 200.41 miles per hour. The record stood for 38 years.

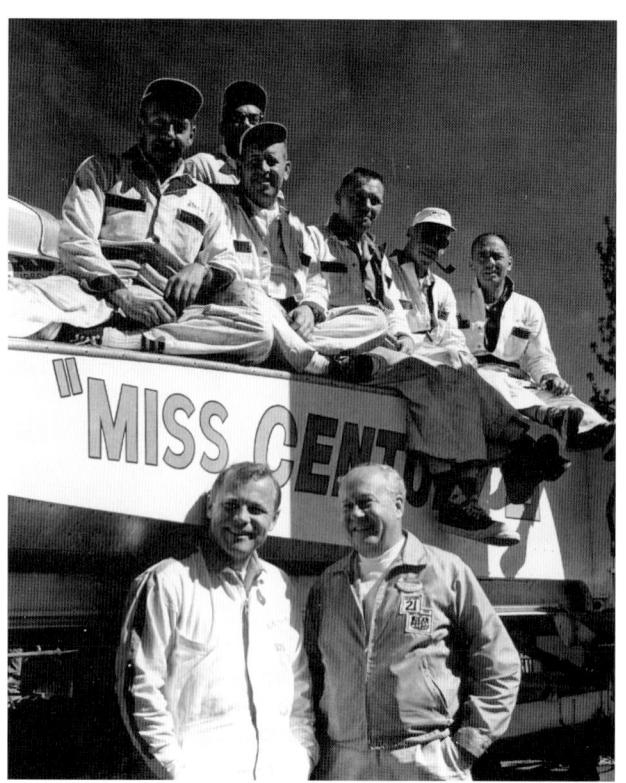

The 1962 season belonged to Bill Muncey, Willard Rhodes, and the *Miss Century 21*. They won five out of six major races, including the Gold Cup, the Spirit of Detroit Trophy, and the national championship. Muncey and Rhodes gave credit for the boat's performance to the crew. From left to right are (first row) Bill Muncey and Willard Rhodes; (second row) Stan Adsit, Ray Ballard, Bud Hubbard, crew chief Jack Ramsey, Spank Allen, and Joe Langer (behind).

4

THE SCHOENITH YEARS

1963 TO 1972

Under Lee Schoenith's leadership, the URC began to grow. He added the Alabama Governor's Cup to the 1963 schedule, and then in 1964, he added the San Diego Cup and the short-lived Dakota Cup in Newton, North Dakota. The year 1965 saw Ogden, Utah, put on a race. In 1966, there were new races in Tampa, Florida; Kelowna, British Columbia; and Sacramento, California. The Schoenith years also brought a growth in commercial sponsorship. In the past, companies like Bardahl, Thriftway, and U.S. Equipment had sponsored boats, but almost without exception, the owner of the boat was also the owner of the company, and the IRS viewed the sponsorships as nothing more than a hobby. In 1963, Milo and Glen Stone secured the Exide Corporation to sponsor their new hydroplane. In 1964, Joe Schoenith brought Smirnoff Vodka on board to sponsor his *Gale* team, and Bernie Little was successful in securing Anheauser Bush's Budweiser Beer to sponsor his fledging race team.

Detroit outbid Seattle by almost $10,000 and was awarded the 1963 Gold Cup. Seventeen boats showed up for the race, 12 qualified, and Seattle's *Miss Bardahl* took home first place as well as the national championship. The 1964 Gold Cup went to Detroit as well, and the *Bardahl* repeated as the winner of both the Gold Cup and national championship.

Seattle outbid Detroit for the 1965 Gold Cup. Detroit put on the Spirit of Detroit Trophy, which was won by local favorite Chuck Thompson in Bill Harrah's *Tahoe Miss*. The Gold Cup returned to Detroit in 1966, but two weeks before the race, tragedy stuck at the President's Cup in Washington, D.C., where three of the sport's top boats crashed, killing three of the top drivers, including defending national champion Ron Musson.

The field limped into Detroit licking its wounds from the devastating losses of the President's Cup. Chuck Thompson driving Joe Schoenith's *Smirnoff* won his first two preliminary heats and was a clear favorite going into the third heat. Shortly after crossing the starting line, his boat bounced violently and disintegrated in a tower of spray and splinters. Thompson was killed, and for the fourth time in two weeks, the sport faced the death of one of its top drivers. Schoenith, in his role as URC commissioner, pulled the shaken racing community together and kept the season going. He, along with his close friend Bill Muncey, kept the sport from falling apart at this dark time. Mira Slovak, driving Bill Harrah's *Tahoe Miss*, won the Gold Cup and national championship.

The 1967 Gold Cup was held in Seattle, and Detroit hosted the world championships. Detroit-based automotive giant Chrysler stepped into the sport, sponsoring Bill Sterett's *Miss Chrysler Crew* powered by twin Chrysler Hemis. *Chrysler Crew* won the world championship race in Detroit to become the only automotive-powered unlimited hydroplane to win a major race since before World War II.

Three weeks after the world championship race, while the unlimited teams were running for the Atomic Cup in Tri-Cities, Washington, a riot broke out back in Detroit. It started early Sunday morning during a welcome home party for two returning Vietnam veterans at an unlicensed drinking club in a predominately African American neighborhood along Twelfth Street. Police were called and arrested all 82 patrons of the club. After the police left, a large group of angry young men, who believed that several innocent friends had been arrested, began to kick out windows in a nearby store. Violence escalated, and soon Detroit was in the grips of one of the worst race riots in the history of the nation. It took five days and 7,200 arrests to quell the riots. By the time the smoke cleared, 42 people were dead and over 2,000 buildings were destroyed.

When the unlimited racers returned to Detroit in 1968 for the Gold Cup they were met by a much-changed city. The road to the pits was lined with empty burned-out buildings. David Smith, one of the *Miss Bardahl* crewmen, said, "It looked like a war zone!" There were armed guards in the pits and at the hotels that the teams stayed at. Billy Schumacher won the race in the *Miss Bardahl*, but tragedy continued to stalk the sport. Popular driver Warner Gardner was killed when his boat, the *Miss Eagle Electric*, crashed during the final heat.

San Diego successfully bid on the Gold Cup in 1969, so Detroit put on the world championship race. Billy Muncey won the race in George Simon's bright red *Miss U.S.* The Gold Cup and the national championship were both won by Bill Sterett and the *Miss Budweiser*.

The Gold Cup stayed in San Diego for 1970. Bill Muncey left the *Miss U.S.* team and went to work driving for his longtime friend Lee Schoenith in the *Myr Sheet Metal*. Muncey and the *Myr* won the Horace E. Dodge Cup in Detroit. Budweiser again claimed both the Gold Cup and national championship.

During the off season between 1970 and 1971, Schoenith secured Atlas Van Lines to sponsor his team and build a brand-new boat. Meanwhile, tiny Madison, Indiana, won the bid for the 1971 Gold Cup. Detroit put on the Horace E. Dodge Cup. Budweiser won the Dodge Cup, and one week later the *Miss Madison* pulled off the upset of the decade when the underdog team won the Gold Cup in its own hometown!

Lee Schoenith, Bill Muncey, and the Atlas Van Lines totally dominated the 1972 season. They won the Detroit Gold Cup, the national championship, and came within a whisker of winning every race in the circuit. The only thing that kept Muncey and Schoenith from having a perfect season was a second-place finish at the President's Cup.

The Schoenith family was rich, powerful, and controversial. The head of the family was Joe Schoenith. In the early 1940s, Joe bought W. D. Gale Electric, and in 1950, he bought his first hydroplane and named it *Gale* and let his 20-year-old son Lee drive it. Over the next 25 years, the *Gale* team would campaign 16 different boats and win 27 races, 4 national championships, and 2 Gold Cups.

Lee Schoenith was the oldest son of Joe and Millie Schoenith. Lee had a successful racing career but retired from active driving in 1958. In 1962, Lee became commissioner of the URC and oversaw all aspects of the sport. During Lee's tenure as commissioner, the sport became far more professional, with increased prize money, race sites, and television coverage.

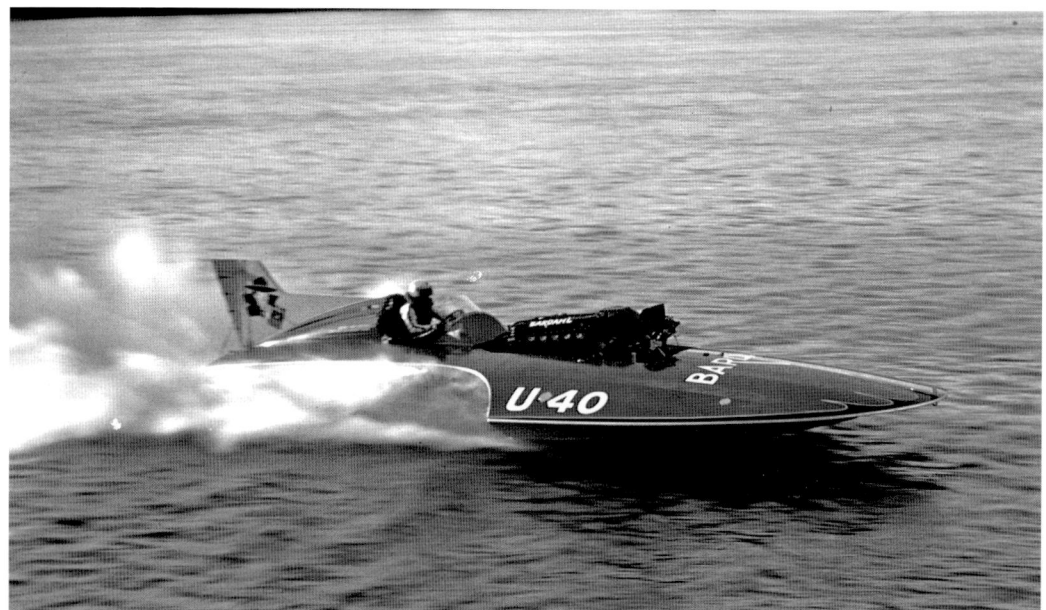

The new bidding system to determine the Gold Cup's location took effect in 1963, and Detroit won the honor of hosting the Gold Cup with a bid of $36,250! Ron Musson and the *Miss Bardahl* won the race in 1963 and 1964. (Courtesy of Bill Osborne.)

The Spirit of Detroit Trophy was introduced in 1964 for boats that did not make it into the Gold Cup. The big twin-engine *Such Crust IV* driven by Walt Kade beat the *Mariner Too* and *Savair's Mist* to claim the trophy. (Photograph by Sandy Ross.)

Shirley Mendelson, daughter of famous Detroit racer Herb Mendelson, revived the *Notre Dame* race team and campaigned a number of boats from 1962 to 1973. This photograph shows the second *Notre Dame* racing with the *Miss Bardahl* in the 1964 Gold Cup. The *Miss Bardahl*, with Ron Musson driving, won. (Photograph by Sandy Ross.)

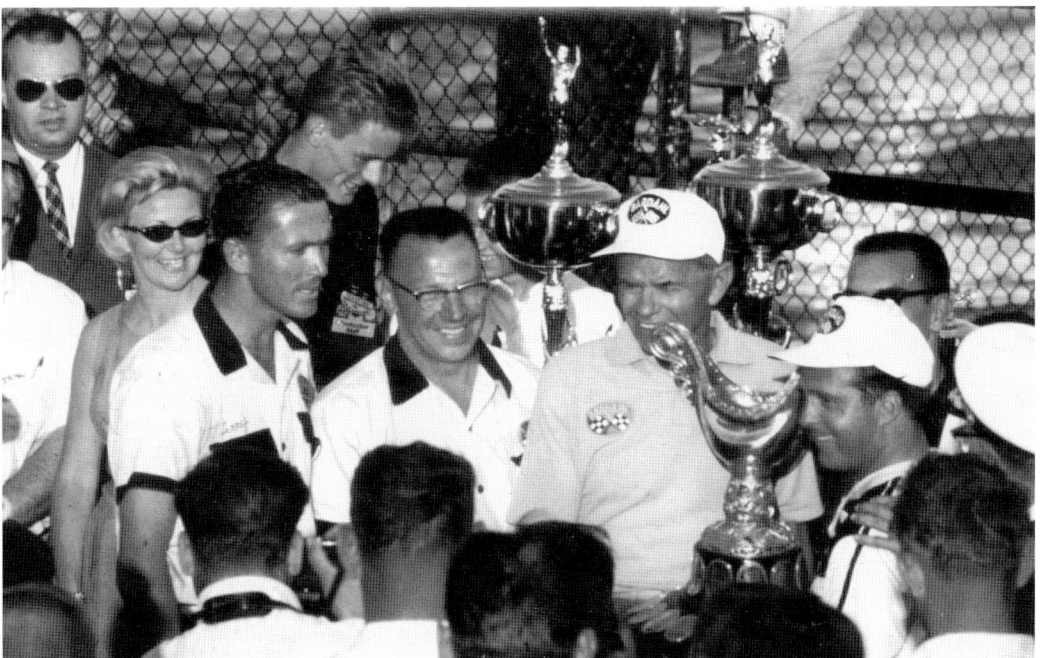

Ron Musson and the *Miss Bardahl* team celebrate their 1964 Gold Cup victory. From left to right are Betty Musson, Jerry Zuvich, Ole Bardahl, and Ron Musson, and Dixon Smith (in dark glasses behind Ron).

Chuck Thompson and the *Tahoe Miss* team experimented with a two-way radio during the 1964 Gold Cup. Noise from the motor forced them to abandon the effort, but by the mid-1980s, radios were commonplace equipment on race boats. (Photograph by Sandy Ross.)

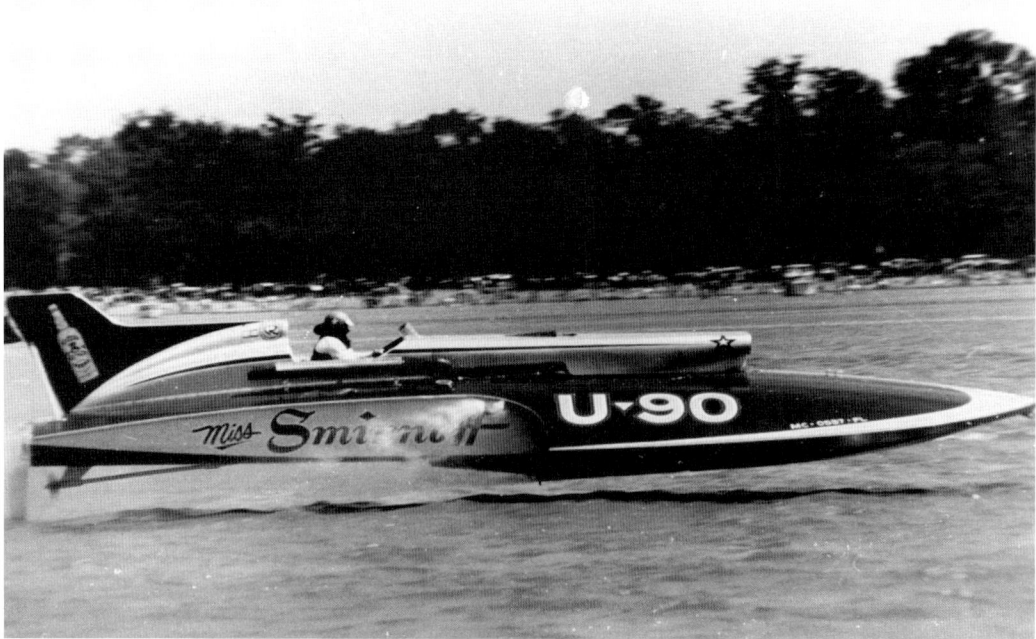

The Schoenith team was sponsored by Smirnoff Vodka in 1964. The new *Miss Smirnoff* with Bill Cantrell driving took fifth place in the Gold Cup. (Photograph by Phil Kunz.)

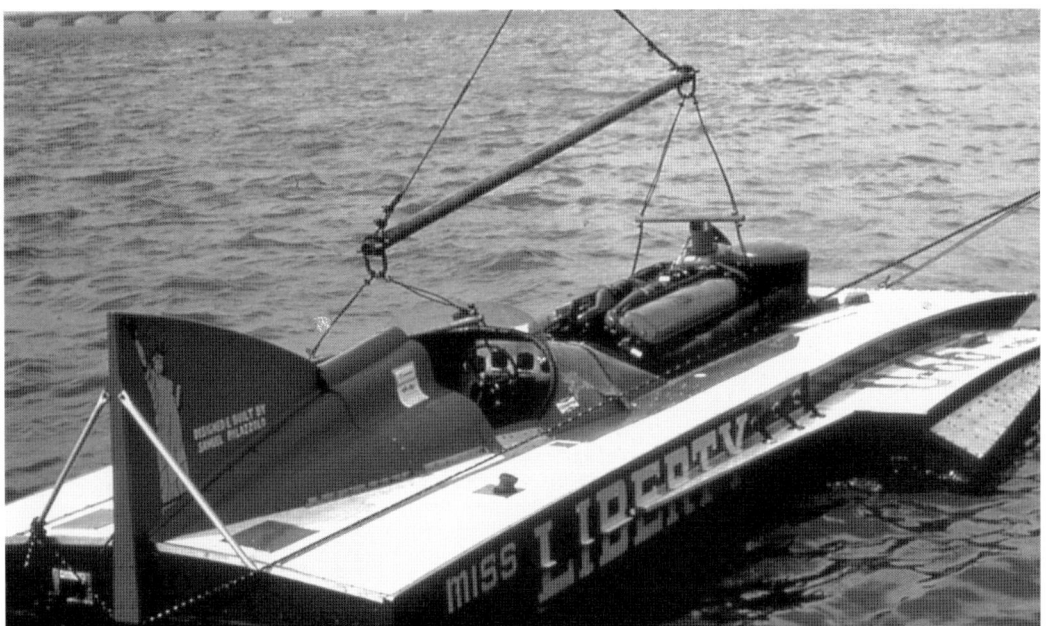

The inventive spirit was still alive in Detroit in the early 1960s. Sam Palazzolo brought his radical home-built Miss Liberty to the 1964 Gold Cup. Walt Kade attempted to qualify the boat but was not successful. (Photograph by Sandy Ross.)

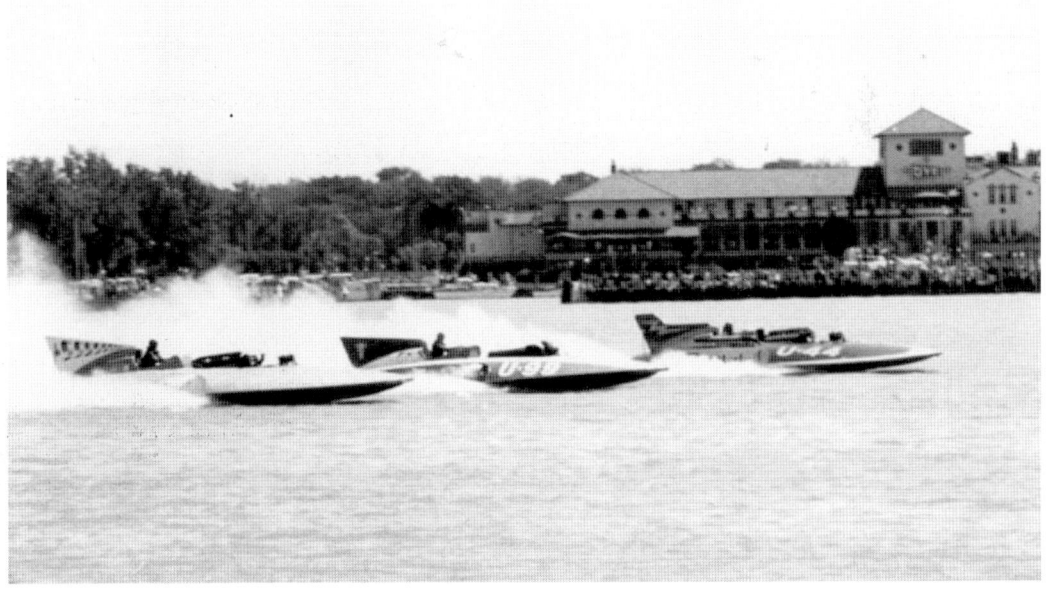

Gales Roostertail, Mariner Too, and the Blue Chip race past the Detroit Yacht Club. All three boats were run by Detroit teams.

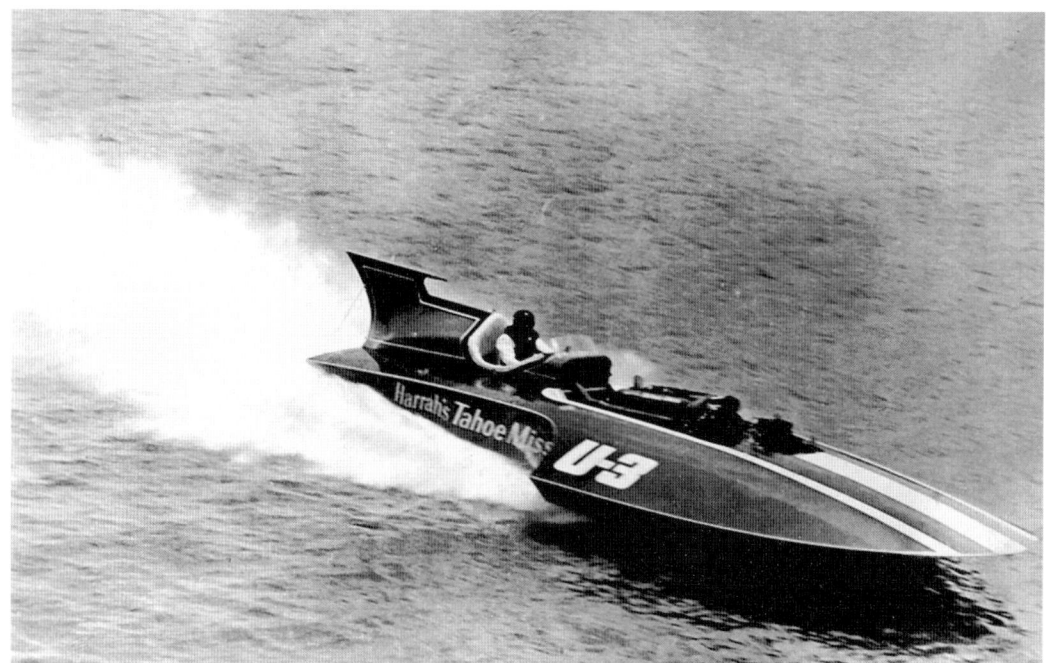

Chuck Thompson won the 1965 Spirit of Detroit race in the *Harrah's Tahoe Miss*. Bill Harrah chose to replace Thompson with Mira Slovak in 1966.

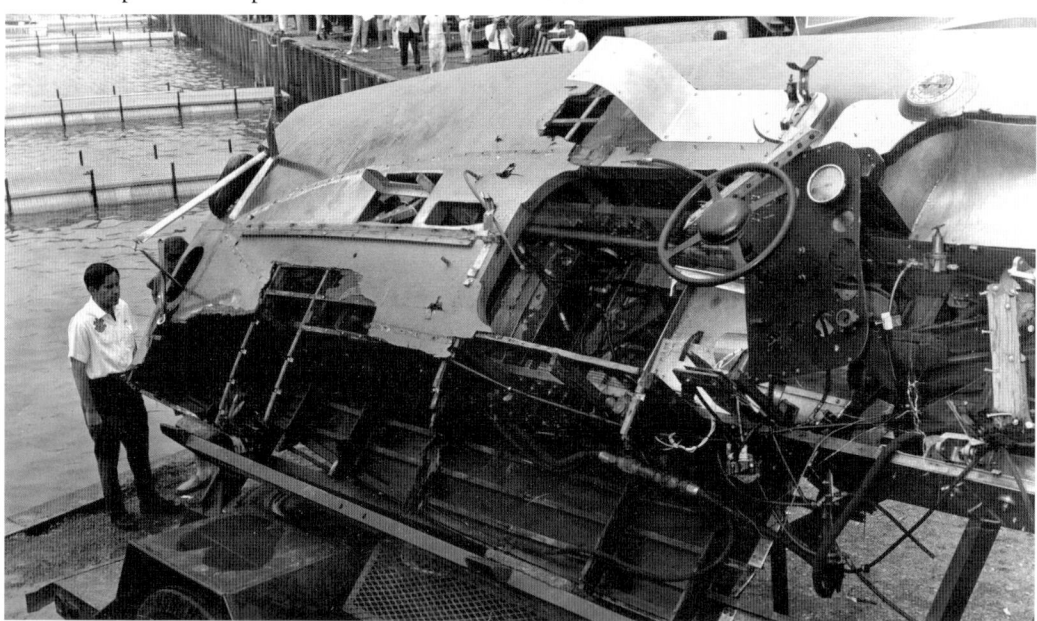

Bill Cantrell was the normal driver for the *Smirnoff*. Cantrell was hurt at the first race of the season, so Chuck Thompson was asked to fill in for the injured Cantrell at the Detroit Gold Cup. Thompson was leading heat 3-A when the boat bounced wildly and disintegrated, killing Thompson. This photograph shows the shattered remains of the boat in the pits after the race. (Photograph by Bruce Hubbard.)

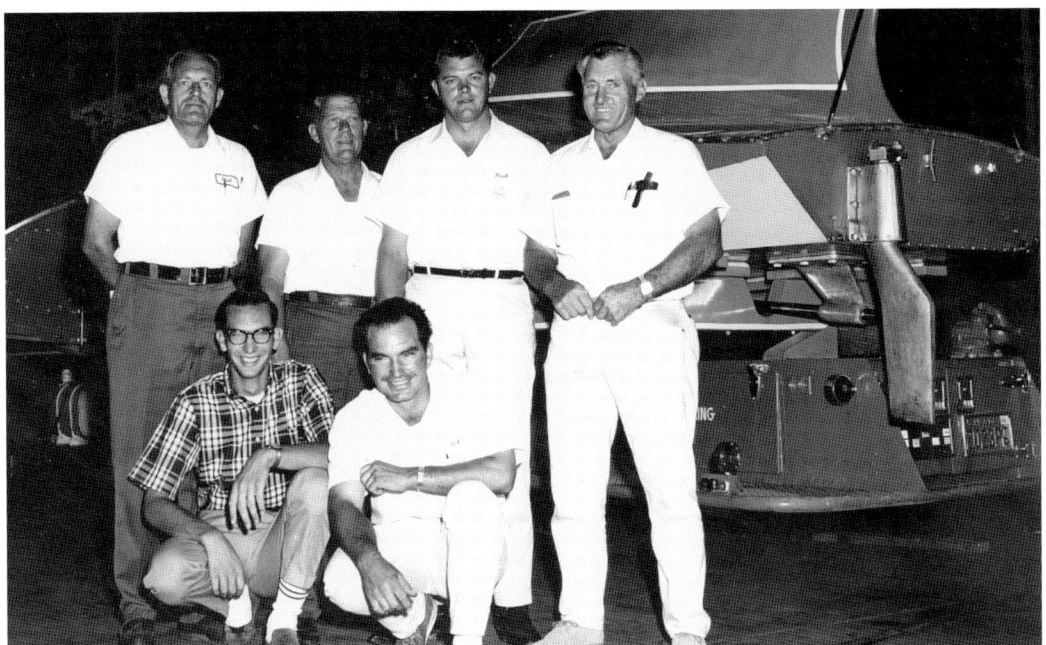

Mira Slovak won the Gold Cup and the national championship in the *Tahoe Miss* in 1966. Here the crew poses with the boat. From left to right are (first row) Dixon Smith and Mike Fontana; (second row) Walt Borland, George Goschl, Herb ?, and Andy Anderson, crew chief.

The Dodge family returned to unlimited racing in 1966 when Horace Dodge's niece Yvonne Ranger and her husband, Jim, campaigned the *My Gypsy*. Jim Ranger drove the boat and was named Rookie of the Year after winning the Seattle Seafair Trophy Race and taking second place in national high points. (Photograph by Sandy Ross.)

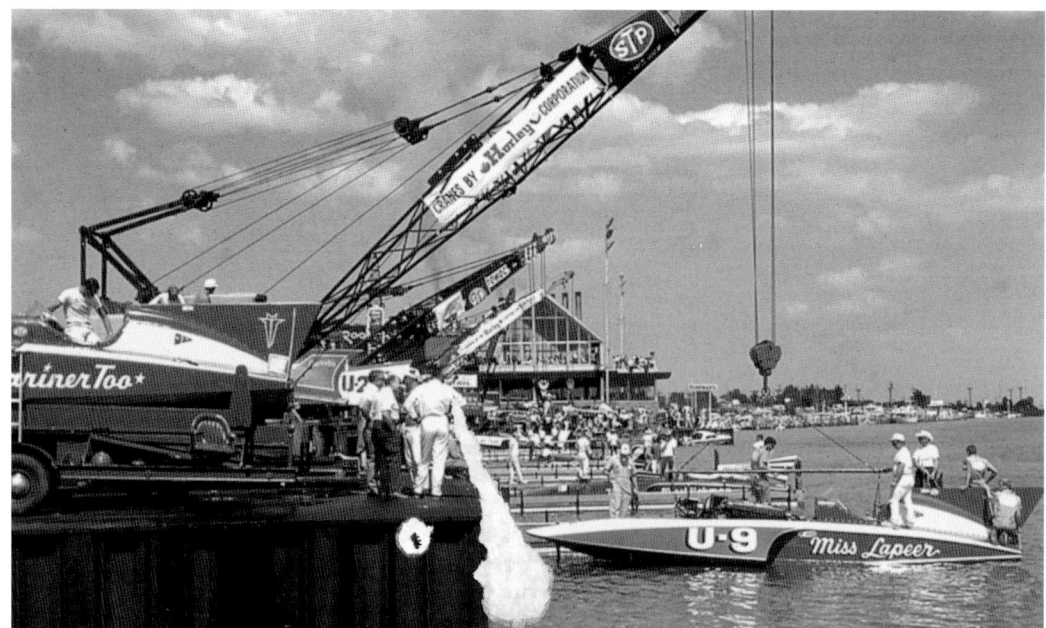

In 1966, the Dodge family built the Dodge Memorial Pits and Pit Tower and deeded them to the City of Detroit to provide a permanent home for hydroplane racing in the Motor City. This photograph from 1967 shows boats in the pits getting ready for the 1967 world championship race.

Miss Chrysler Crew was powered by twin Chrysler Hemis. She was owned and driven by Bill Sterett and won the 1967 world championship race in Detroit. This was the first victory by an automotive-powered unlimited in postwar racing.

It took two attempts to get the 1968 Gold Cup in Detroit. The race was originally scheduled for the end of June, but high winds forced the race to be postponed until September. When the race was run, the *Miss Eagle Electric* driven by Warner Gardner was running in second place in the final heat when she crashed right in front of the Detroit Yacht Club and Gardner was killed.

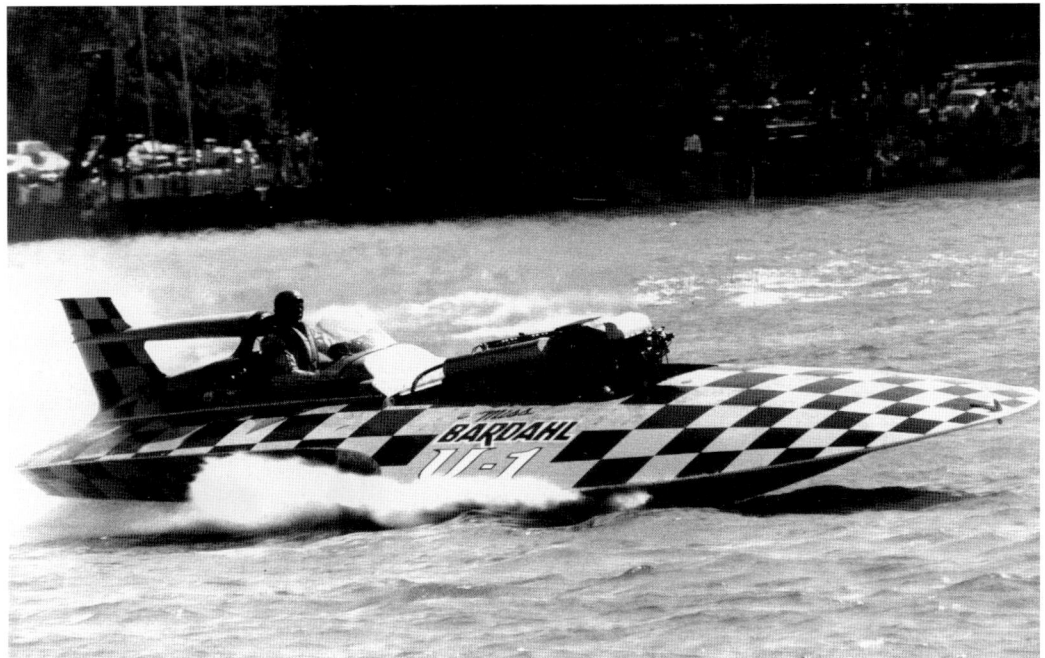

After the *Miss Eagle Electric* crashed, the final heat was rerun, and Billy Schumacher and the *Miss Bardahl* staged a breathtaking deck-to-deck duel with Bill Sterett and the *Miss Budweiser*. Schumacher won and claimed his second Gold Cup in a row! (Photograph by Phil Kunz.)

Bill Sterett and the *Miss Budweiser* spin out while chasing Fred Alter and the *Miss Schweppes* during heat 1-B of the 1969 world championship. (Photograph by Rich Ormbrek.)

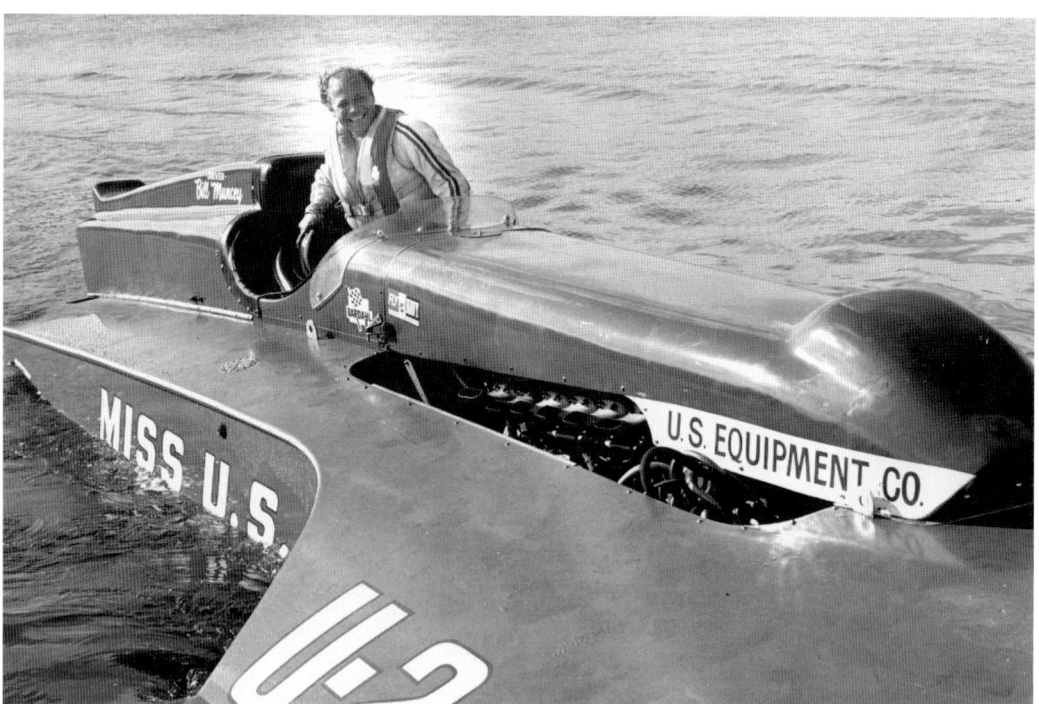
Bill Muncey returned to the winner's circle in Detroit by driving George Simon's bright red *Miss U.S.* to victory in the 1969 world championship race. (Photograph by Sandy Ross.)

Bill Muncey teamed up with the Schoeniths in 1970 when he agreed to drive their *Myr Sheet Metal*, sponsored by A. B. Myr Industries of Belleville. Muncey and the *Myr* won the 1970 Horace Dodge Cup.

Muncey and Lee Schoenith were longtime friends who enjoyed the opportunity to race on the same team after spending almost 20 years as competitors. Here Fran Muncey, in the dark jacket, stands next to Lee Schoenith, while Bill Muncey prepares to put on his helmet for a qualifying run in the *Myr*. (Photograph by Sandy Ross.)

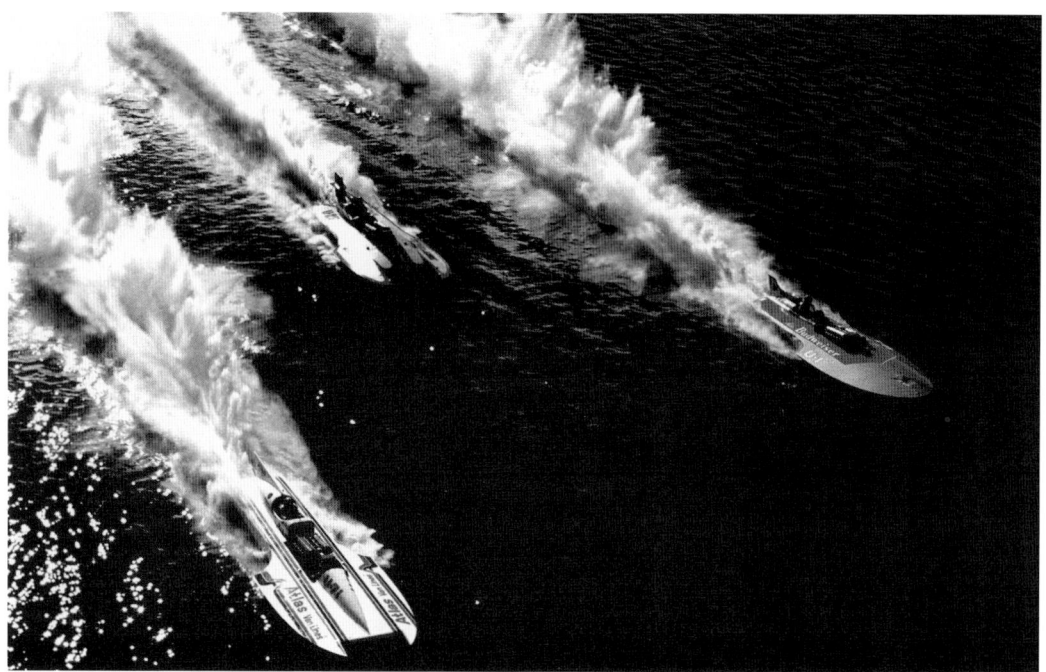

Miss Budweiser, *Pay N' Pak*, and *Atlas Van Lines* run to the start in the 1971 Horace Dodge Cup. (Courtesy of Bill Osborne.)

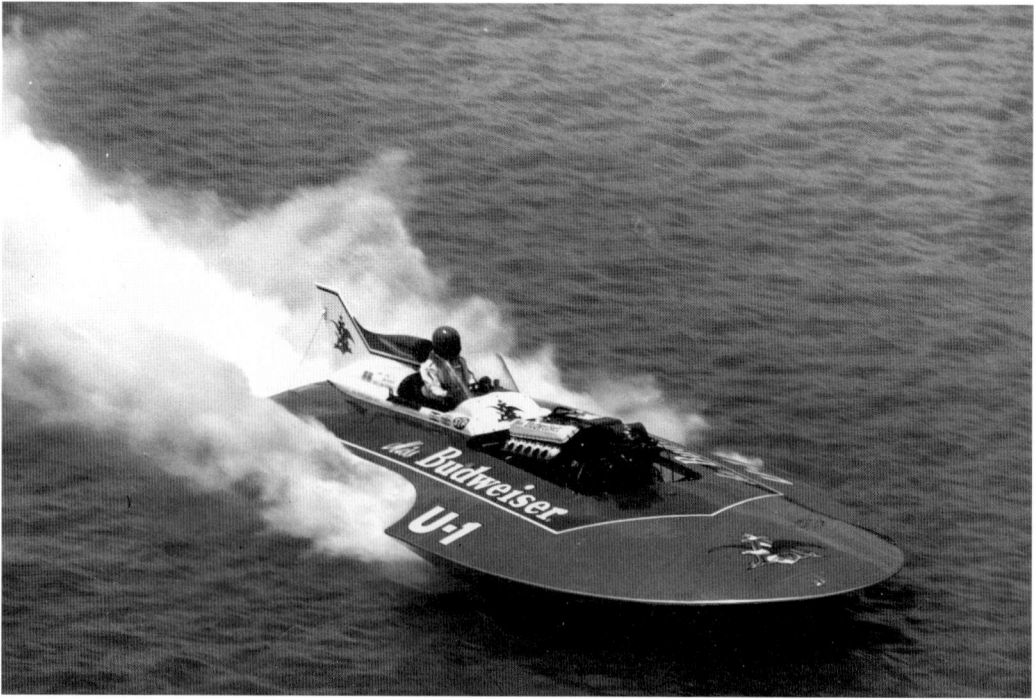

Dean Chenoweth drove the *Miss Budweiser* to a first-place finish in the 1971 Horace Dodge Cup. (Courtesy of Bill Osborne.)

While Bill Muncey drove for the *Thriftway* team, he won 18 races, including 4 Gold Cups and 3 national championships. When the *Thriftway* retired from racing, many people felt that Muncey's career was finished. In 1972, he came roaring back with a vengeance.

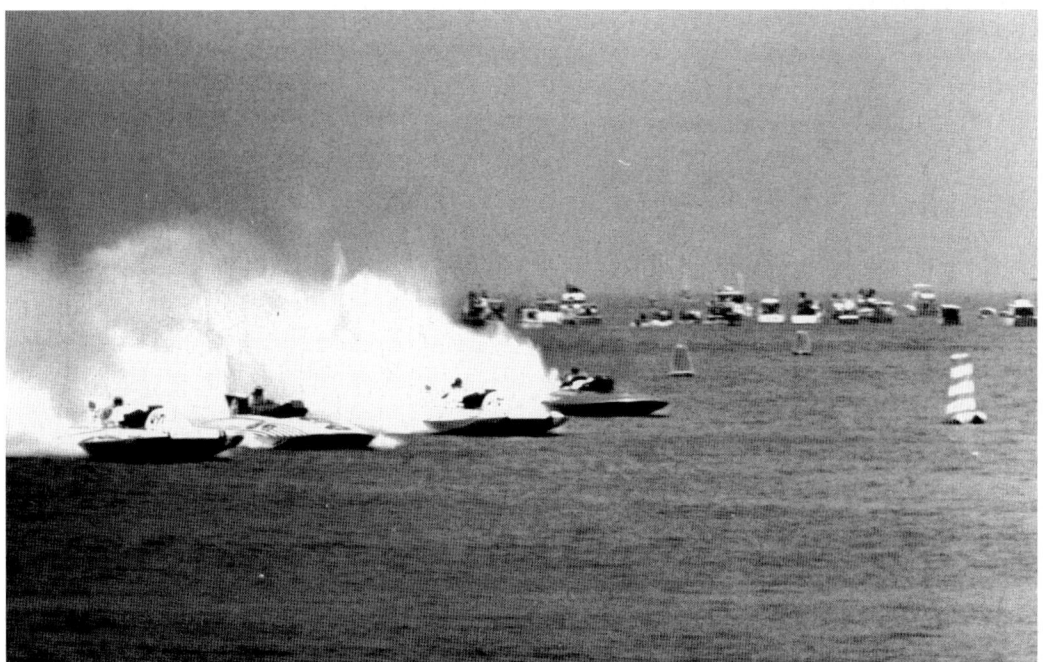

Bill Muncey and the *Atlas Van Lines* lead the *Pizza Pete*, *Atlas II*, and *Miss Budweiser* to the starting line of the final heat of the 1972 Gold Cup.

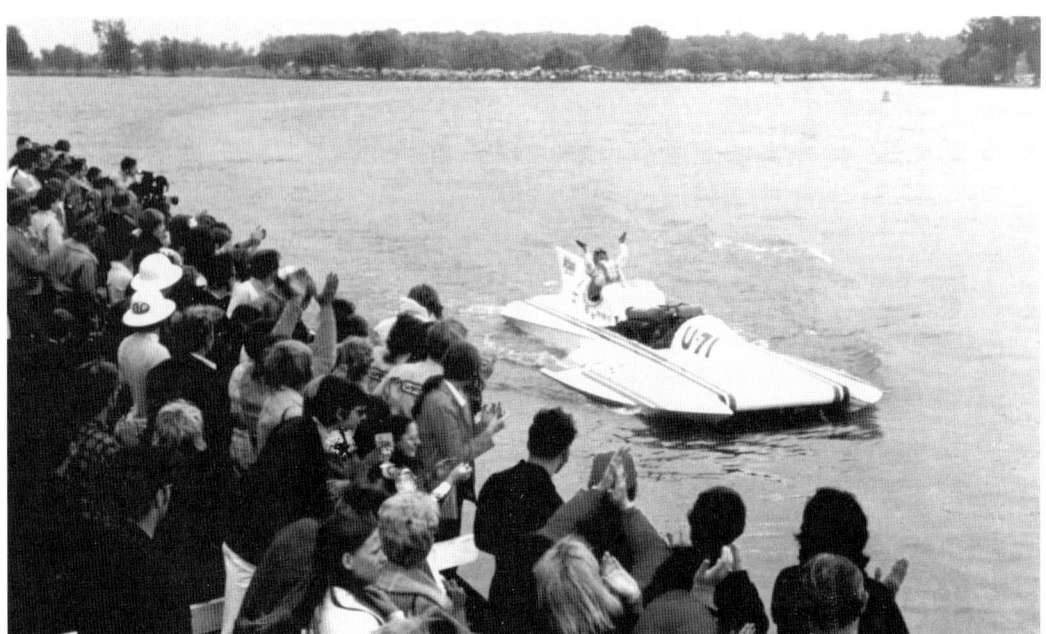

Bill Muncey coasts the *Atlas Van Lines* in front of the grandstand to celebrate his 1972 Gold Cup victory. This victory, in front of his hometown crowd in Detroit, tied him with the great Gar Wood with five Gold Cup wins!

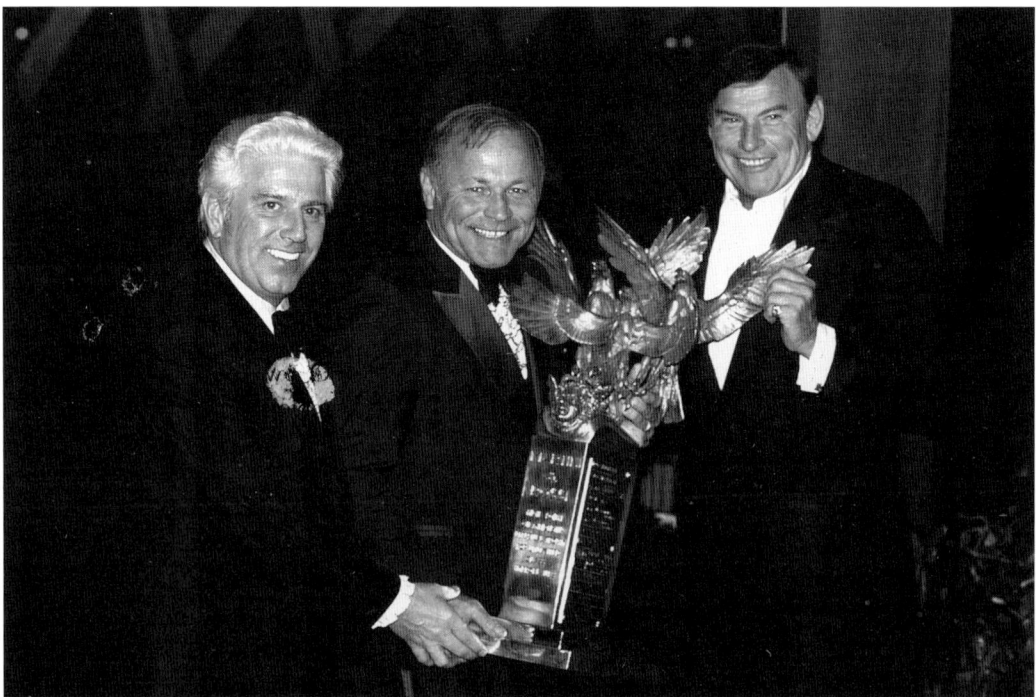

Lee Schoenith (left) and Bill Muncey (center) receive the Martini and Rossi National High Point Trophy honoring the 1972 season from Bernie Little (right). (Courtesy of Bill Osborne.)

5

THE YEARS OF CHANGE

1973 TO 1983

At the start of the 1970s, the sport of unlimited hydroplane racing was still dominated by round-nosed wooden boats with engines that sat in front of the driver.

By 1973, things were changing pretty fast. Dave Heerensperger launched his new Ron Jones–designed, lightweight, "pickle forked" boat with a rear wing and all honeycomb aluminum construction.

In 1973, the Gold Cup went to Tri-Cities, Washington, and Detroit put on the Gar Wood Memorial. Dean Chenoweth and the *Miss Budweiser* won the Detroit race and the Gold Cup, but Trophy Remund and the *Pay N' Pak* beat the *Miss Budweiser* by 275 points to claim the national championship in one of the closest contests ever.

The 1974 season saw four brand-new boats enter competition. All four were designed and built by Ron Jones, son of *Slo-mo-shun* designer Ted Jones. Three of the new boats featured rear engines, and one, the U-95, was powered by twin helicopter turbines!

Detroit was now represented on the circuit by just two teams, the *Gale* team, sponsored by Atlas Van Lines, and the *Miss U.S.* team owned by George Simon. The primary *Atlas* was badly damaged in a preseason test session on the Detroit River. Bill Muncey suffered minor injuries but was well enough to drive a backup *Atlas Van Lines* for the season opener in Miami, Florida, on June 2. The year 1974 was a disappointing year for Detroit fans; the *Atlas* was winless and finished third in national high points. The new Ron Jones–designed *Miss U.S.* was seriously damaged in a major fire at the Gold Cup in Seattle and ended the year in 13th place. Still the Gar Wood Trophy was well attended, and over 100,000 fans saw *Miss Budweiser* win for the second year in a row.

Things began to look up for Detroit fans in 1975. The Schoenith team built a new *Atlas Van Lines*, patterned after the highly successful Ron Jones boats. Tommy D'Eath had the *Miss U.S.* running flawlessly in Detroit and easily won the Gar Wood Trophy. Out west, *Pay N' Pak* won the Gold Cup in Tri-Cities, Washington, and claimed the national championship too.

Detroit was the high bidder and won the right to host the 1976 Gold Cup. In a surprise move, both Dave Heerensperger and Lee Schoenith retired from racing at the end of 1975. Bill Muncey picked up the Atlas sponsorship from Schoenith and then purchased Heerensperger's entire racing inventory to create Muncey Enterprises, an instant contender. An estimated 600,000 fans showed up to watch Bill Muncey and the *Atlas* battle against Tommy D'Eath and *Miss U.S.* in the 1976 Gold Cup. The race was marred by two serious accidents that sent the *Olympia Beer* and the *Miss Budweiser* to the bottom of the river. D'Eath and the *Miss U.S.* won. Shortly after the race, George Simon announced that he would be retiring from racing. Shocked Detroit fans realized that after 60 years of dominating the sport, there would be no major Detroit team on the circuit in 1977.

The big story at the start of 1977 was that Bill Muncey was retiring the old rear-cockpit *Atlas* hull and replacing it with a new forward-cockpit boat. The new boat had been designed by *Pay N' Pak* crew chief Jim Lucero and built by Norm Berg in 1975. Muncey acquired the boat when he purchased the *Pay N' Pak* racing inventory before the 1976 season but elected not to run the new boat that year. Muncey had long been a vocal critic of the forward-cockpit design, saying that its only benefit was that it made the driver "the first one to the scene of the accident!"

When the boat was first tested in the spring of 1977, it was fast but flighty and required a totally different driving style. Many fans wondered how long it would take Muncey to learn to drive from in front of the motor. They did not have to wonder long. Muncey won his first three races in the new *Atlas*, including the Gar Wood Trophy in Detroit. The Detroit victory was even more remarkable because the day before the race, Muncey slipped on the wet deck of his boat and broke his right foot. He used crutches to get around the pits and actually had to be lifted into the cockpit by his crew. He would use his right foot to operate the throttle for the start and first lap of the race and then switch to his left foot!

Muncey and the *Atlas* won six races that year, including the Gold Cup, but lost the national high points by 904 points. The rest of decade belonged to Muncey and his "Blue Blaster" *Atlas Van Lines*. They won every race but one in 1978 and all but two of the races in 1979.

Things changed dramatically in 1980, when Bernie Little unleashed his new Griffon-powered *Miss Budweiser*. The *Budweiser* proved to be far superior to Muncey's *Atlas*, as the *Atlas* had been to the rest of the fleet. The *Budweiser* won six races in 1980 and six more in 1981. Muncey and the *Atlas* struggled valiantly to keep up, but their day was clearly over. In the last race of 1981, the world championship in Acapulco, Mexico, Muncey and the *Atlas* were leading the final heat when the *Atlas* blew over backward and Muncey was killed.

Bill's widow, Fran, elected to keep the team together and built a new boat for 1982. The torch was passed to a new younger generation when Chip Hanauer drove the new *Atlas* to an emotional Gold Cup victory in Detroit. Less than a month later, Dean Chenoweth was killed when the *Miss Budweiser* crashed in Tri-Cities, Washington, and Jim Kropfeld took over the *Budweiser* cockpit.

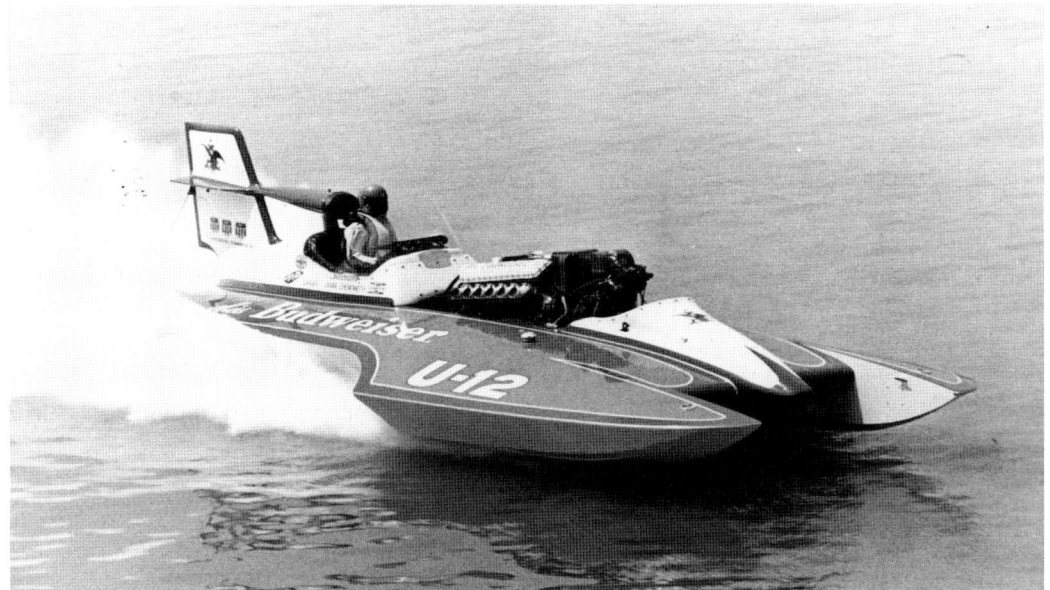

During the early 1970s, hydroplane designs were changing quickly. The low-profile, wide-transom boats designed and built by Ron Jones were beginning to dominate the sport. In 1973, the *Miss Budweiser* with Dean Chenoweth behind the wheel won the Gar Wood Trophy in Detroit as well as the National Champions Regatta. (Photograph by Joe Migon.)

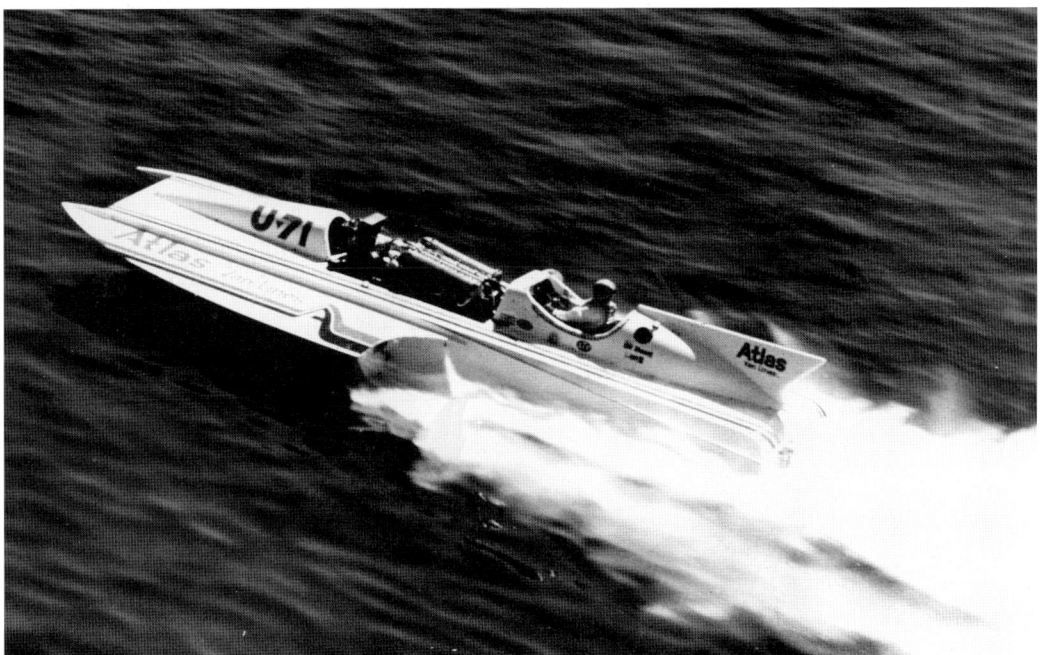

The *Atlas Van Lines* that so dominated the 1972 season was obsolete by the end of 1973. It did not win a single race all season and could only manage a disappointing eighth place in the National Champions Regatta.

In an effort to keep up with changing designs, the *Atlas* was modified to sport a delta wing prior to the 1974 season. The modification did not seem to work, and the boat crashed violently in its first test session.

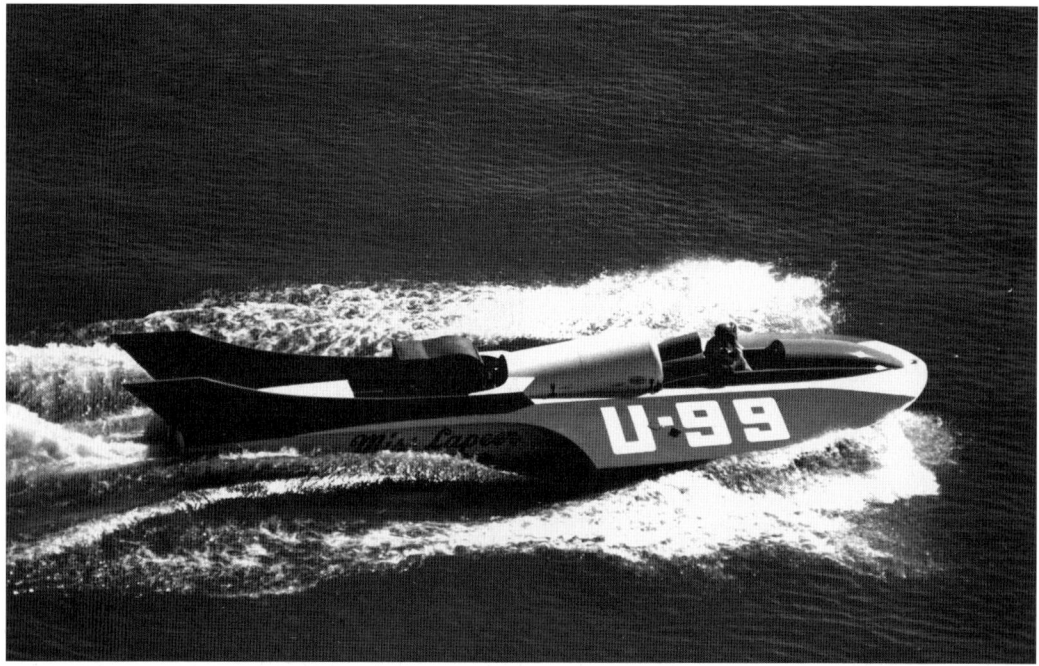

Jim Herrington debuted his experimental turbine-powered *Miss Lapper* at the 1974 National Championship Regatta. The big boat was unable to qualify with Fred Alter driving. (Courtesy of Bill Osborne.)

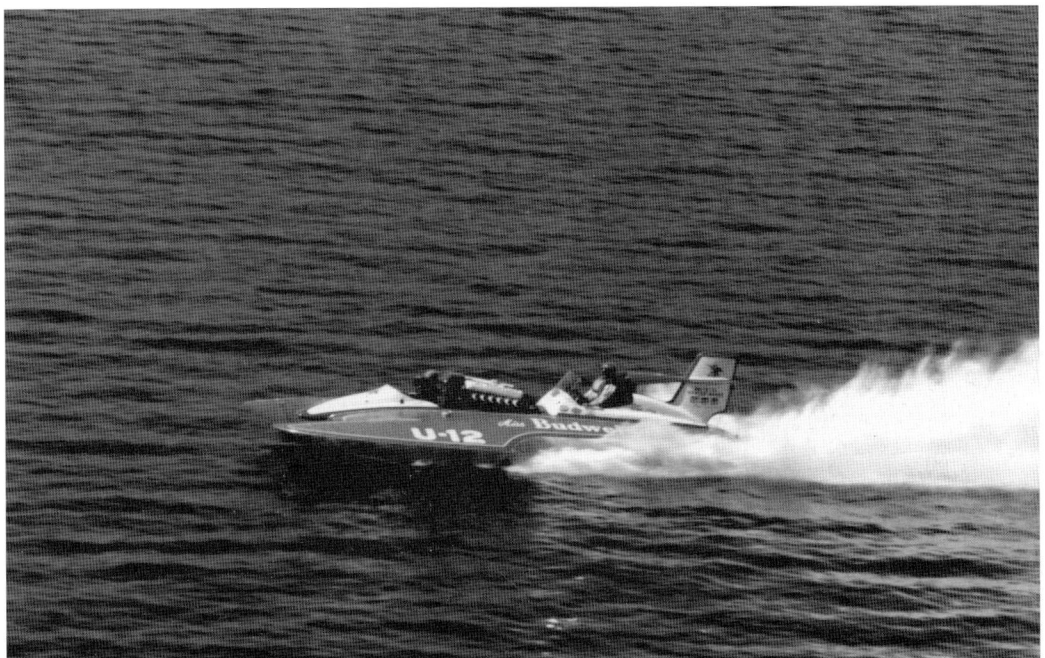

Howie Benns and the *Miss Budweiser* won the Gar Wood Memorial in 1974, giving Bernie Little back-to-back victories in Detroit.

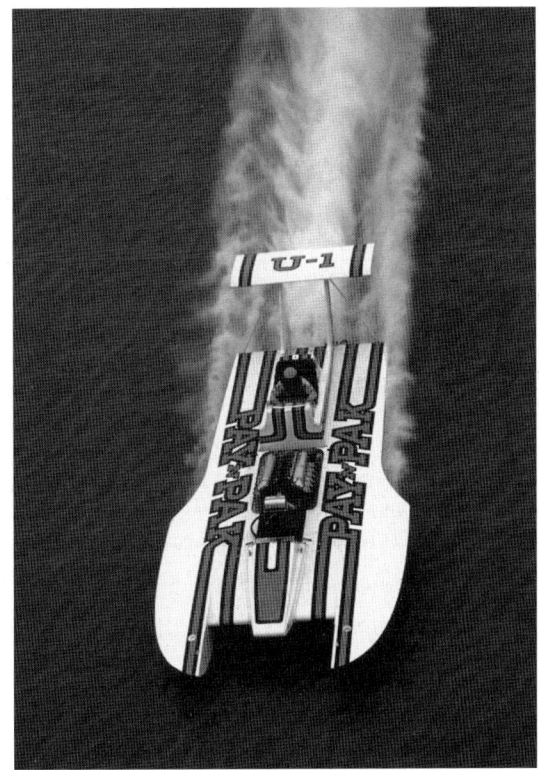

The *Pay N' Pak* was national champion in 1973 and 1974 but had a hard time winning in Detroit, coming in second place behind the *Miss Budweiser* in both 1973 and 1974. (Courtesy of Bill Osborne.)

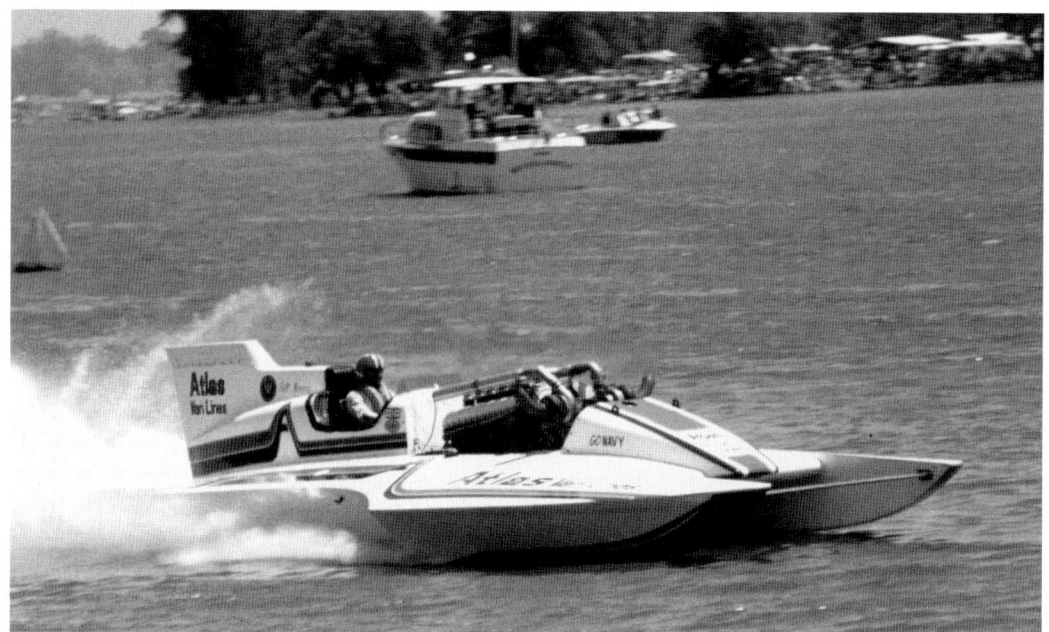

In 1975, the *Atlas* team built a new boat to try to stay competitive with the newer Ron Jones–designed boats. The *Atlas* was not able to complete a single heat or score a single point at the 1975 Gar Wood Trophy Race.

George Simon's Ron Jones–designed rear-engine hydroplane, which had shown flashes of brilliance in 1974, finally put together a complete race and won all three heats to claim the 1975 Gar Wood Trophy.

In 1976, the Gold Cup returned to Detroit, and the *Olympia Beer*, driven by two-time Gold Cup winner Billy Schumacher, was the fastest qualifier. The boat nosed in and sank during heat 3-A.

Bill Muncey and the *Atlas Van Lines* were leading the final heat when Howie Benns was thrown from the *Miss Budweiser* and the race was stopped. While waiting for the restart, damage to the boat's wing was discovered. It could not be repaired in time for the restart, so the *Atlas* ran the final with no wing. (Courtesy of Bill Osborne.)

Tom D'Eath and the Miss U.S. raced side by side with Bill Muncey and the Atlas for four laps in the final heat before the U.S. pulled away to earn the victory and give George Simon his first Gold Cup trophy after more that 20 years of trying. (Courtesy of Bill Osborne.)

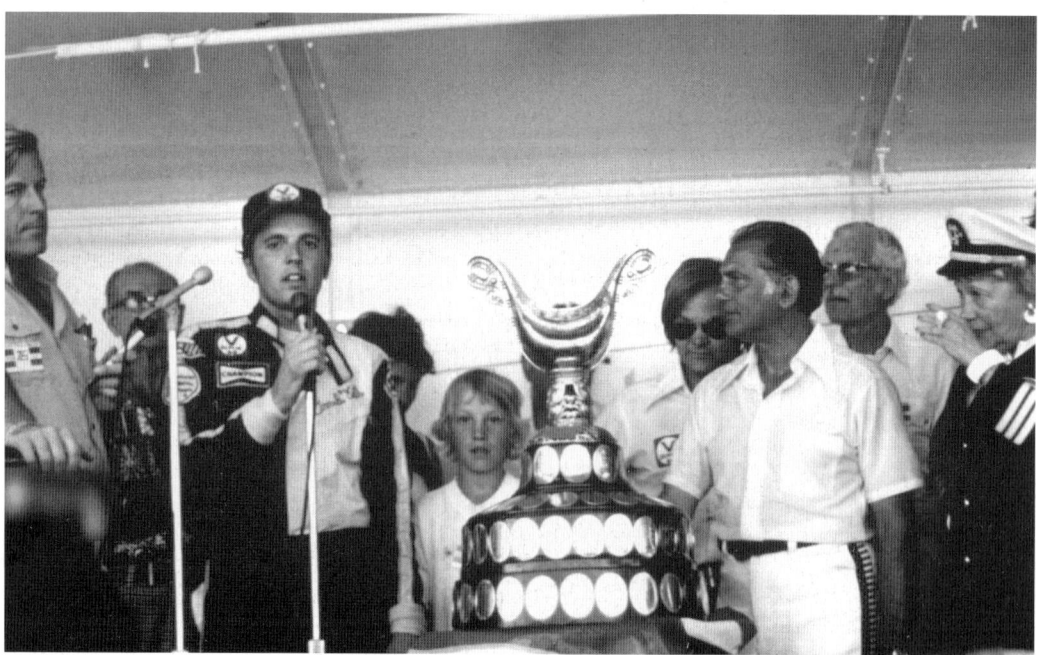

Tom D'Eath (holding the mic) accepts the Gold Cup Trophy in an emotional celebration as George Simon (to the right of the trophy) looks on. (Courtesy of Bill Osborne.)

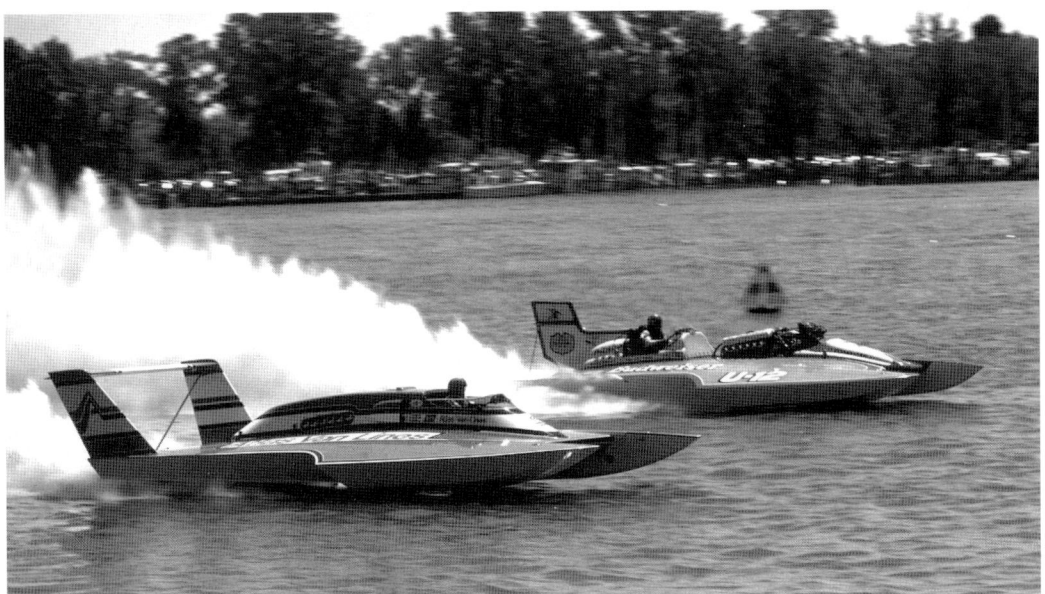

Bill Muncey brought out a new rear-engine *Atlas Van Lines* in 1977. Fans quickly nicknamed the boat the "Blue Blaster" because of the boat's blue paint scheme. Muncey and the "Blue Blaster" won the first three races of the 1977 season, including the Gar Wood Trophy. In this photograph, Muncey passes Mickey Remund and the *Miss Budweiser*. (Courtesy of Bill Osborne.)

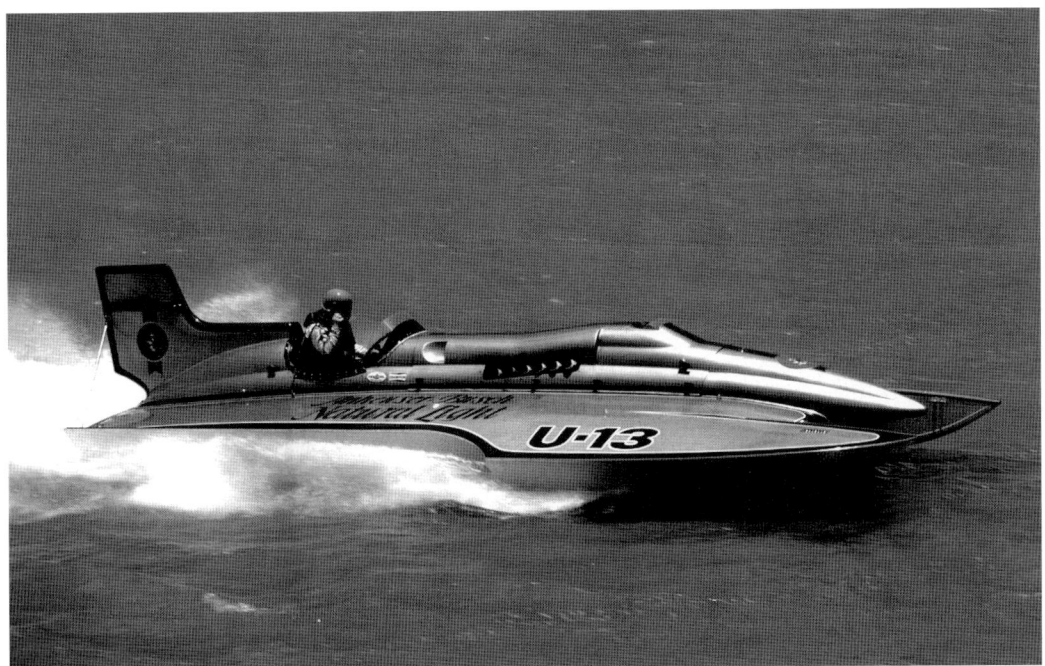

The former *Olympia Beer* was purchased by Bernie Little and raced as *Anheuser Busch Natural Light* with Tom Sheehy driving. The silver and blue boat took second place at the 1977 Gar Wood Trophy. (Courtesy of Bill Osborne.)

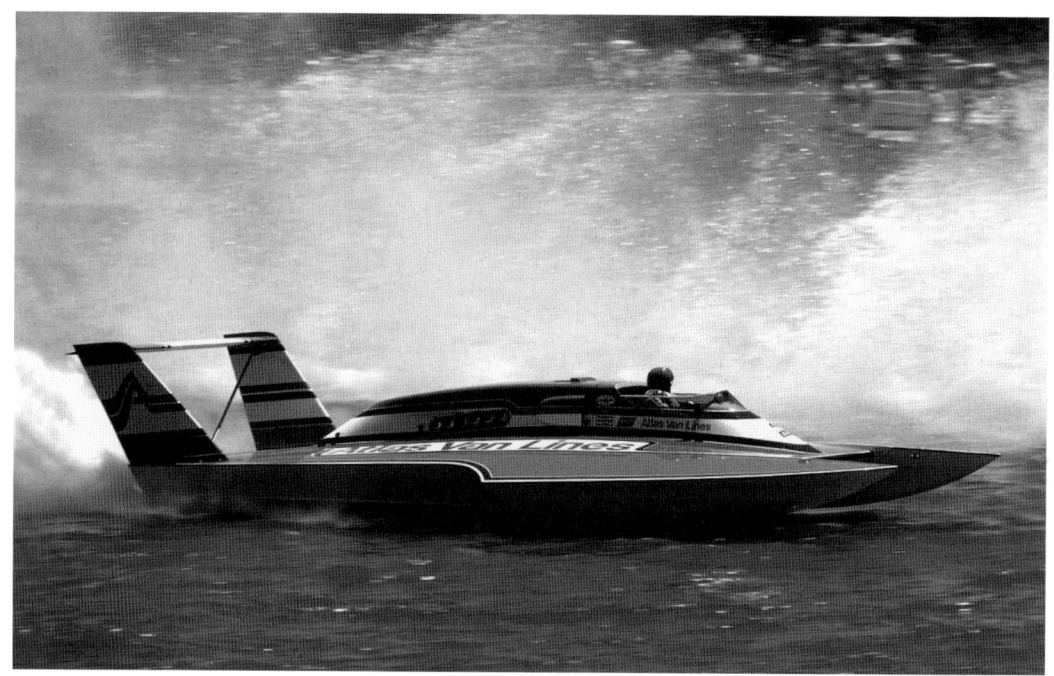

Bill Muncey and the *Atlas Van Lines* won six out of seven races in 1978, including the Spirit of Detroit Race. (Courtesy of Bill Osborne.)

The *Savair's Probe* was built in 1960 and was one of the last round-nosed, front-engine hydroplanes left on the circuit, but driver Bob Miller surprised everyone with a respectable third-place finish in the 1978 Spirit of Detroit Race. (Courtesy of Bill Osborne.)

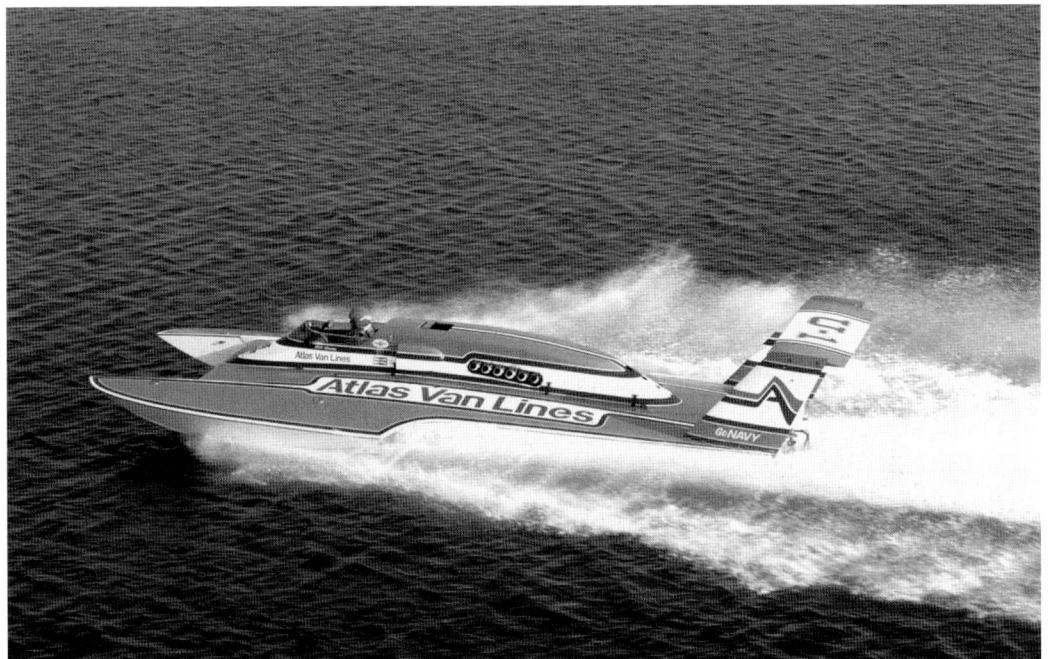

The "Blue Blaster" continued to dominate the fleet in 1979, winning seven out of nine races, including the 1979 Spirit of Detroit Race. (Courtesy of Bill Osborne.)

Bill Cantrell and Graham Heath raced the old My Gypsy in 1979 and 1980 as the Miss Kentuckiana Paving. (Courtesy of Bill Osborne.)

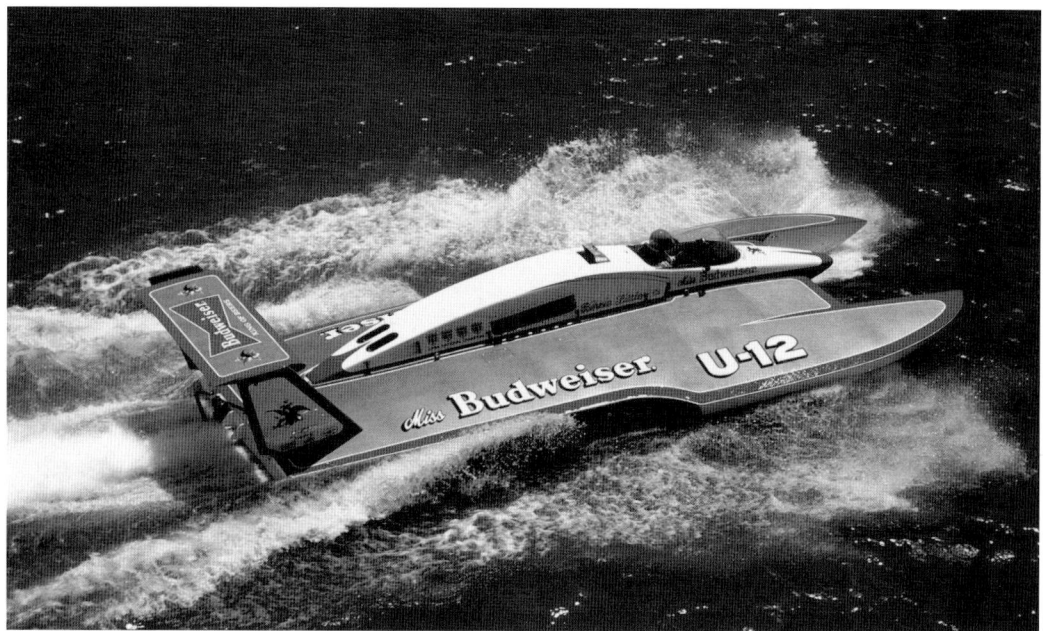

In 1980, Dean Chenoweth drove the brand-new Ron Jones–designed Rolls Griffon–powered *Miss Budweiser* to victory in five out of the first five races of the season, including the Spirit of Detroit Race and the Gold Cup. (Courtesy of Bill Osborne.)

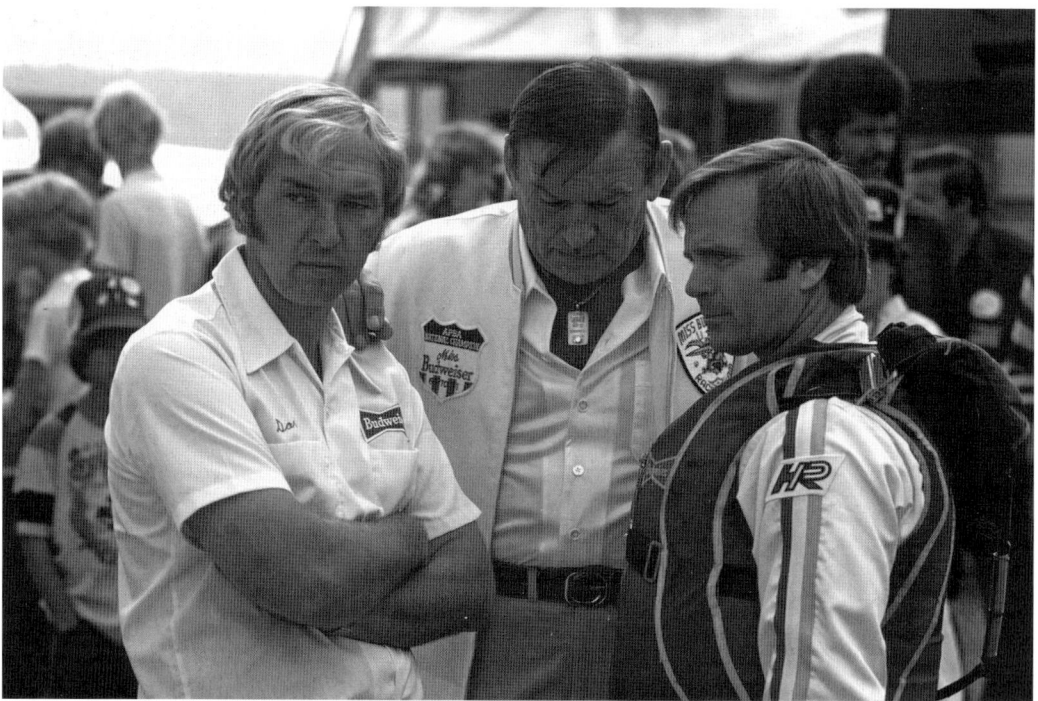

Miss Budweiser crew chief Dave Culley (left) talks strategy with Bernie Little (center) and Dean Chenoweth (right). (Courtesy of Bill Osborne.)

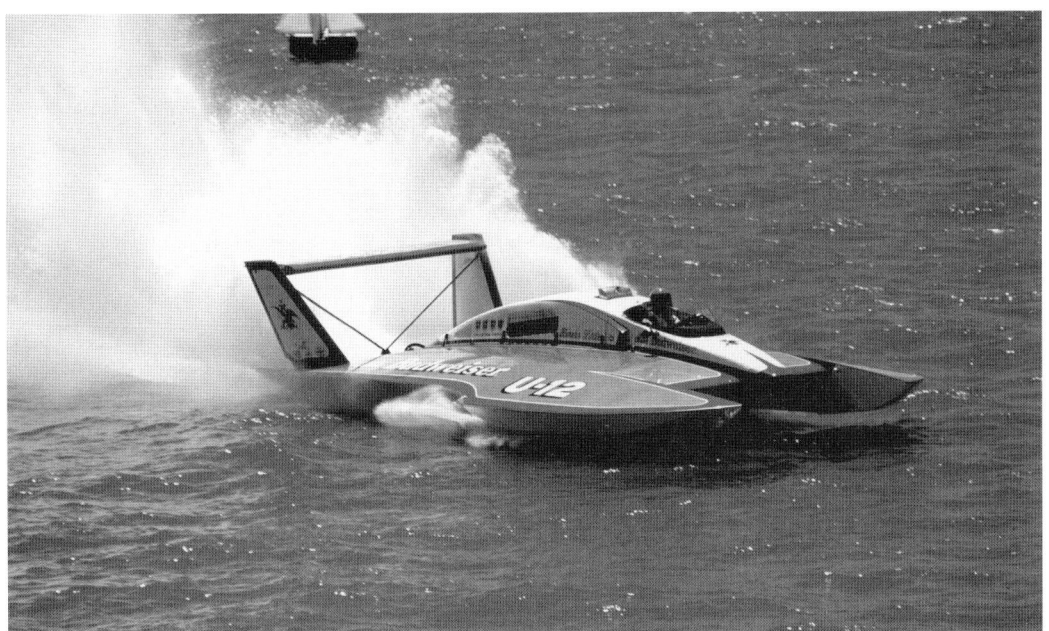

The *Miss Budweiser* continued to dominate the competition in 1981, winning six out of eight races, including the Stroh's Silver Cup in Detroit and the Gold Cup in Tri-Cities, Washington. (Courtesy of Bill Osborne.)

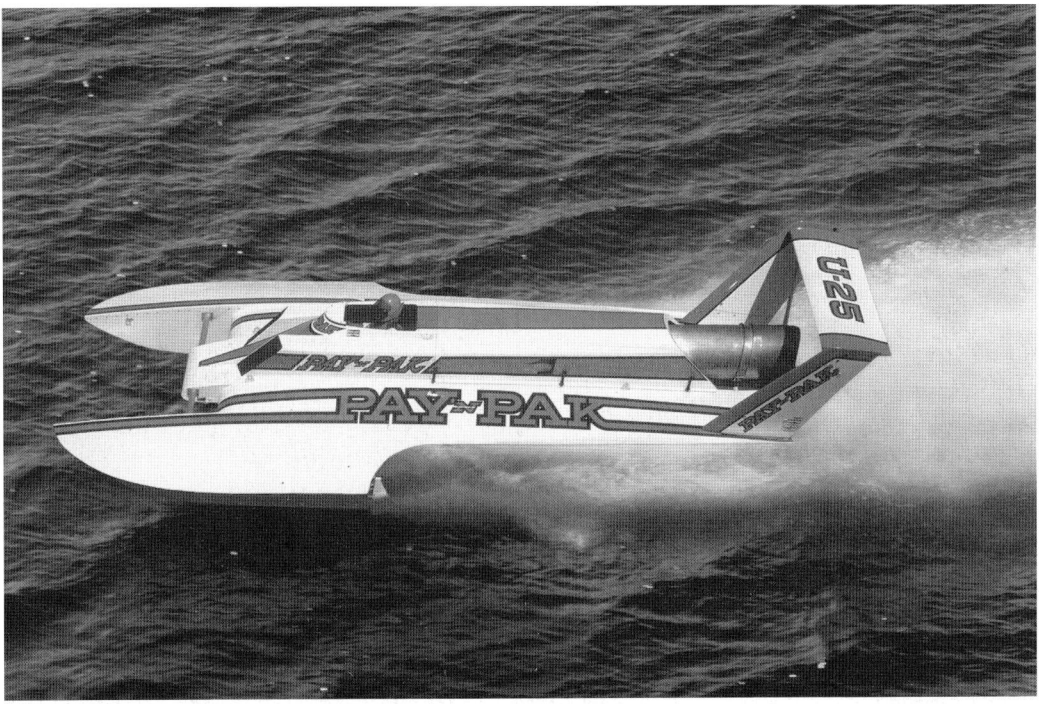

Dave Heerensperger's turbine-powered *Pay N' Pak* showed flashes of brilliance in 1981 but could only manage a seventh-place finish in Detroit. (Courtesy of Bill Osborne.)

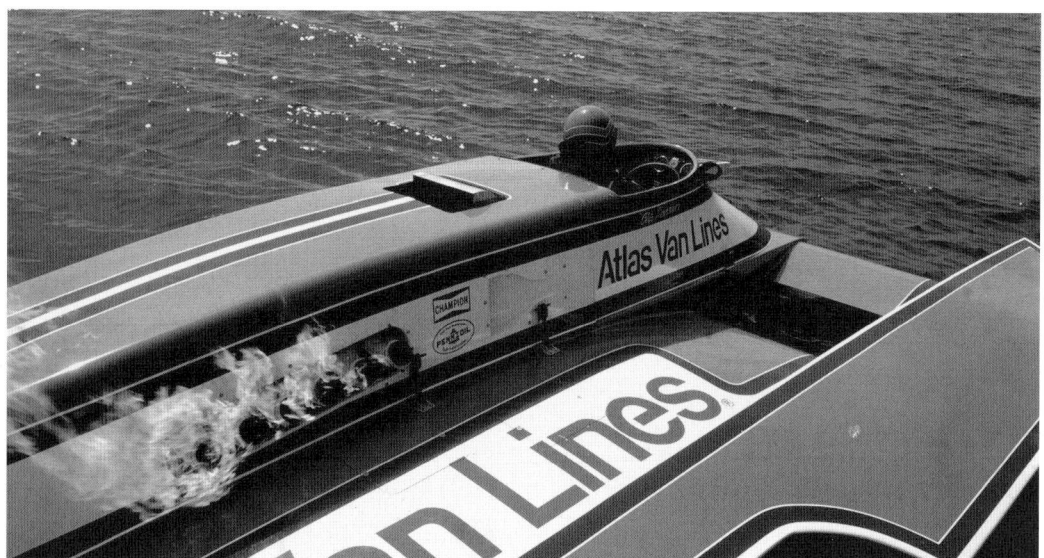

In the final race of the 1981 season, Bill Muncey's *Atlas Van Lines* crashed and he was killed. Bill's widow, Fran, faced the painful decision between closing down the team and laying off the crew or keeping the team going with a new driver. She elected to keep the team together and hired Chip Hanauer to drive a brand-new *Atlas*. Chip and the *Atlas* won the 1982 Gold Cup in Detroit. (Courtesy of Bill Osborne.)

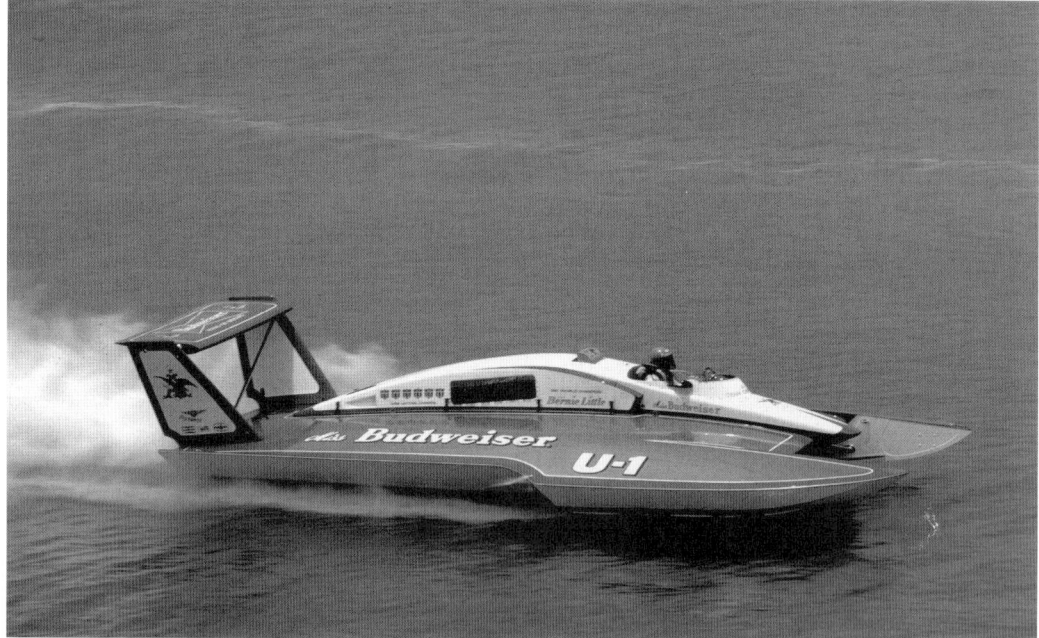

Tragedy continued to plague the unlimiteds when *Miss Budweiser* driver Dean Chenoweth was killed while attempting to set a new qualifying record in Tri-Cities, Washington, in July 1982. Ron Armstrong and then Jim Kropfeld replaced Chenoweth in the *Budweiser* cockpit in 1983. (Courtesy of Bill Osborne.)

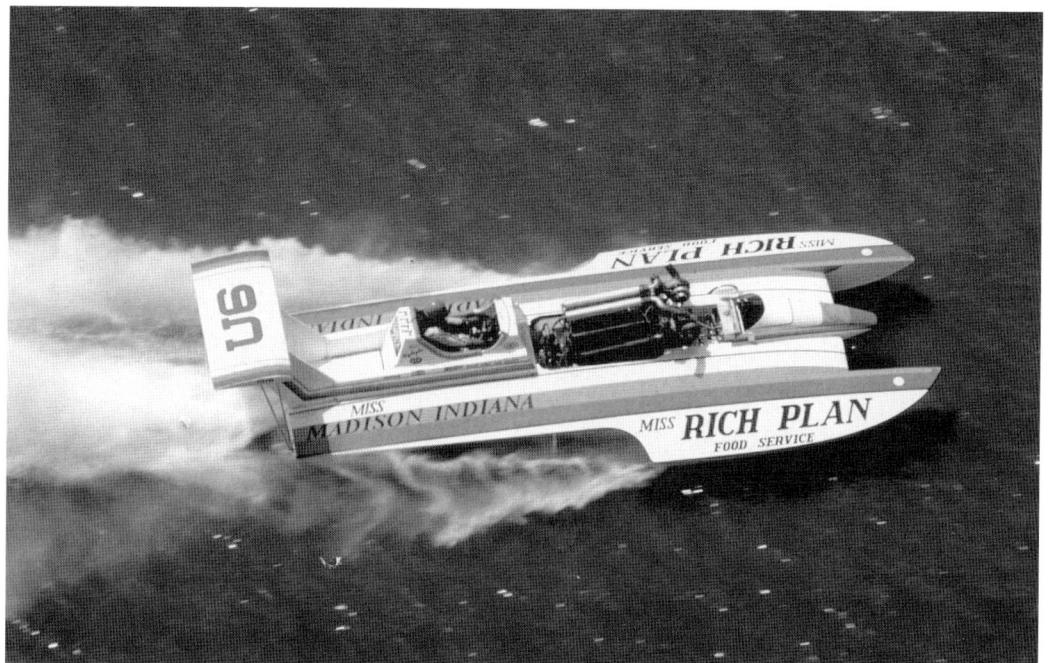

Ron Snyder drove the Miss Rich Plan Food Service to a second-place finish in the 1983 Stroh's Thunderfest. (Courtesy of Bill Osborne.)

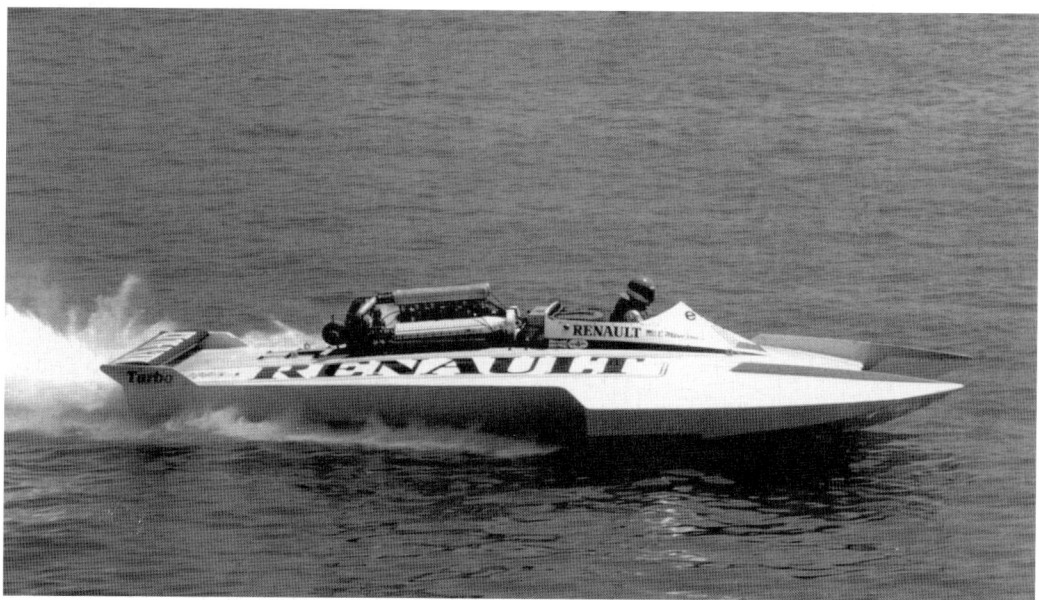

Lee Schoenith's younger brother Jerry campaigned the turbocharged Allison-powered Miss Renault in 1983. This was the first major team to represent Detroit since George Simon retired the Miss U.S. team at the end of the 1976 season. Schoenith won the season-ending Budweiser World Championship race in Houston. This would be the last race won by any member of the Schoenith family. (Courtesy of Bill Osborne.)

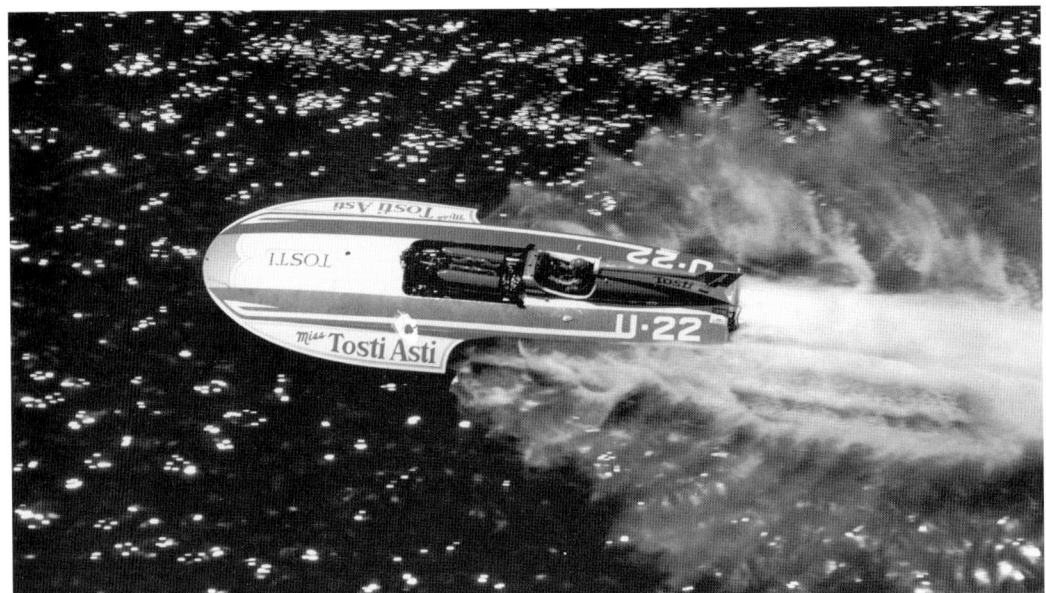

The U-22 *Miss Tosti Asti* was originally built for Paul Sawyer in 1956, but Sawyer's wife became ill and he retired from racing to take care of her. Eventually Jim Sedam purchased the 25-year-old boat and ran it as the *Tosti Asti* with Todd Yarling driving. They finished ninth in the Stroh's Thunderfest. (Courtesy of Bill Osborne.)

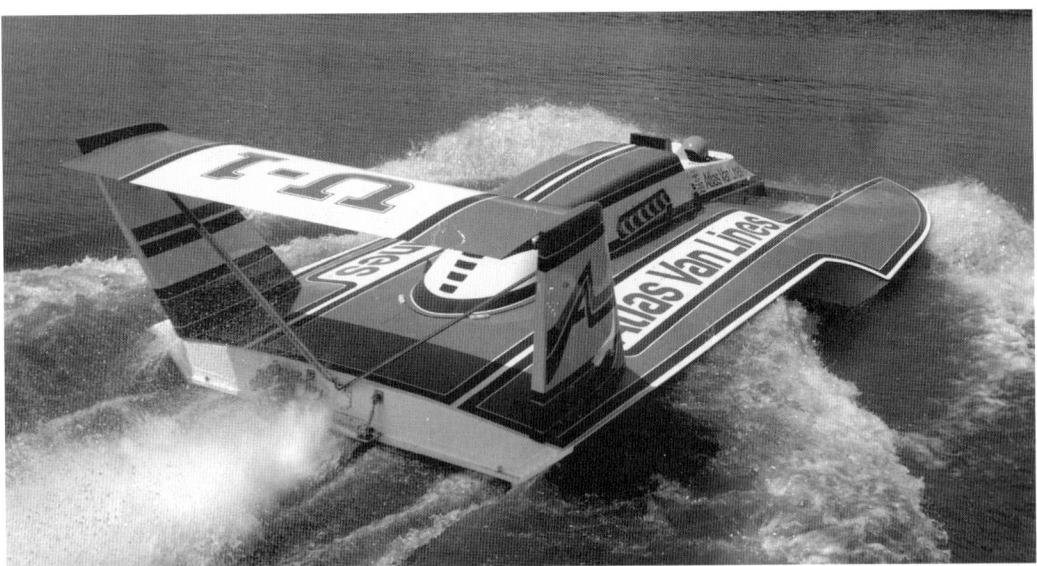

Chip Hanauer and the *Atlas Van Lines* won the Stroh's Thunderfest and went on to capture the Gold Cup and national championship in 1983. (Courtesy of Bill Osborne.)

6

THE TURBINE YEARS

1984 TO 1990

As the sport moved in to the mid-1980s, the supply of World War II surplus Merlin and Allison engines that dominated boat racing since the 1940s began to dry up. It became obvious that a new power plant was necessary. A number of different teams had experimented with turbine engines in the 1970s and early 1980s, and Dave Heerensperger even won one race with the turbine-powered *Pay N' Pak* in 1982.

In 1984, Fran Muncey and Jim Lucero launched an innovative turbine-powered *Atlas Van Lines*. The boat was powered by a Lycoming T-55 L-7 that produced an incredible 2,850 horsepower yet only weighed 600 pounds. To many racing fans, a turbine engine is an exotic mystery, but actually nothing could be further from the truth. The reason turbines are so light is that they are really very simple straightforward machines with only a couple of moving parts. Turbines, like their piston engine counterparts, are internal combustion engines that produce power by harnessing the energy from the explosion caused when a spark is added to gasoline. In a piston engine, the explosion is contained inside a cylinder, and the force of the explosion pushes a piston up and turns a crankshaft that is connected to the propeller and causes the propeller to rotate, pushing the boat forward. In a turbine, the explosion takes place in an open-ended "can" and the exploding gasses rush past a series of fan blades, the gas causes the fan blades to turn a shaft, that shaft is connected to the propeller, and the turning propeller pushes the boat forward just like it would in a piston-powered boat.

The new turbine-powered *Atlas* showed flashes of brilliance, winning the Governor's Cup in Madison, Indiana, and the Gold Cup in Tri-Cities, Washington, but the tried-and-true *Miss Budweiser* captured six races, including the Stroh's Thunderfest in Detroit and the national championship.

Atlas Van Lines retired from boat racing at the end of the 1984 season, and Miller Brewing stepped up to take over the sponsorship of the Muncey team. With Chip Hanauer behind the wheel, the *Miller American* won the Stroh's Thunderfest in Detroit, the Gold Cup in Seattle, and three other races to capture the first turbine-powered national championship. Since that date forward, every national championship and all but one Gold Cup victory have gone to turbine-powered boats.

In 1986, Detroit hosted the Gold Cup, and the trophy was won again by Chip Hanauer and the *Miller*. This victory gave Chip Hanauer his fifth Gold Cup win in a row and tied him with Gar Wood for most consecutive Gold Cup victories. Hanauer and the *Miller* won five races that year. The new turbine-powered *Miss Budweiser* driven by Jim Kropfeld only won three races but still managed to win the national championship.

Starting in 1987, the URC mandated that all new boats had to have enclosed safety canopies. This was a major reversal on the URC's part. For decades, drivers were prohibited by rule from

wearing seat belts. The reasoning was that officials believed that a driver stood a better chance of surviving a crash if he were thrown free of a crashed boat than he would if he were strapped into a boat that was sinking. The new rule was made possible by the adoption of honeycomb aluminum as the construction material of choice. Honeycomb aluminum boats were far less likely to sink, making it safer for the driver to strap into the boat.

Kropfeld and the *Miss Budweiser* won the 1987 Budweiser Thunderboat Championship on the Detroit River, as well as the 1987 national championship, but Chip Hanauer continued his stranglehold on the Gold Cup with a win in San Diego.

In the first race of the 1988 season at Miami, Florida, the *Miss Budweiser* spun out going into the first turn of the final heat. *Jif Presents Mr. Pringles*, driven by Scott Pierce, could not avoid the accident and drove right over the *Budweiser's* cockpit. Kropfeld suffered a broken neck, but the roll cage and enclosed safety canopy definitely saved his life. While Kropfeld healed, Bernie Little hired Detroit native Tom D'Eath to take over the *Budweiser's* cockpit. When Tom D'Eath won the Gold Cup in the *Miss U.S.* in 1976, his crew chief was Ron Brown. In 1988, Ron Brown was the crew chief on the *Miss Budweiser*, and fans and competitors were excited to see the two old teammates back together.

Chip Hanauer drove the *Miller High Life* to victory in the Budweiser Thunderboat Championship in Detroit. He also claimed the Gold Cup in Evansville driving the *Circus Circus*, but Tom D'Eath and the *Budweiser* won the national championship.

Miller Brewing decided to get out of unlimited racing at the end of 1988, and Fran Muncey chose to retire as well. Bill Bennett, owner of Circus Circus Casinos, bought all of Muncey's equipment and hired veteran limited racer Dave Villwock as crew chief for his team. Hanauer stayed on as the driver.

When the 1989 season kicked off, Jim Kropfeld was back in the cockpit of the *Miss Budweiser* and won two of the first five races but was replaced by Tom D'Eath at the Syracuse, New York, race. D'Eath and the *Budweiser* won in Syracuse and went on to win the Gold Cup and national championship. Chip Hanauer and the *Circus Circus* won the Budweiser Thunderboat Championship in Detroit.

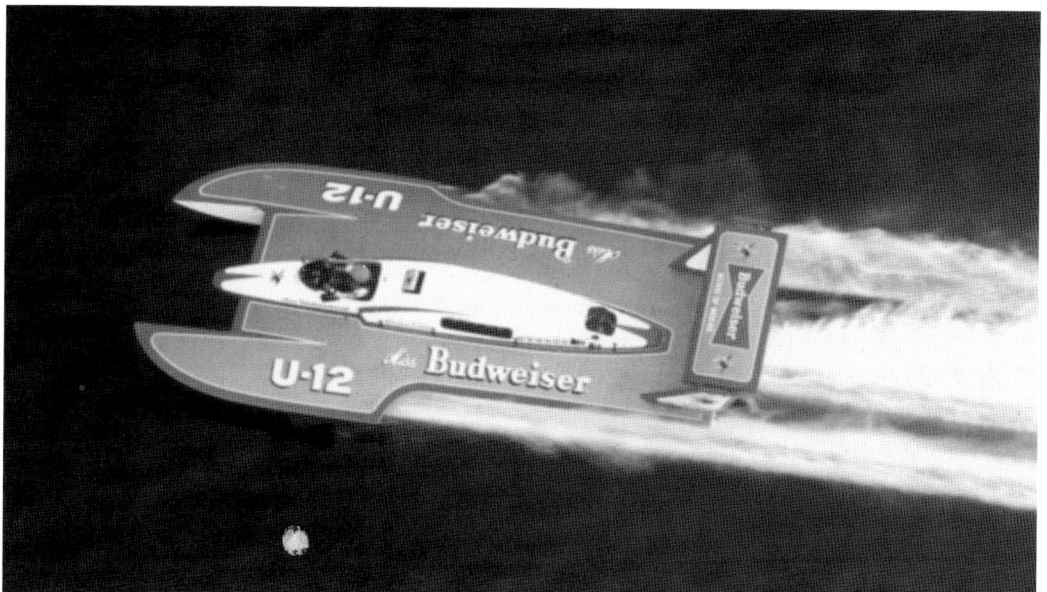

While several top teams experimented with turbine engines in 1984, the Budweiser team stuck with its tried-and-true Rolls-Royce Griffon and was rewarded with six victories and a national championship. One of the *Bud*'s victories came at the 1984 Stroh's Thunder fest in Detroit. (Courtesy of Bill Osborne.)

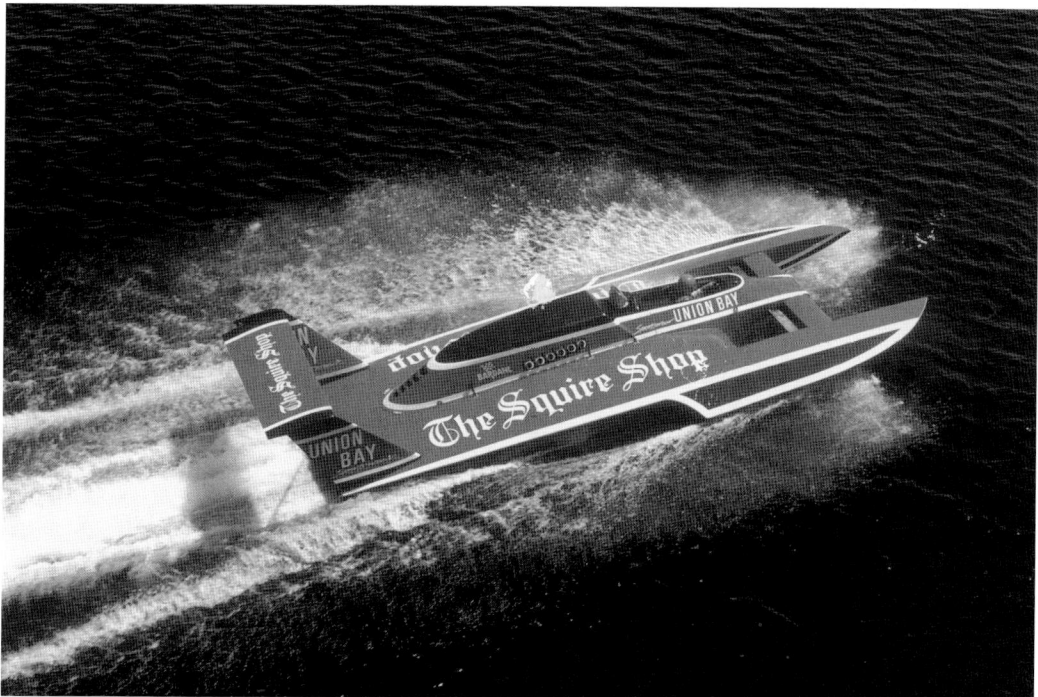

Mickey Remund drove Bob Steil's *The Squire Shop* to second place in Detroit on his way to a second place in national high points in 1984. (Courtesy of Bill Osborne.)

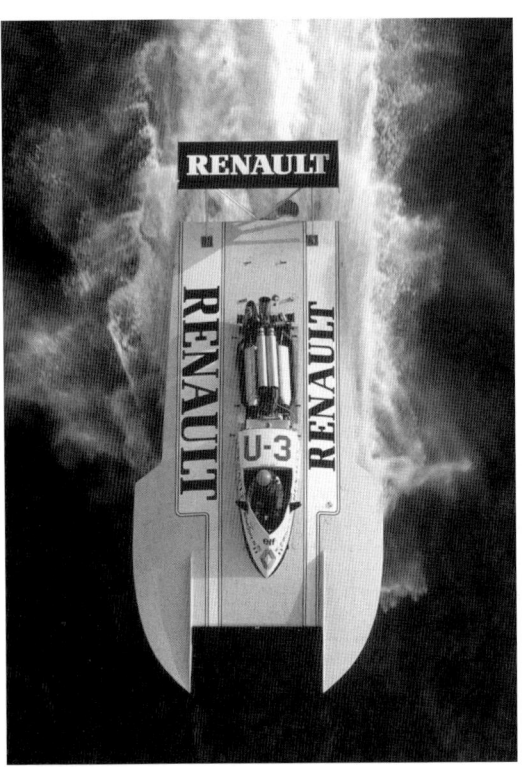

Jerry Schoenith's *Miss Renault* continued to put in a respectable performance, capturing fourth place at the 1984 Detroit race. (Courtesy of Bill Osborne.)

Chip Hanauer and the new turbine-powered *Atlas Van Lines* could only manage sixth place at the 1984 Stroh's Thunderfest in Detroit, but two weeks later, they won the Gold Cup in Tri-Cities, Washington. (Courtesy of Bill Osborne.)

Steve Woomer's U-10 picked up 7-Eleven as a sponsor for 1985. With Steve Reynolds driving, the team took second place at the 1985 Stroh's Thunderfest. (Courtesy of Bill Osborne.)

Atlas Van Lines retired from racing at the end of the 1984 season. Fran Muncey was successful in landing Miller Brewing to sponsor the team in 1985. Miller executives gave drive Chip Hanauer one mission: "Beat Budweiser!" Hanauer did just that, winning five races, including the Stroh's Thunderfest, the Gold Cup, and the national championship. (Courtesy of Bill Osborne.)

In 1986, Bernie Little yielded to the inevitable and replaced his Griffon-powered *Miss Budweiser* with a new turbine-powered boat. His effort was rewarded with three race wins and a national championship. (Courtesy of Bill Osborne.)

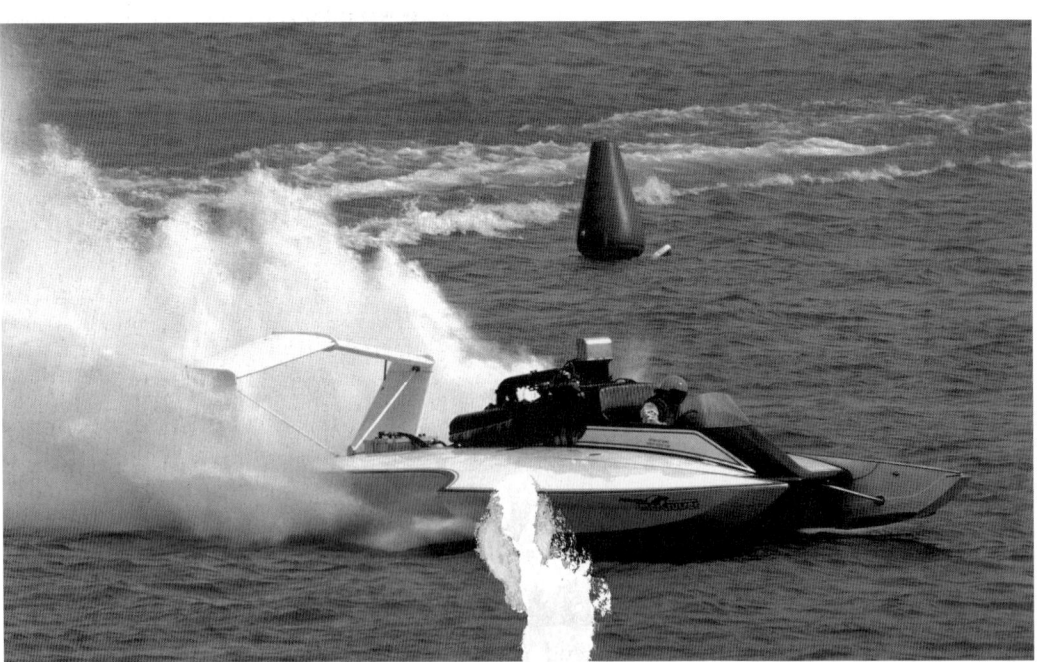

Jerry Hopp and Al Thoreson ran their Allison-powered U-7 without a sponsor in Detroit in 1986. They failed to qualify for the race, but their efforts reminded many fans of the heroic efforts made by home-built boats from the early 1950s. (Courtesy of Bill Osborne.)

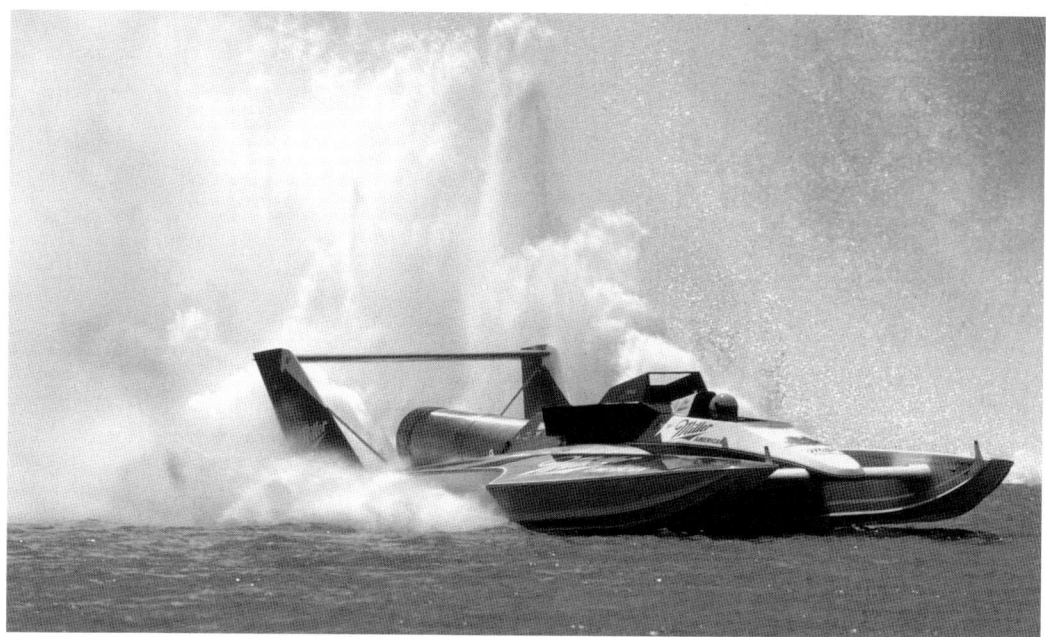

Chip Hanauer and the *Miller American* won the Gold Cup in Detroit. It was Hanauer's fifth win and tied him with Gar Wood for the number of Gold Cup victories. Hanauer, like Gar Wood, won his first five Gold Cups successively. (Courtesy of Bill Osborne.)

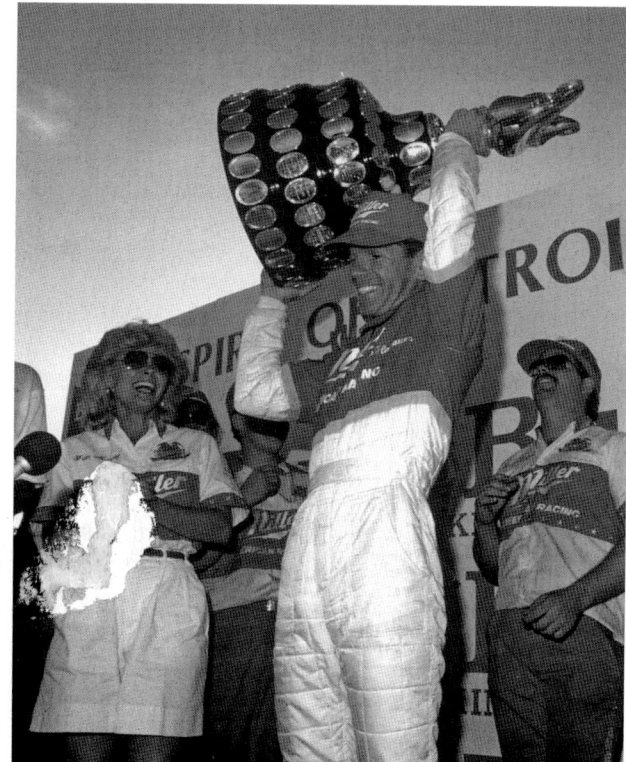

Fran Muncey (left) looks on with joy as Chip Hanauer hoists his fifth consecutive Gold Cup over his head. (Courtesy of Bill Osborne.)

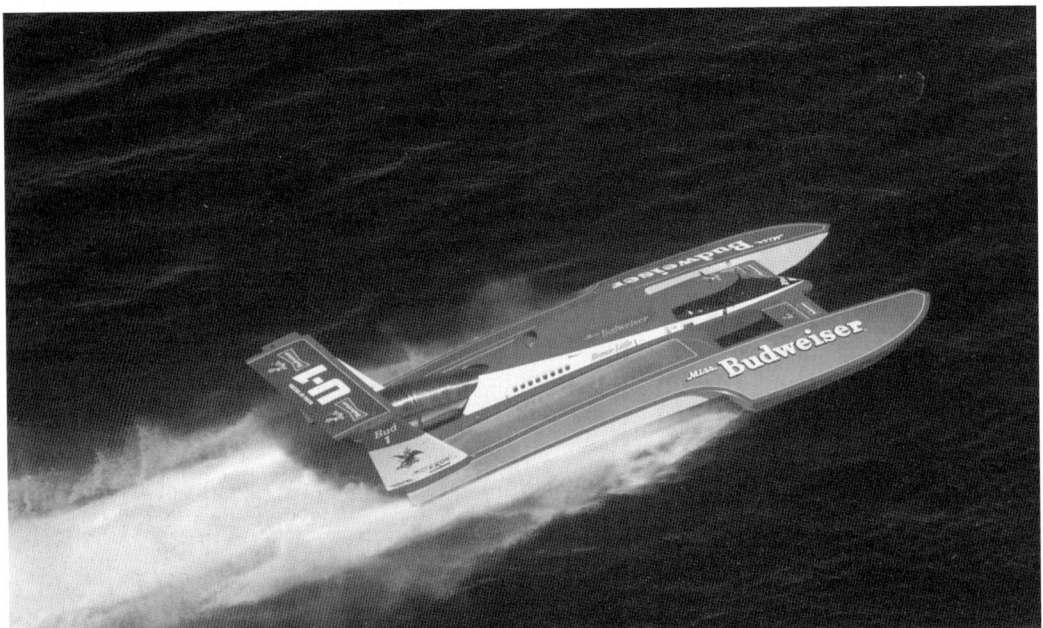

After only one year of racing, Bernie Little replaced his original turbine *Miss Budweiser* (T-1) with a brand-new turbine *Miss Budweiser* (T-2). Jim Kropfeld drove the new boat to victory in five races and the national championship. (Courtesy of Bill Osborne.)

Mickey Franklin tried but failed to qualify Mike Bancroft's automotive-powered *Eliminator* at the 1987 Budweiser Thunderboat Championship. (Photograph by Mark and Julie Hooton.)

Scott Pierce slides Bill Wurster's *Mr. Pringles* around Detroit's tight Roostertail Turn on his way to winning the 1987 Budweiser Thunderboat Championship.

Scott Pierce waves to fans after driving Bill Wurster's *Mr. Pringles* to victory in the 1987 Budweiser Thunderboat Championship.

Chip Hanauer put Miller back in the winner's circle in Detroit in 1988. (Photograph by Mark and Julie Hooton.)

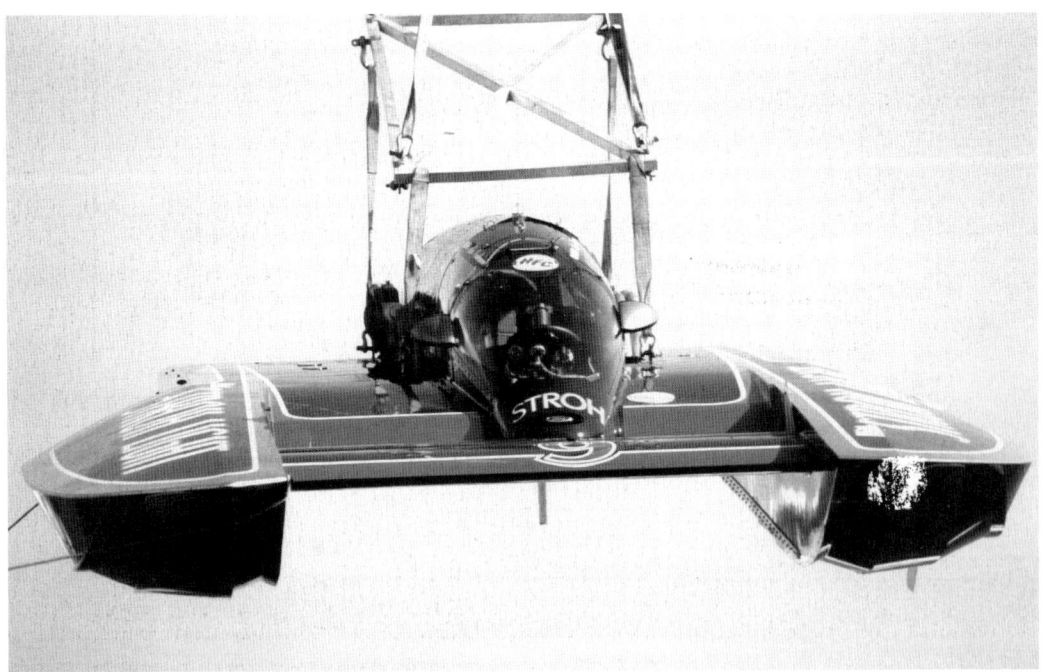

After several years of sponsoring the Detroit race, Stroh's Brewing decided to sponsor a race boat in 1988. However, Al Vordermeier's automotive-powered *Miss Stroh Light* was unable to qualify for the 1988 Budweiser Thunderfest.

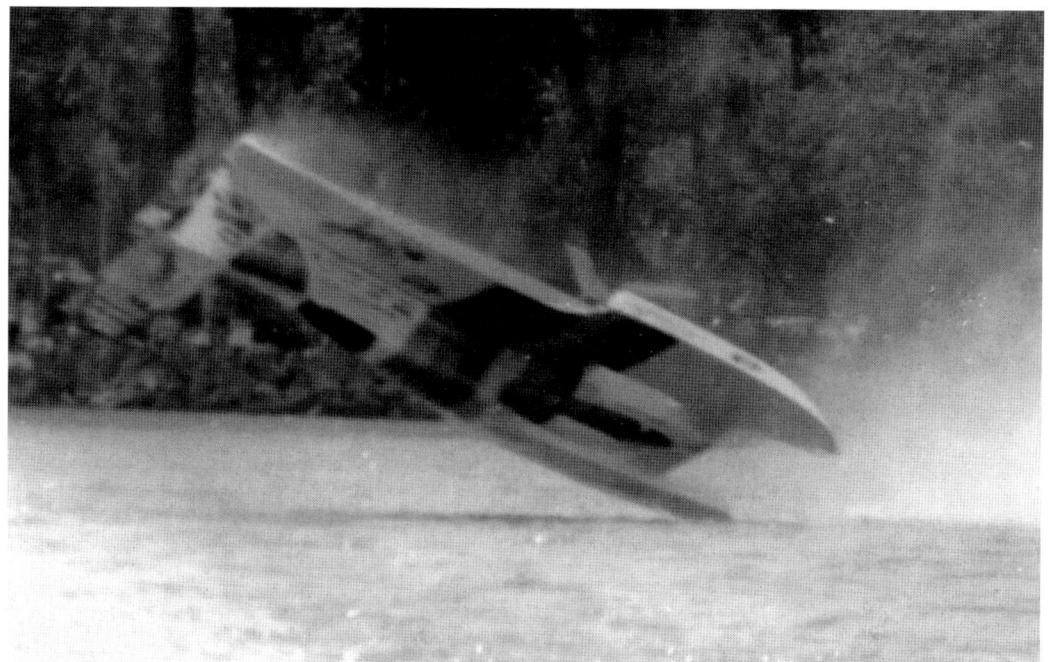

Scott Pierce won the Budweiser Thunderfest in 1987 but had very different luck in 1989. His *Mr. Pringles* flipped in heat 1-B.

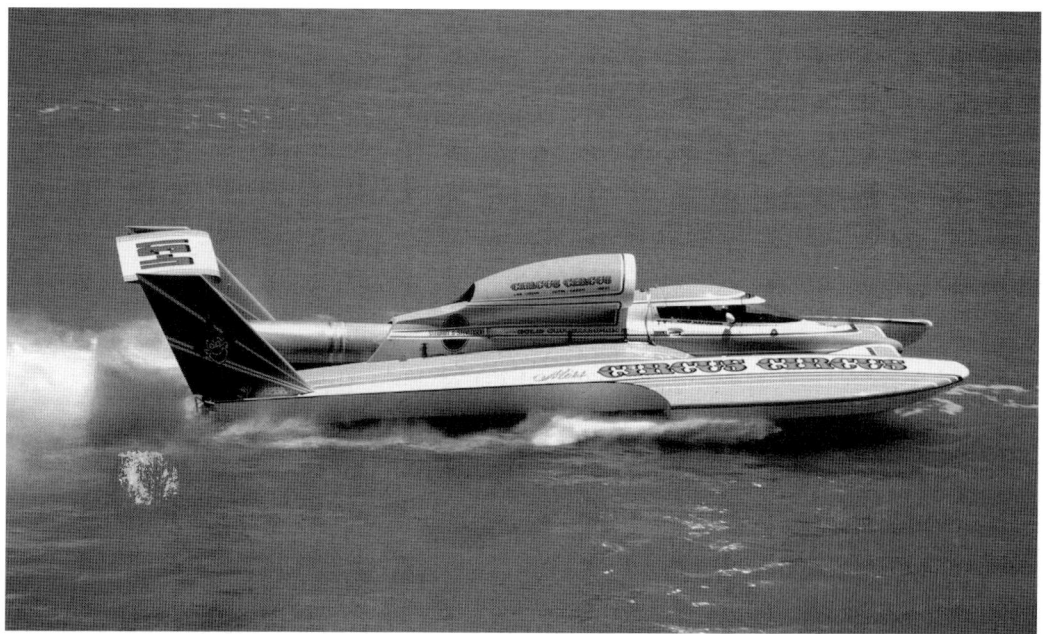

Miller Brewing dropped out of hydroplane racing after the 1988 season. Fran Muncey sold her entire team to Bill Bennett, who owned Circus Circus Casinos. Bennett ran the boat in 1989 as *Miss Circus Circus*, and Chip Hanauer won the Spirit of Detroit Race for the new owner. (Courtesy of Bill Osborne.)

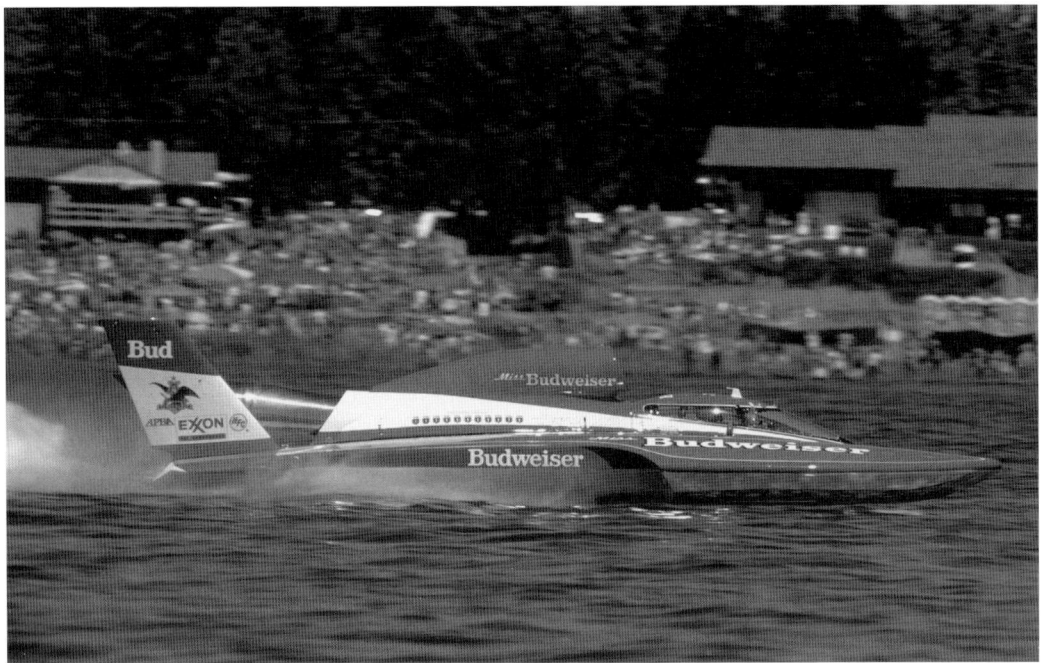

The Gold Cup returned to Detroit in 1990, and hometown favorite Tom D'Eath drove the Miss Budweiser to victory. It was D'Eath's third Gold Cup. (Courtesy of Bill Osborne.)

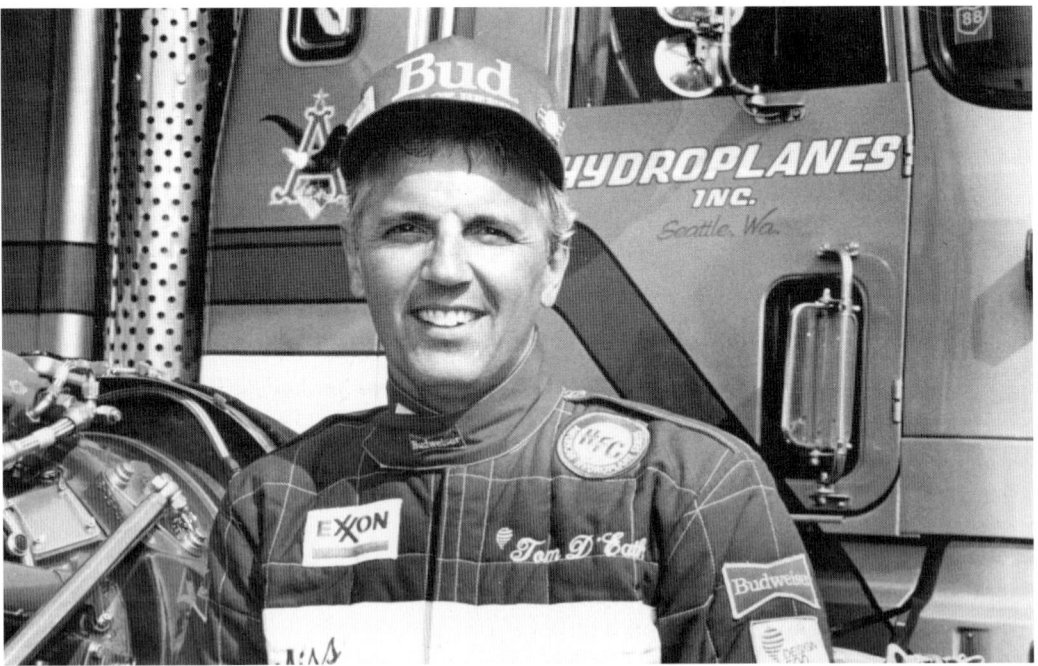

When Detroit native Tom D'Eath won the 1990 Gold Cup, he became one of only two drivers to win the Gold Cup in three consecutive decades. D'Eath victories came in 1976, 1989, and 1990. The other driver to achieve this feat was Bill Muncey, also a native of Detroit.

The Gold Cup Years

1991 to 2002

In 1990, the URC declared that the Detroit River would become "The Permanent Home of the Gold Cup." There was a time when such an announcement would have caused an angry protest from the West Coast, but after years of awarding the race based on a bidding system, fans around the country had lost interest in where the race would be held. (Although there continued to be great interest in who won the race.)

With Chip Hanauer driving and Dave Villwock setting up the boat, the *Circus Circus* was a formidable team in 1990. They won 6 out of 11 races and gave Bill Bennett his one and only national championship. But Tom D'Eath and the *Miss Budweiser* won the Gold Cup on the Detroit River. With this victory, D'Eath became one of only two men to win the Gold Cup in three successive decades. D'Eath's victories came in 1976, 1989, and 1990. The other man to accomplish this was also a Detroit native. Bill Muncey won twice in the 1950s (1956 and 1957), twice in the 1960s (1961 and 1962), and four times in the 1970s (1972, 1977, 1978, and 1979). Chip Hanauer's incredible string of seven consecutive Gold Cup victories all came in the 1980s.

Shortly before the start of the 1991 season, D'Eath was injured in a car racing accident and was in no condition to defend his Gold Cup and national championship victories. Bernie Little hired Scott Pierce to drive for the Budweiser team. Mark Tate, a third-generation boat racer from Detroit, signed on to drive the *Winston Eagle* and surprised everyone by winning the Gold Cup in his very first race in the boat! Pierce and the *Budweiser* earned the national championship by winning three races that year.

Bernie Little coaxed Chip Hanauer out of retirement in 1992 and used him to replace Scott Pierce. Hanauer rewarded Bernie with back-to-back Gold Cup victories in 1992 and 1993. In 1994, Mark Tate won his second Gold Cup in Steve Woomer's *Smokin' Joe's*.

Hanauer and Bernie Little were back on the Gold Cup trophy stage in 1995 accepting Little's 10th Gold Cup trophy. In 1996, Dave Villwock drove Fred Leland's *PICO American Dream* to victory. The *American Dream* was sponsored by Detroit-based Progressive Tool and Industries Company; their victory ended a 20-year draught, since the last Detroit-sponsored boat, *Miss U.S.*, won the Gold Cup in 1976.

Chip Hanauer retired from racing in the middle of the 1996 season after the *Miss Budweiser*'s canopy failed during an accident in the Gold Cup.

Bernie Little, always a shrewd businessman, realized that his main competition in 1997 would be coming from Dave Villwock. He also knew that it would take a lot of money to try to improve his equipment and beat Villwock. So instead of spending a small fortune to try to beat Villwock, he simply hired him to drive for the *Budweiser* team. The decision was immediately vindicated

when Villwock and the *Miss Budweiser* won the first five races of the season, including the Gold Cup. Villwock's victory string ended when the *Budweiser* crashed violently in the final heat at Tri-Cities, Washington. The *Miss Budweiser's* canopy failed, and Villwock was seriously injured, losing two fingers off his right hand. Most observers figured that Villwock's career driving the unlimited was over, but Villwock surprised everyone by returning in 1998 and winning 8 out of 10 races, including the Gold Cup in Detroit and the national championship.

In 1999, Chip Hanauer signed on to drive Fred Leland's *Miss PICO*. The *American Dream* was clearly slower than Villwock's *Budweiser*, but Hanauer's incredible driving ability earned the Detroit-sponsored *PICO* three victories in the first five races of the season. The highlight of the season came in an emotional final heat in the Gold Cup in Detroit, when Hanauer stole the inside lane from Villwock and captured his 11th Gold Cup victory.

Villwock and the *Budweiser* bounced back to win the Gold Cup in 2000.

In 2001, Mike Jones's U-9 was sponsored by Tubby's Grilled Submarines, a Detroit-based restaurant chain. Nobody gave the U-9 much of a chance to win, and the odds got even longer when the skid fin pulled off the boat at the Madison, Indiana, race, the week before the Gold Cup. Mike Hanson, the boat's talented driver and team manager, led the mostly volunteer crew in a weeklong, around-the-clock repair job. Their hard work paid off when the *Miss Budweiser* spun before the start of the final heat, and the U-9 made a perfect start and ran away from the rest of the field to give Jones, Hanson, and Tubby's their one and only Gold Cup victory.

Villwock and the *Miss Budweiser* won the 2002 Gold Cup to give Bernie Little his 14th and final Gold Cup. Shortly before the 2003 season started, Bernie Little died of pneumonia. His son Joe continued to run the team for two more seasons but never was able to capture a Gold Cup.

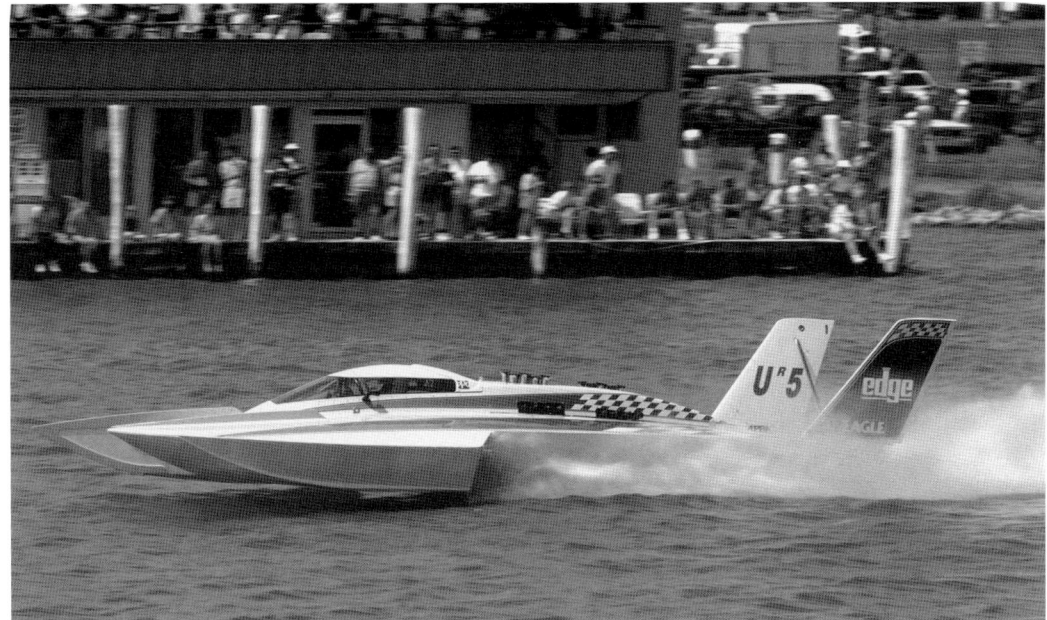

Even though turbine-powered hulls dominated the sport, racers continued to experiment with other forms of power. Mike and Larry Ruttkaukas campaigned the *Edge Superior Performance* in Detroit and earned an eighth-place finish. (Courtesy of Bill Osborne.)

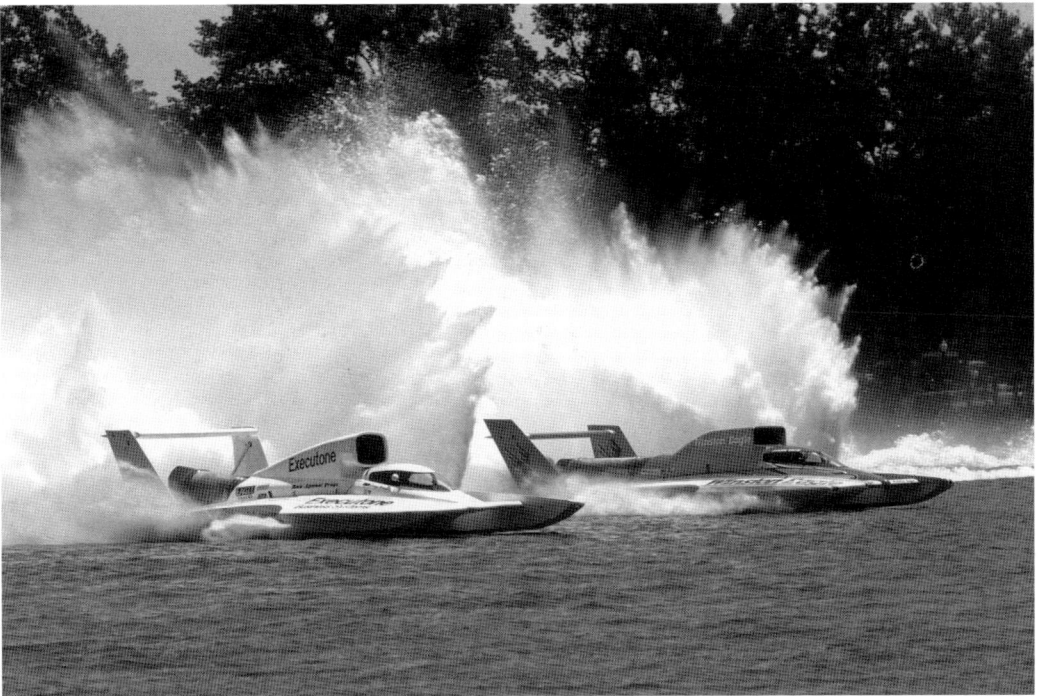

The *Winston Eagle*, driven by Detroiter Mark Tate, edged out the *Executone* to win the 1991 Gold Cup in Detroit. (Courtesy of Bill Osborne.)

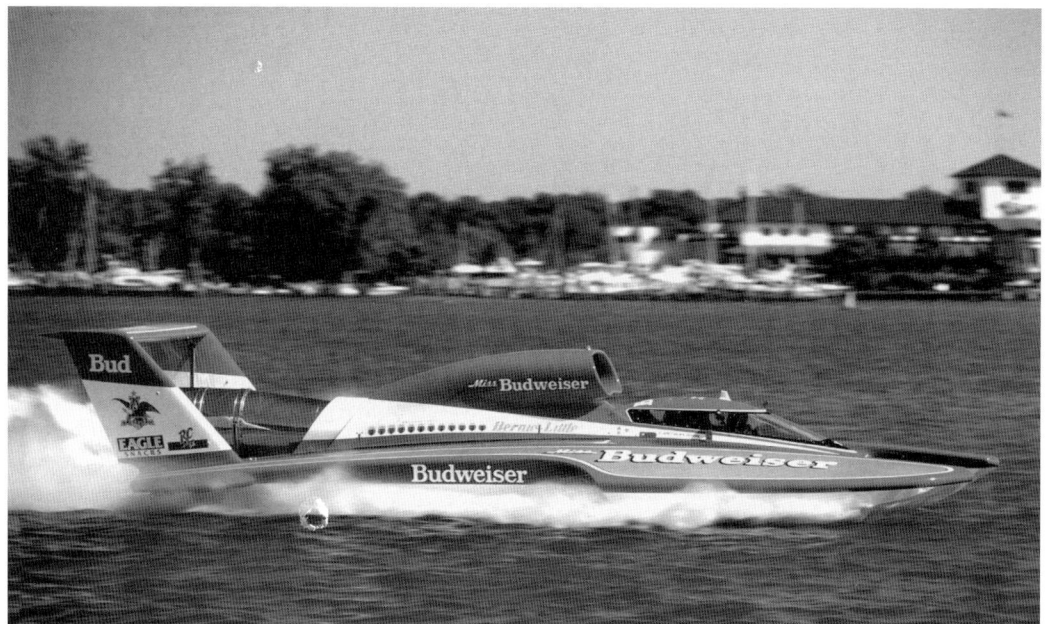

In 1992, Chip Hanauer came out of retirement to drive Bernie Little's *Miss Budweiser*. Hanauer won seven races, including the Detroit Gold Cup, on his way to a national championship. (Courtesy of Bill Osborne.)

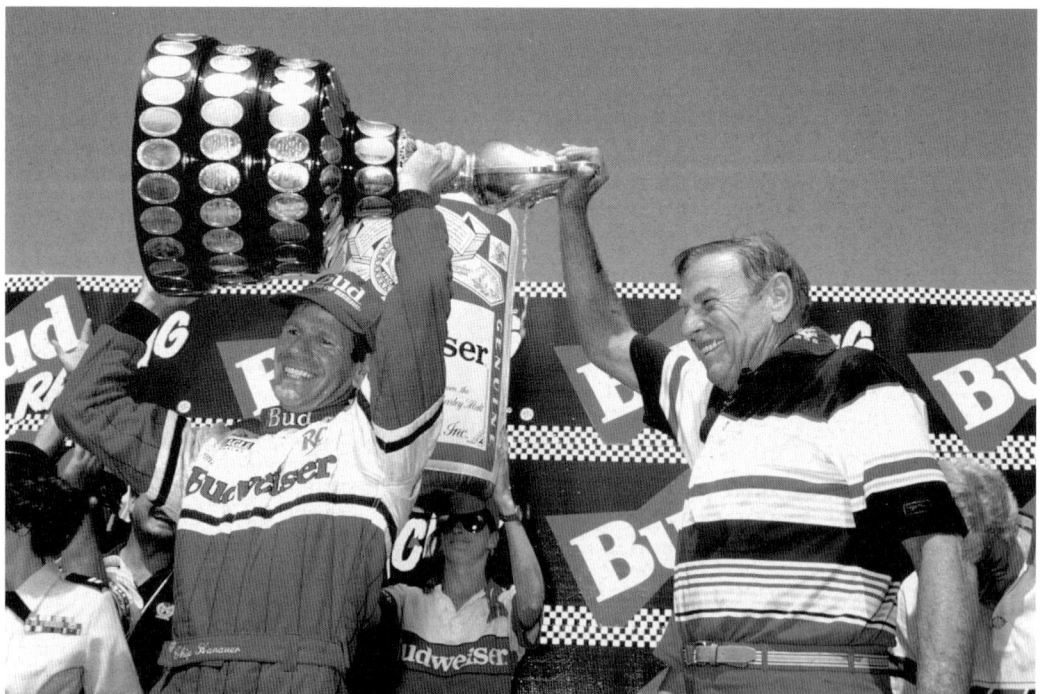

Chip Hanauer (left) and Bernie Little (right) celebrate on the victory stage after the 1992 Gold Cup. (Courtesy of Bill Osborne.)

Hanauer and the *Miss Budweiser* won the Gold Cup again in 1993. It was Hanauer's eighth Gold Cup, which tied him with Bill Muncey for all-time Gold Cup victories. (Courtesy of Bill Osborne.)

Bill Wurster's *Tide* took second place in the 1993 Gold Cup. It was the fourth year in a row that Wurster's boat had come in second in the Gold Cup. (Courtesy of Bill Osborne.)

HYDROPLANE RACING IN DETROIT

Robb Thomson and the Exide Corporation stepped into hydroplane racing in a big way in 1994. They sponsored a two-boat team, based in Detroit, and were the title sponsor for the Gold Cup. Mark Evans drove the *Miss Exide* to a fourth-place finish in the 1994 Exide Batteries APBA Gold Cup. (Courtesy of Bill Osborne.)

From left to right are Robb Thomson, Exide team owner; Mark Evans, driver of *Miss Exide*; Jimmy King, driver of *Miss Exide II*; and Mira Slovak, driver of the 1963 *Miss Exide*. (Courtesy of Bill Osborne.)

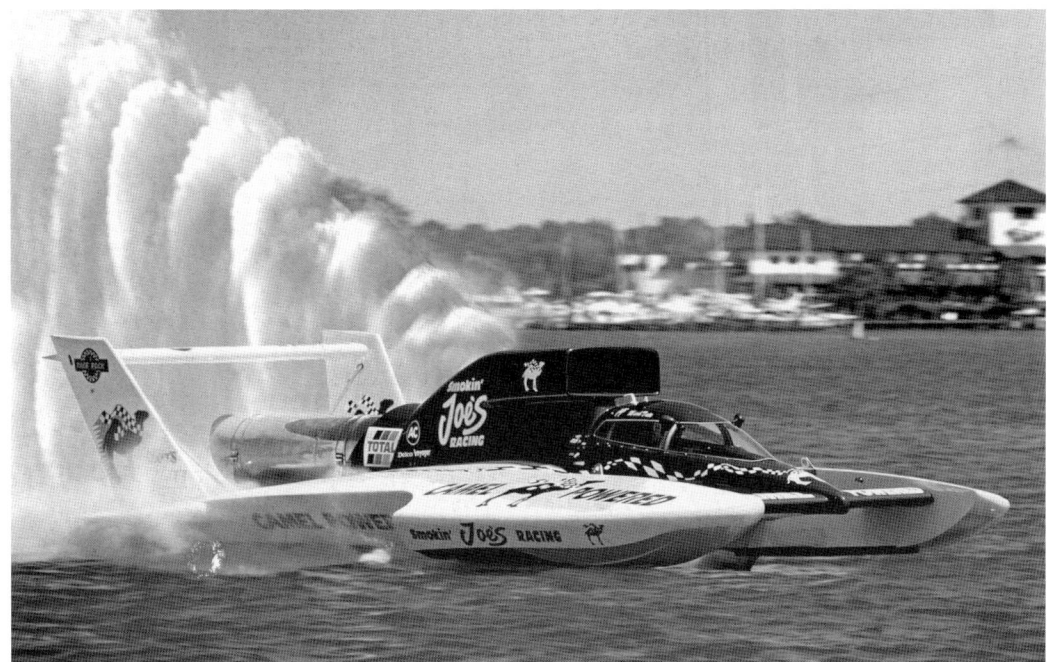

In 1994, Mark Tate drove Steve Woomer's *Smokin' Joe's* to victory in the Gold Cup. (Courtesy of Bill Osborne.)

Mark Tate celebrates on the victory stand after the 1994 Gold Cup. Tate was a third-generation boat racer who began racing when he was 13 years old. (Courtesy of Bill Osborne.)

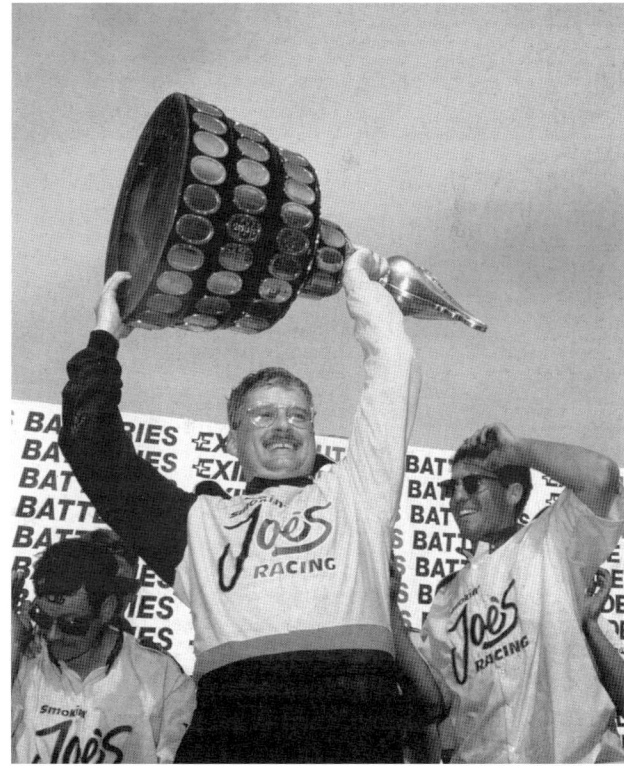

Fans line the fence to watch boats leave the pits for the start of heat 2-A of the 1995 Gold Cup. (Photograph by Kristyl Girschner.)

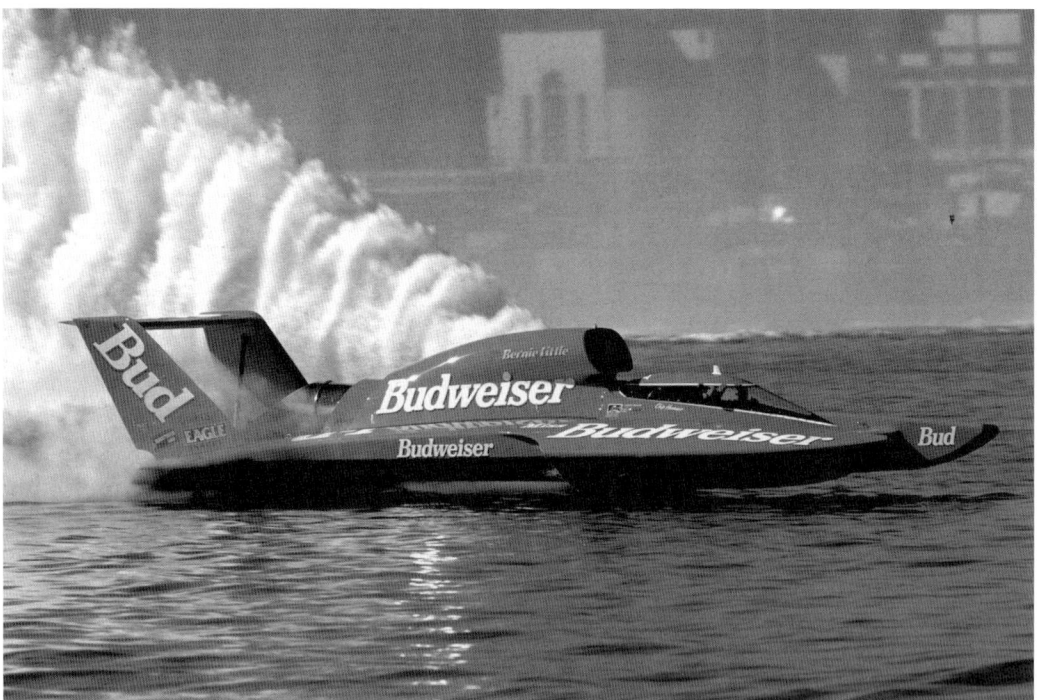

Chip Hanauer and the *Miss Budweiser* racked up another Gold Cup victory on the Detroit River in 1995. (Courtesy of Bill Osborne.)

The two top contenders were knocked out of the 1996 Gold Cup early when *Miss Budweiser* flipped and landed on top of the *Smokin' Joe's*. Thanks to the mandatory safety canopies on all boats, neither driver was injured. However, the *Budweiser* canopy was badly damaged, and Hanauer felt that the boat was not safe to drive, so he retired.

Mark Evans took over in the *Budweiser* cockpit when Hanauer retired. He drove the quickly repaired boat to a second-place finish. (Courtesy of Bill Osborne.)

Fred Leland's PICO American Dream was sponsored by Detroit-based Progressive Tool and Industries Company. The PICO, driven by Dave Villwock, won the 1996 Gold Cup. (Courtesy of Bill Osborne.)

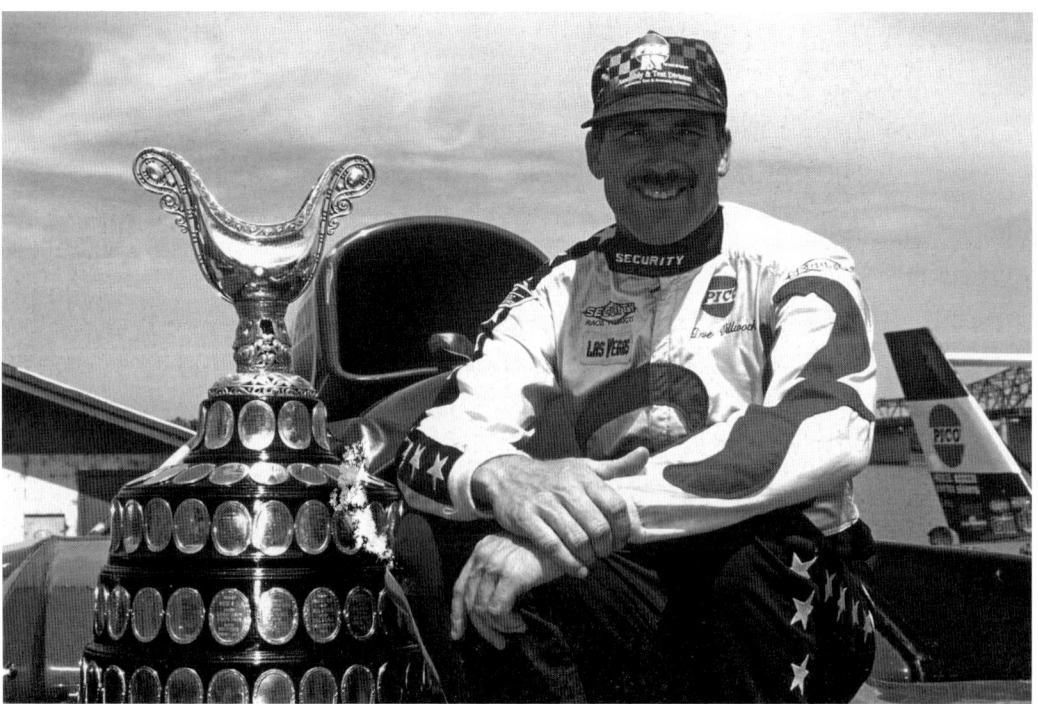

Dave Villwock poses with the Gold Cup in front of the PICO American Dream. (Courtesy of Bill Osborne.)

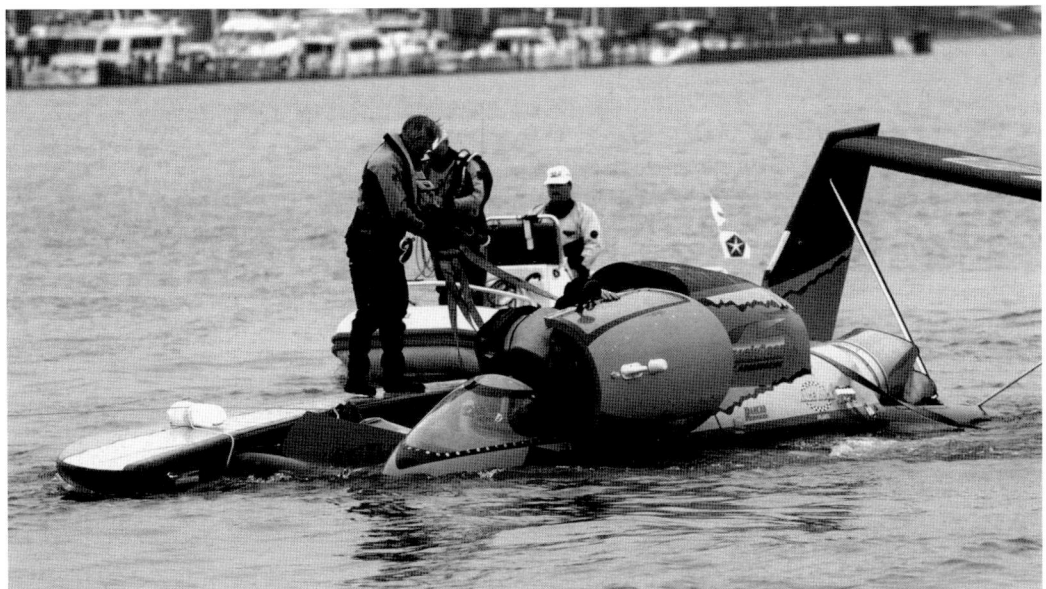

During the five-minute period before the start of heat 2-A of the 1997 Gold Cup, Nate Brown in the *Truck Gear* and Mark Evans in the *PICO American Dream* collided almost head on. Brown's boat, shown here, was badly damaged and had to withdraw from the race. Evans's boat was repaired, and he finished in fifth place. (Courtesy of Bill Osborne.)

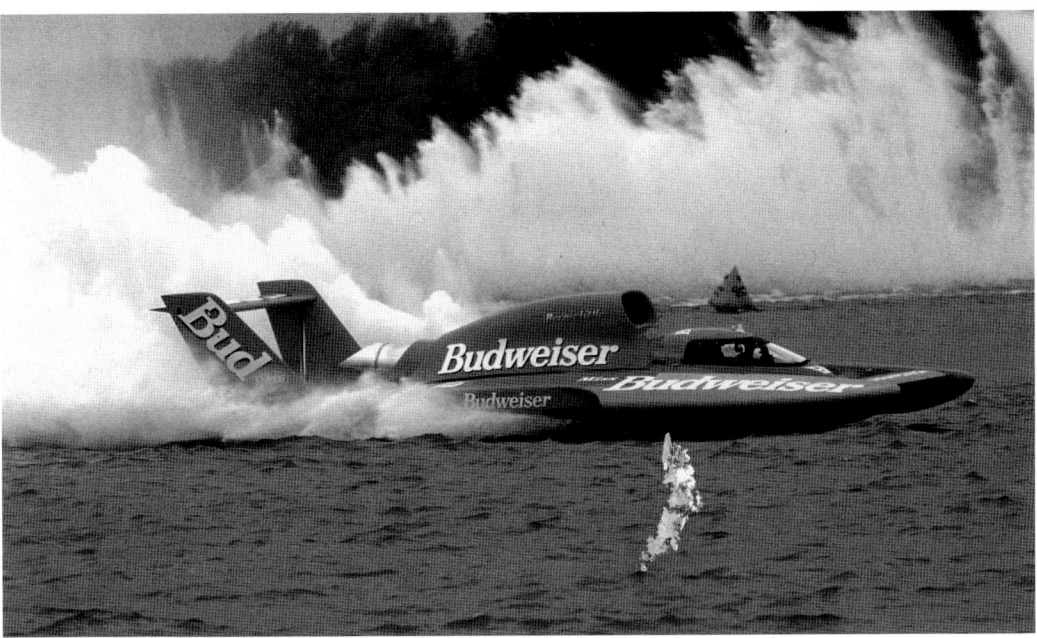

Dave Villwock jumped from the *PICO* to the *Budweiser* for 1997. He won the 1997 Gold Cup in the *Miss Budweiser* and became the first driver to win back-to-back Gold Cups, driving for two different teams since Danny Foster won in 1947 with *Miss Peps V* and then in 1948 with *Miss Great Lakes*. (Courtesy of Bill Osborne.)

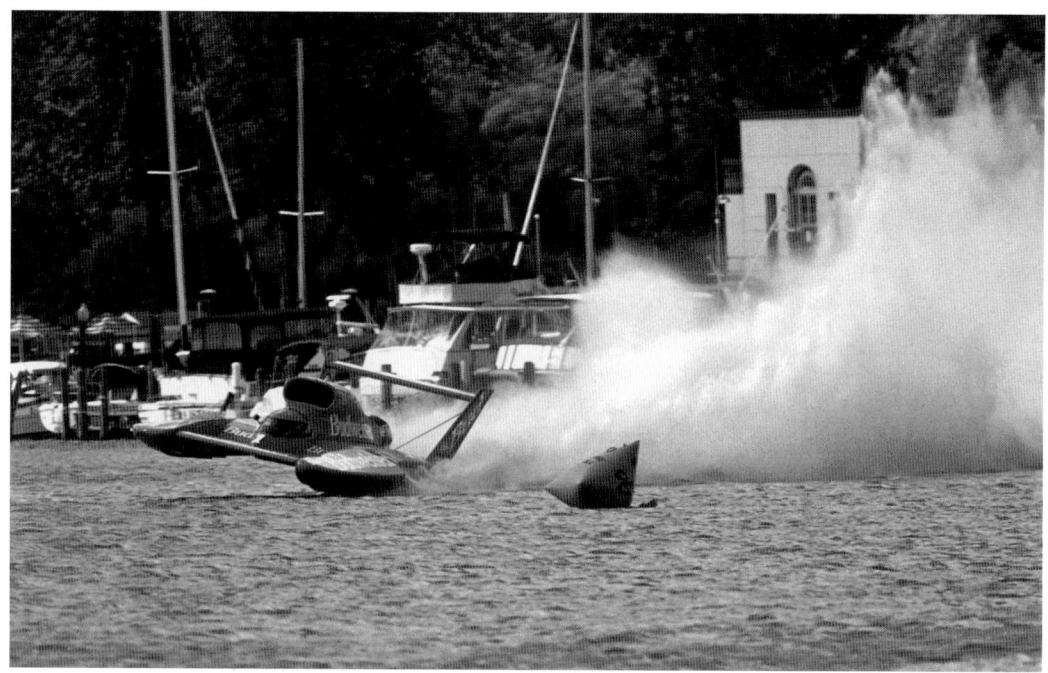

Dave Villwock and the *Miss Budweiser* had an easy win in the 1998 Gold Cup.

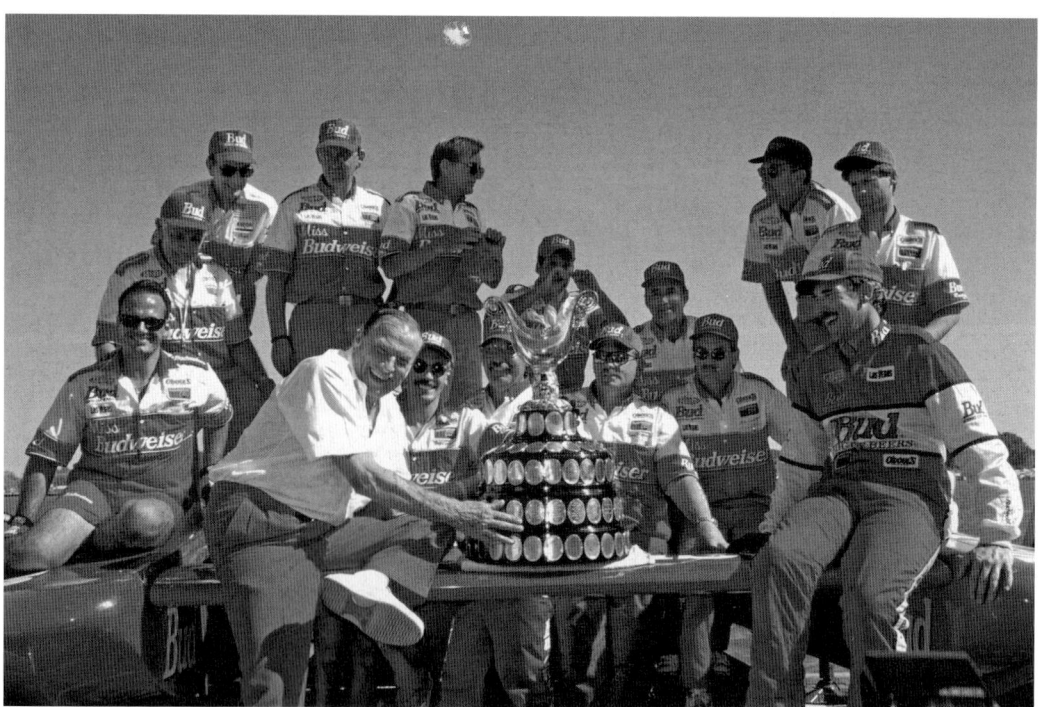

The *Miss Budweiser* was supported by a very large and talented crew. Bernie Little (left of trophy) and Dave Villwock (right of trophy) celebrate their 1998 Gold Cup victory. (Courtesy of Bill Osborne.)

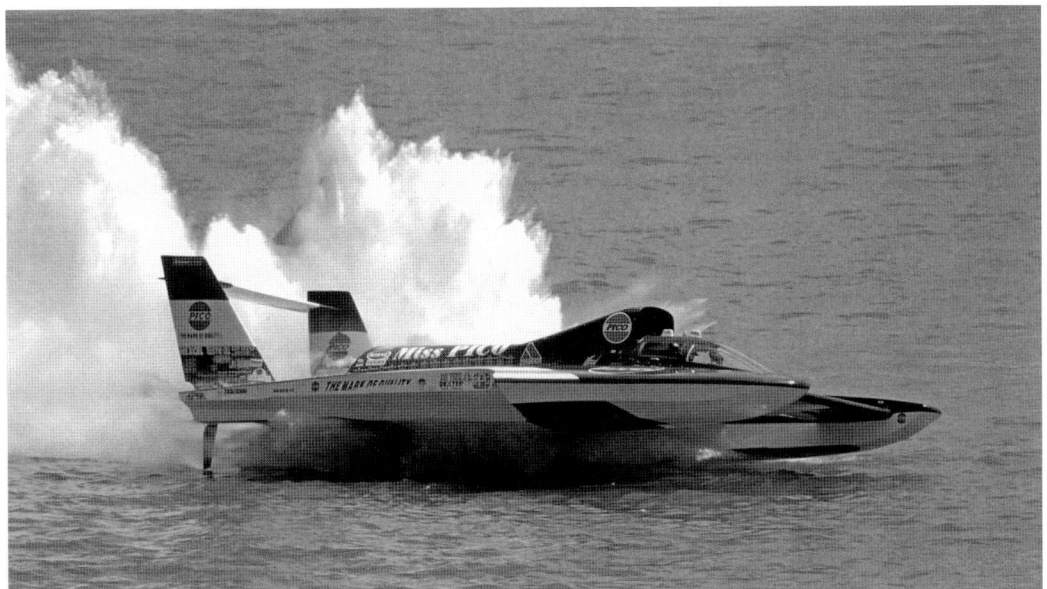

Larry Wisne, owner of Progressive Tool and Industries Company, was tired of watching the boat he sponsored coming in second to Dave Villwock and the *Miss Budweiser*. He lured Chip Hanauer out of retirement, and Hanauer responded by winning three of the first five races in 1999, including the Gold Cup in Detroit. (Courtesy of Bill Osborne.)

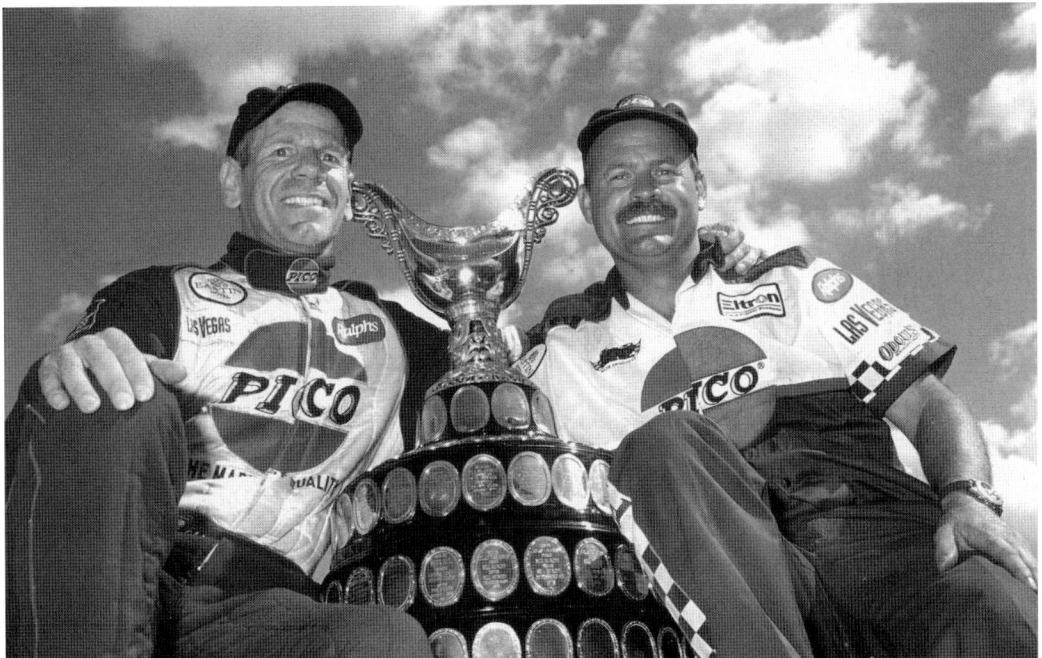

Chip Hanauer (left) and crew chief Ken Dryden (right) celebrate their 1999 Gold Cup victory. Dryden was a very talented driver in his own right, whose racing career was cut short by a horrific accident that broke both his legs in Seattle in 1994. (Courtesy of Bill Osborne.)

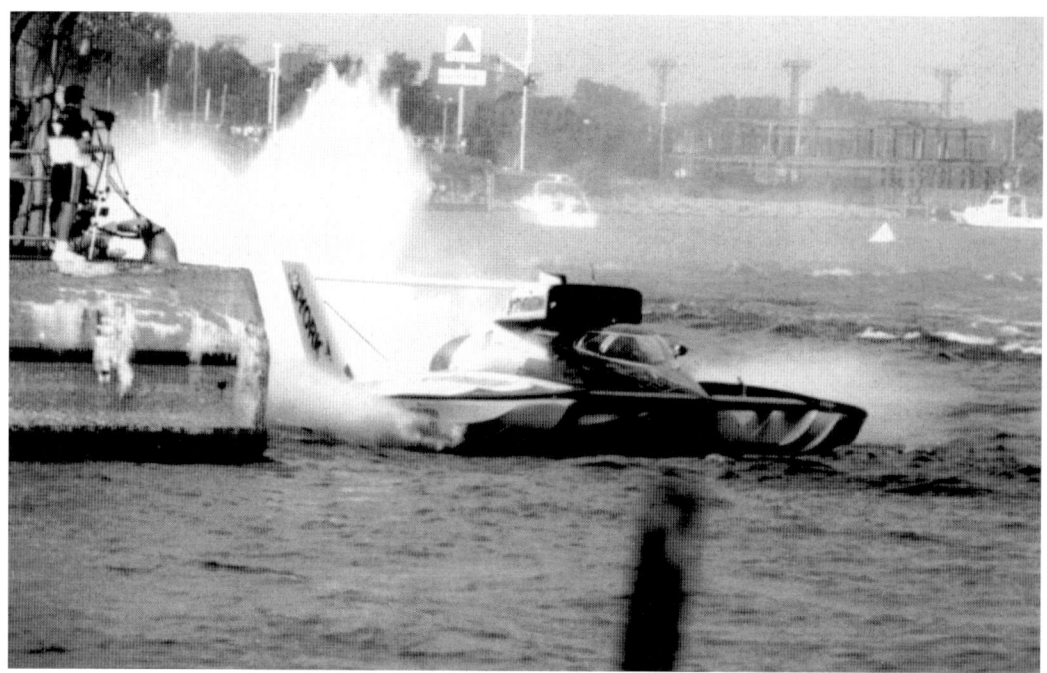

Rookie driver George Stratton had a close call with the seawall along the north side of the Detroit River. Stratton was killed two months later when the *Appian Jeronimo* blew over backward while testing for the San Diego race. (Photograph by Paul T. White.)

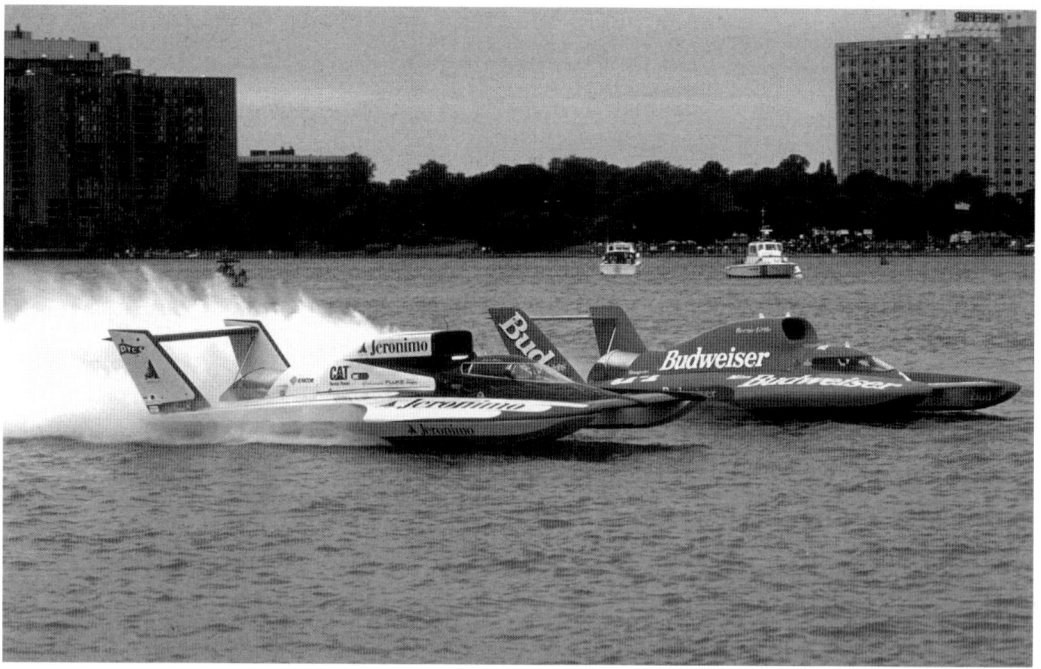

Dave Villwock gave Bernie Little his 13th Gold Cup victory in 2000. (Courtesy of Bill Osborne.)

Greg Hopp drove Fred Leland's *Zentix* to a second-place finish in the 2001 Gold Cup. (Courtesy of Bill Osborne.)

In 2001, the Detroit Yacht Club sponsored Kim Gregory's U-15, and the boat was called *Miss DYC*. (Courtesy of Bill Osborne.)

Mike Jones is a past president of the APBA and has been involved in all classes of powerboat racing his whole life. His wife, Lori, is also an avid fan of the sport. Together they own the U-9 race team, and their boat the *Tubby's Grilled Submarines* won the 2001 Gold Cup. (Courtesy of Bill Osborne.)

The *Tubby's Grilled Submarines* was driven by Mike Hanson. In this photograph, Mike (right) and his brother Larry (left) celebrate with the trophy on the Gold Cup victory platform. (Courtesy of Bill Osborne.)

Racing on the Detroit River is always tough. Here veteran driver Mark Tate hits a buoy during the 2002 race. (Courtesy of Bill Osborne.)

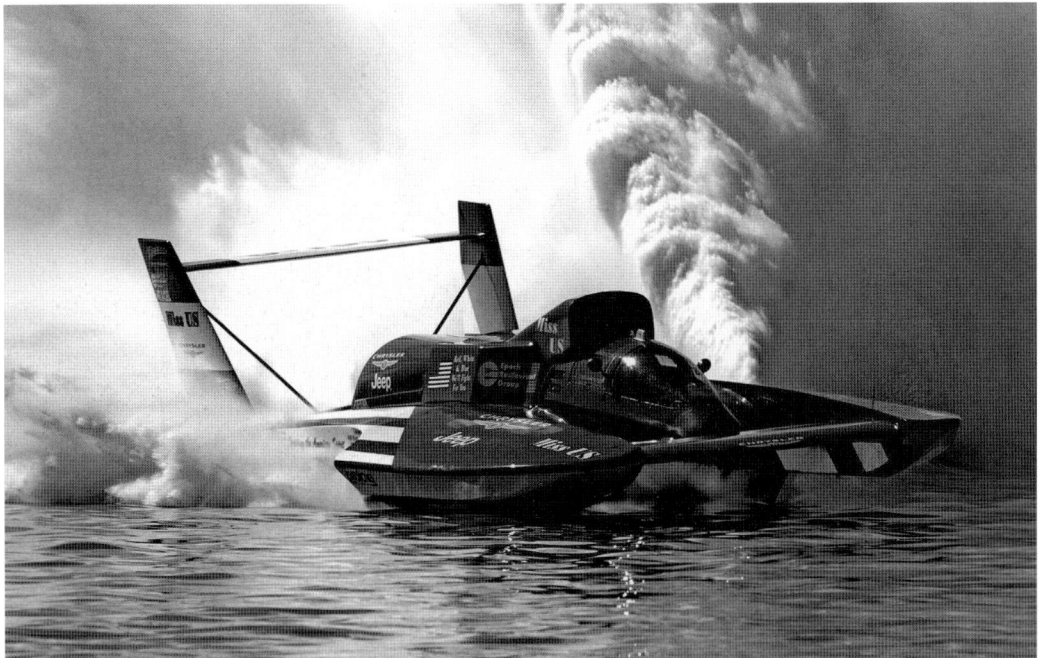

Fred Leland's U-100 was called *Miss Chrysler Jeep* when the boat ran in the 2002 Gold Cup. With Greg Hopp driving, the boat finished in eighth place. (Courtesy of Bill Osborne.)

The Detroit Yacht Club's relationship with Kim Gregory's team that started in 2001 continued in 2002. Here Mike Weber bounces the Miss DYC through the rough Roostertail Turn. (Courtesy of Bill Osborne.)

Dave Villwock and the Miss Budweiser continued their winning ways with a record 14th Gold Cup for Bernie Little. It would be the Budweiser's last Gold Cup trophy. Little passed away before the start of the 2003 season, and the team left the sport at the end of 2004 without winning another Gold Cup. (Courtesy of Bill Osborne.)

A New Beginning

2003 TO 2008

The Spirit of Detroit Association that had been putting on the Detroit races since 1962 fell on hard finical times in 2003, and the Gold Cup race was very nearly canceled. A dedicated group of hydroplane supporters led by three-time Gold Cup winner Tom D'Eath formed a new organization called the Detroit River Regatta Association (DRRA) and worked tirelessly to reschedule the race from mid-July to late August. The extra time was spent raising money, finding sponsors, and negotiating with vendors.

Eleven teams showed up to race for the 2003 Gold Cup, and qualifying was led by Dave Villwock and the *Miss Budweiser*. Competition was fierce with six different boats winning elimination heats. Popular driver Mark Evans was seriously injured when his boat the U-8 *Llumar Window Film* flipped in one of the preliminary heats. Mark's brother Mitch drove the piston-powered U-3 *Miss Fox Hills Chrysler Jeep* to a stunning victory in the final heat to put a piston-powered boat back in the winner's circle for the first time in 20 years. There was a poignant moment during the dockside victory celebration when Mitch talked to his hospitalized brother via cell phone; choking back tears he said, "This one's for you Brother!"

The Detroit Yacht Club sponsored Kim Gregory's yellow and blue U-10 in 2004 for the 100th anniversary of the Gold Cup. The boat was called the *Miss DYC*. During the run to the start of the final heat, the two top contenders, Dave Villwock in the *Miss Budweiser* and Terry Troxell in the *E-lam* bumped into each other. Villwock was disqualified, and the *E-lam* was damaged, allowing Nate Brown to drive the *Miss DYC* to victory. Brown was a last-minute substitute for normal U-10 driver Mike Weber, who had been injured two weeks prior in a race in Madison, Indiana. The win for Brown was very controversial because the announcement of Villwock's disqualification did not come until almost an hour after the race. The Gold Cup trophy had already been awarded to the *Budweiser* team, and Villwock had already made his acceptance speech.

Budweiser retired from the sport at the end of the 2004 season, so the field was wide open when the unlimiteds arrived in Detroit for the 2005 Gold Cup. Detroit native David Bartush shocked the hydroplane community when he won the Gold Cup in his very first race as an unlimited owner, with his U-13 *Miss Al Deeby Dodge*, driven by Terry Troxell.

The year 2006 saw veteran unlimited driver Billy Schumacher return to hydroplane racing as a team owner with his U-37 *Miss Beacon Plumbing*, driven by Canadian Jean Theoret. The U-37 team had an awful weekend at the Gold Cup; plagued by penalties and driver errors, the team almost withdrew and headed for home, but Theoret took first place in a "must win" preliminary to earn the boat a birth in the final. Then in an astounding driving job, Theoret won the final to become the second Canadian ever to win the Gold Cup (the first was Guy Lombardo in 1946).

In 2007, Dave Villwock returned to the Gold Cup winner's circle in the U-16 *Miss E-lam Plus*. This was Villwock's sixth Gold Cup victory, moving him ahead of the great Gar Wood to third place for all-time Gold Cup winners. (Wood had five victories. Villwock still trails Hanauer and Muncey, who have 11 and 8 victories, respectively.) It was a bittersweet accomplishment for team owner Eric Ellstrom, whose mother passed away the Sunday before the race.

The year 2008 was scheduled to be the 100th running of the Gold Cup. Nine boats qualified, and only four miles per hour separated the top six qualifiers. Racing started on Saturday with Jeff Bernard in the *formulaboats.com* and Steve David in the *Oh Boy Oberto*, each winning their respective preliminary heats. Sunday dawned clear and warm, and the second set of heats was run with a slight chop on the river and a building wind. The U-7 flipped at the start of heat 3-A, and then the wind began to build. By 2:00 there were white caps and four-foot rollers on the river, and by 4:00 the race was declared no contest. It was only the second time in the 104-year history of the race that it had been canceled due to weather; the first time was in 1960 at Lake Mead when wind also forced a cancellation.

There has been powerboat racing on the Detroit River for 92 years. During this time the status of the sport has gone up and down just like the level of the river. Sometimes the sport is on the rise and hundreds of thousands of people come to the river to watch the races. Other times it is low and the races struggle to survive, but somehow, through it all, the sport has survived and will continue to survive. As long as there are big boats, fast motors, and men and women willing to drive, there will be hydroplane racing in Detroit.

Since 1984, every Gold Cup winner had been turbine powered. That string of turbine victories came to an end in 2003 when Ed Cooper's Allison-powered *Miss Foxhills Chrysler-Jeep* won the race. (Courtesy of Bill Osborne.)

Driver Mitch Evans celebrates his 2003 Gold Cup victory with his teammates on the deck of the *Miss Foxhills Chrysler-Jeep*. (Photograph by Jim Crisp.)

Terry Troxell and the *Miss E-Lam Plus* were the fastest qualifiers for the 2004 Gold Cup, and many people thought they had a good chance to win, but in heat 1-A the *E-lam* got caught in the fin spray from the *Llumar Window Film* and blew over backward. (Photograph by Jim Crisp.)

Surprisingly, the *E-lam* sustained little damage in this accident and was able to return to competition the following day and claim a third-place finish in the race. (Courtesy of Jim Crisp.)

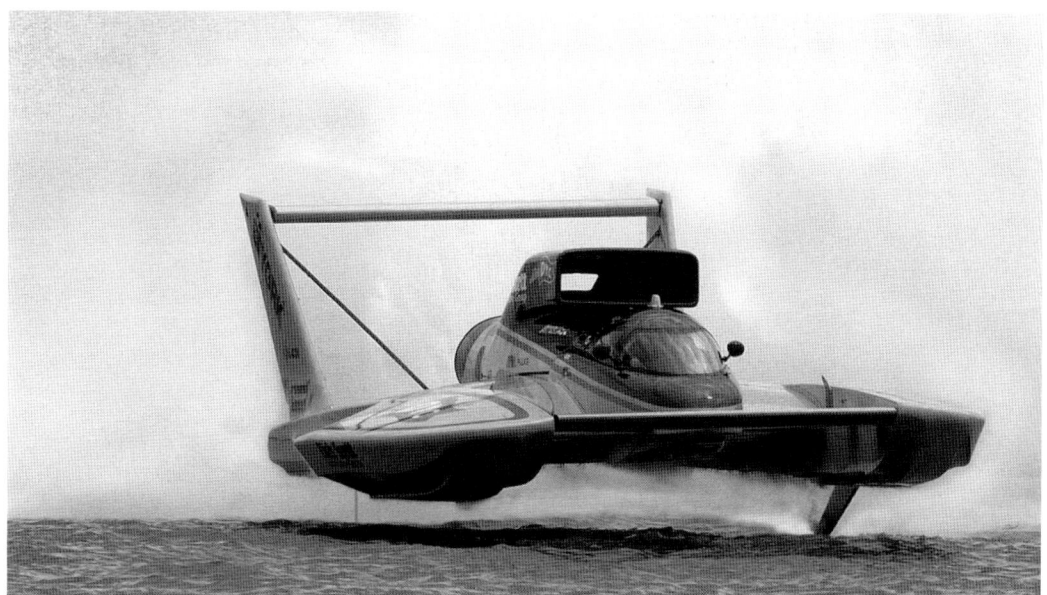

In 2004, the Detroit Yacht Club sponsored Kim Gregory's boat for the sixth year in a row, and they were rewarded with a win. Nate Brown drove the *Miss DYC* to a very controversial victory. The *Miss Budweiser* appeared to win and was even awarded the trophy. It was not until an hour after the race that the *Miss Budweiser* was disqualified for a prerace altercation with the *E-lam*, and the trophy was awarded to *Miss DYC*. (Courtesy of Bill Osborne.)

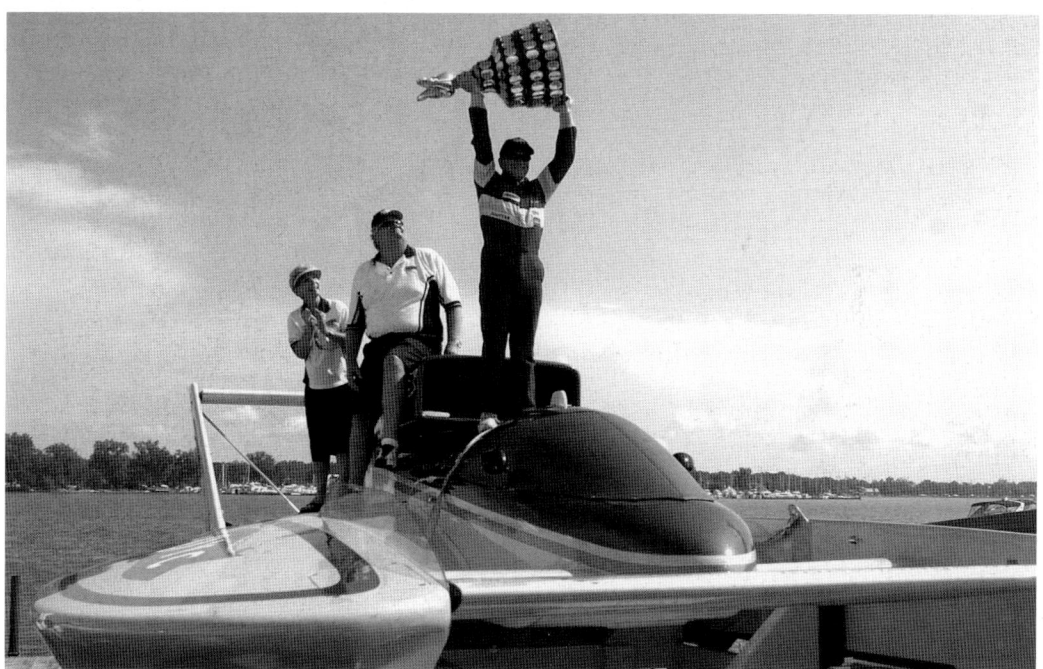

From left to right, Debbie Gregory, Kim Gregory, and Nate Brown celebrate their victory in the 2004 Gold Cup. (Photograph by Jim Crisp.)

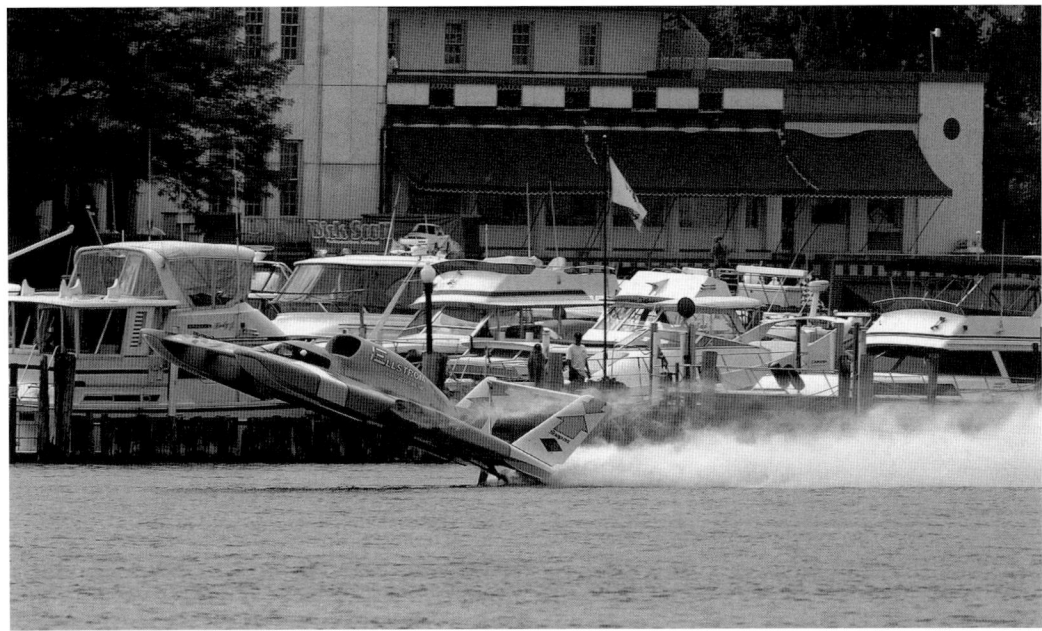

For the second year in a row, the Detroit River proved difficult for the *E-lam* team. J. W. Myers was driving the *Miss E-Lam Plus* in a qualifying effort for the 2005 Gold Cup when the boat became airborne right in front of the Detroit Yacht Club. (Courtesy of Bill Osborne.)

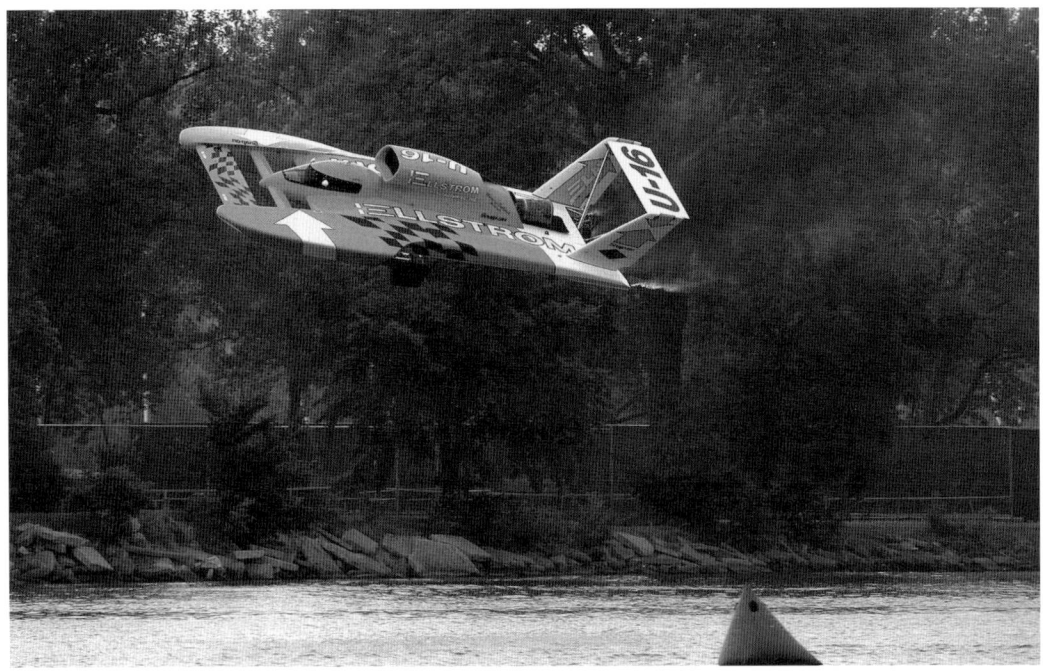

The *Miss E-Lam Plus* made almost two full revolutions before slamming back onto the Detroit River. The boat was repaired in time to take part in the race and was able to capture second place. Driver J. W. Myers was replaced at the next race by Dave Villwock. (Courtesy of Bill Osborne.)

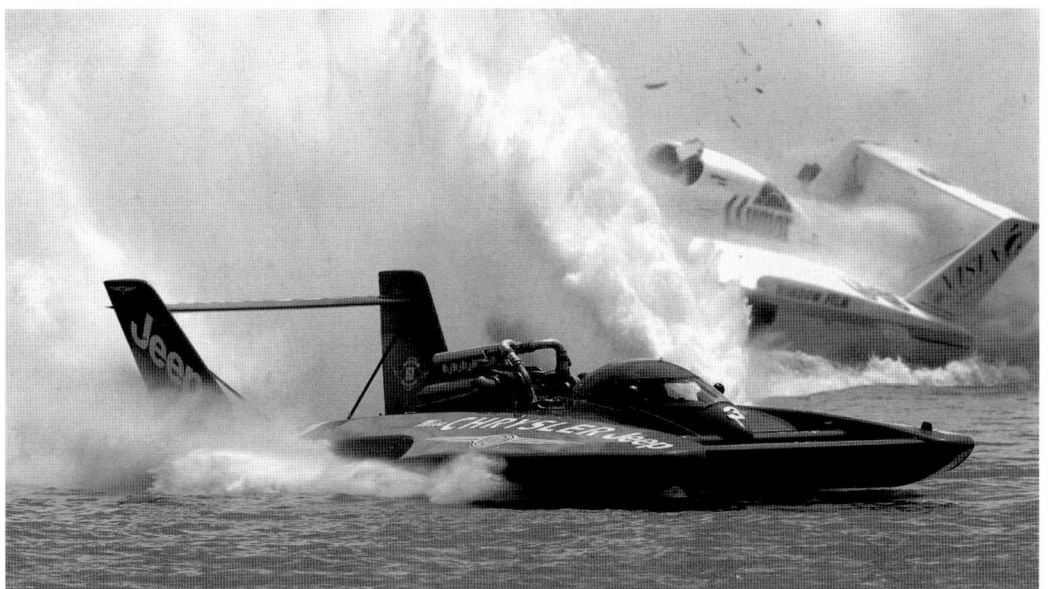

The 2005 Gold Cup was something of a destruction derby. Nine boats qualified for the race, but only three boats were running by the final heat. In this photograph, the U-8 *Llumar Window Film* gets caught in the roostertail of the *Miss Chrysler Jeep* and looses her right sponson. (Courtesy of Bill Osborne.)

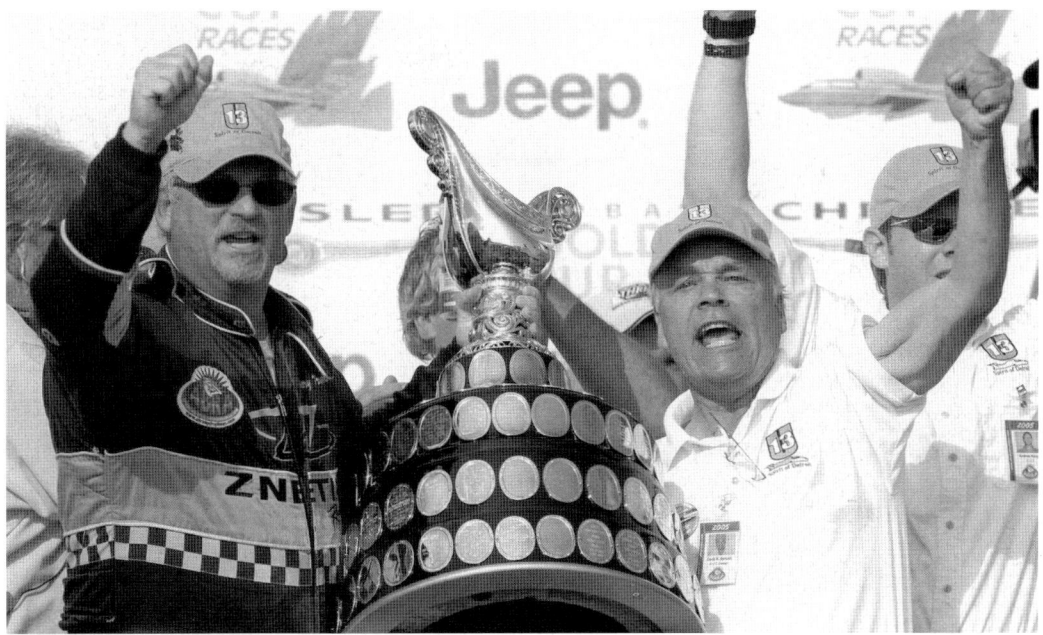

Dave Bartush was a longtime Detroit hydroplane fan who decided to buy a turbine boat and start racing in 2005. In his very first race he won the Gold Cup in his own hometown! In this photograph, driver Terry Troxell (left) celebrates on the victory stand with Dave Bartush (right). (Photograph by Jim Crisp.)

Billy Schumacher won the Gold Cup twice as a driver in the 1960s and returned to the sport as an owner with his wife, Jane, in 2006. Their boat was the U-37 *Miss Beacon Plumbing* and their driver, Jean Theoret, had a difficult weekend, striking a buoy in one heat. (Courtesy of Bill Osborne.)

Theoret got hosed down by the *formulaboats.com* in another heat. (Courtesy of Bill Osborne.)

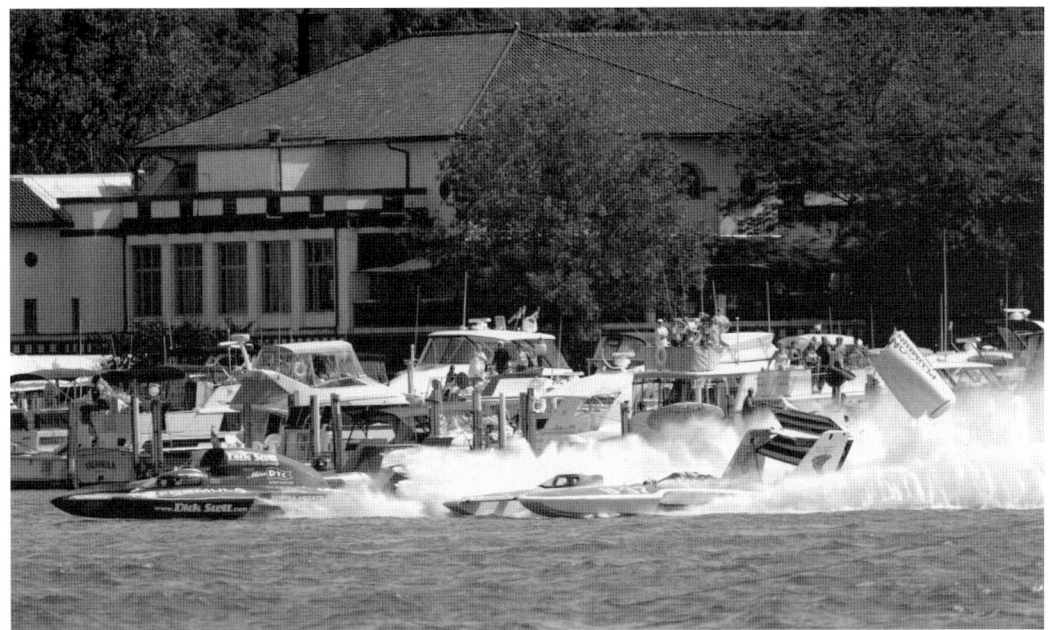

And Theoret lost his engine cowling and wing in the final heat! (Photograph by Jim Crisp.)

But none of it was enough to keep the *Miss Beacon Plumbing* out of the winner's circle. Crew chief Scott Raney (left) hugs driver Theoret (right) on the deck of the boat after their victory. (Courtesy of Bill Osborne.)

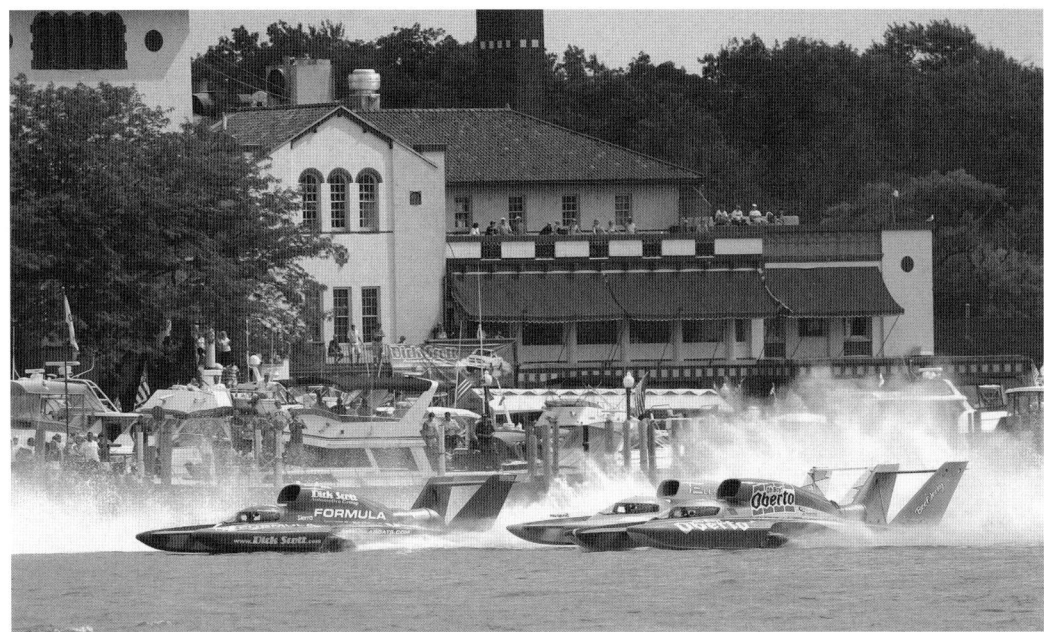

Oh Boy Oberto, Miss E-lam Plus, and formulaboats.com race past the Detroit Yacht Club on their way to the start of the final heat of the 2007 Gold Cup. The formulaboats.com crashed during this heat, and it had to be rerun. (Courtesy of Bill Osborne.)

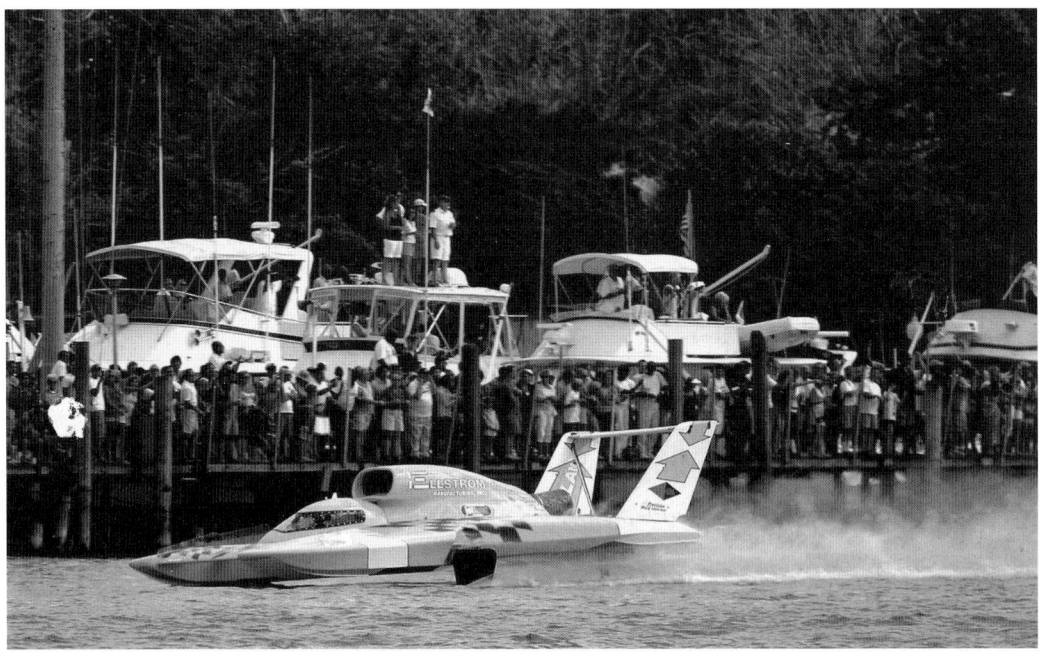

Dave Villwock bounces the Miss E-lam Plus past the Detroit Yacht Club on his way to victory in the 2007 Gold Cup. (Courtesy of Bill Osborne.)

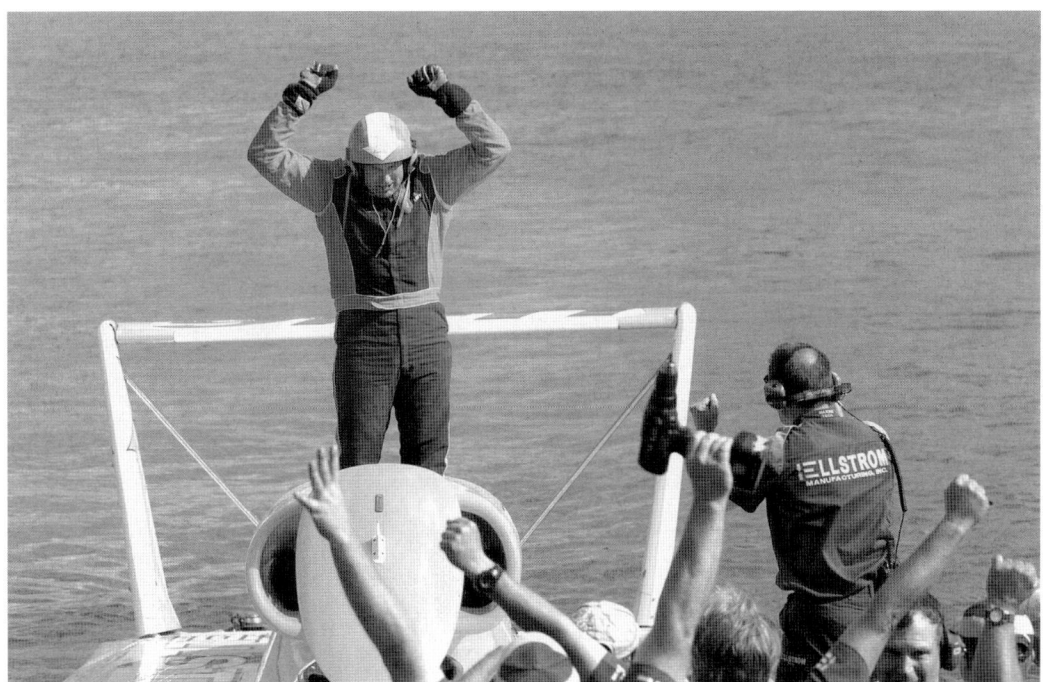

Dave Villwock celebrates his sixth Gold Cup win, which moves him past Gar Wood in all-time Gold Cup victories and leaves him trailing only Bill Muncey with 8 wins and Chip Hanauer with 11. (Courtesy of Bill Osborne.)

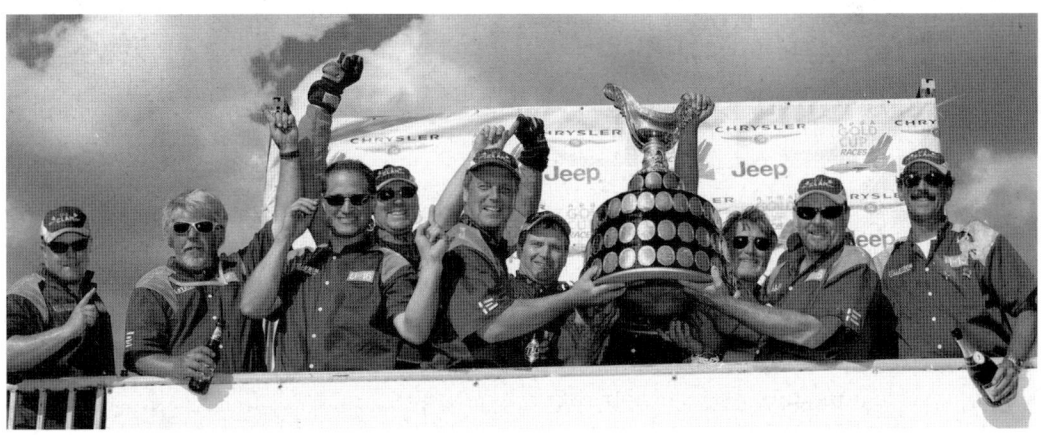

The Ellstrom team celebrates its 2007 Gold Cup victory. For team owner Eric Ellstrom (to the left of the trophy), it was a bittersweet moment. His mother, Kerstin, passed away just a week before the race. (Courtesy of Bill Osborne.)

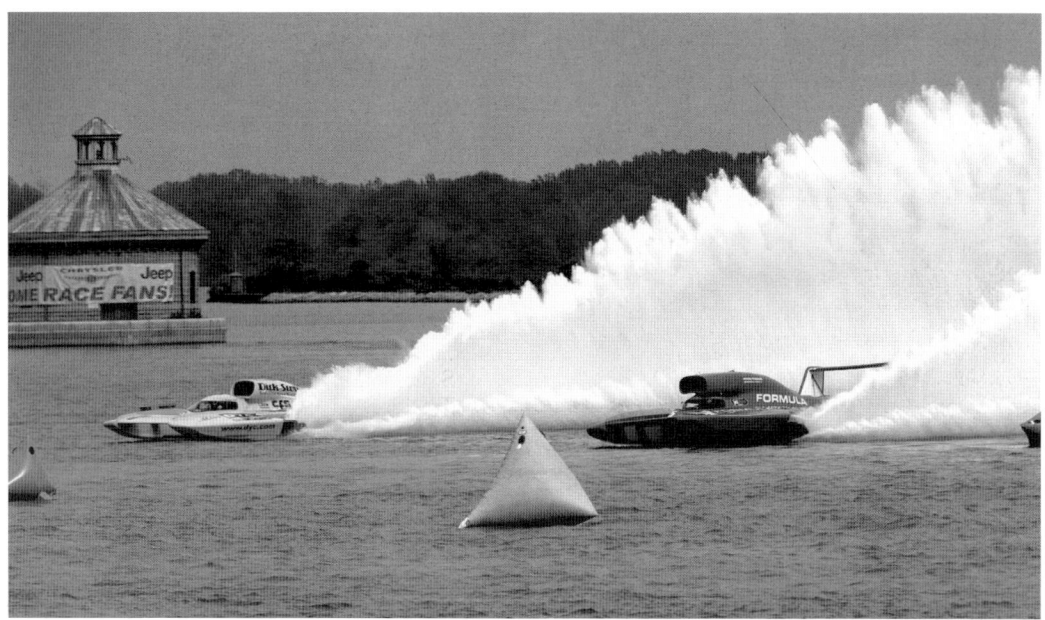

J. Michael Kelly in the *Miss DYC/Spirit of Detroit* races through the Roostertail Turn with Jeff Bernard in the *formulaboats.com*. (Courtesy of Bill Osborne.)

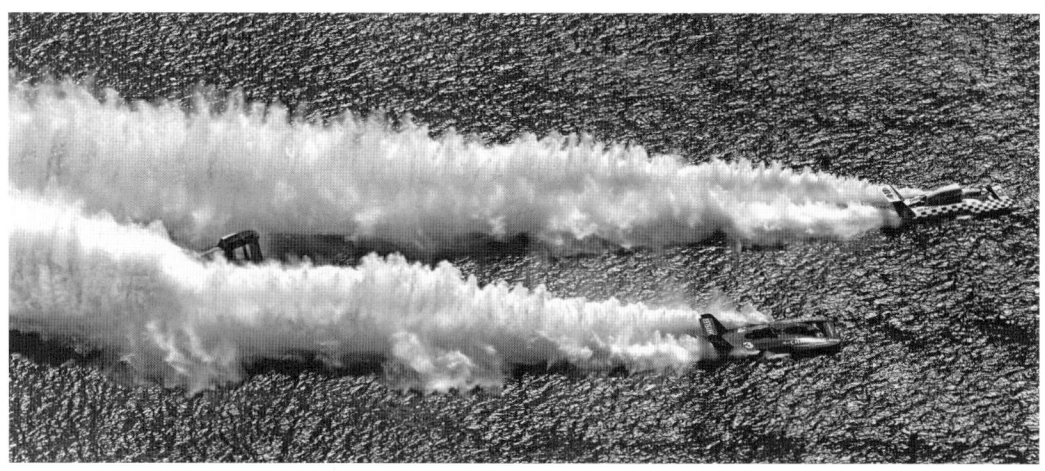

Jean Theoret and the *Miss Beacon Plumbing* lead Jim King and the *Miss Chrysler Jeep* into the first turn of heat 3-A of the 2008 Gold Cup. Looking closely between the two boats' roostertail, one can see the bottom of Mike Allen's *formulaboats.com II*, which is in the process of blowing over backward. Shortly after this accident, the wind picked up, forcing the race to be canceled. (Courtesy of Bill Osborne.)

Detroit Winners (1966–2007)

Year Boat	Owner	Driver	Race
1946 Tempo VI	Guy Lombardo	Guy Lombardo	Gold Cup
1947 Miss Peps V	Russell Dossin	Dan Foster	Detroit Memorial
1947 Notre Dame	Herb Mendelson	Dan Arena	Silver Cup
1948 Tempo VI	Guy Lombardo	Guy Lombardo	Detroit Memorial
1948 Miss Great Lakes	Al Falon	Dan Foster	Gold Cup
1948 Miss Canada III	Ernest Wilson	Harold Wilson	Silver Cup
1949 My Sweetie	Ed Schoenherr	Bill Cantrell	Gold Cup
1949 Skip-a-long	Stan Dollar	Stan Dollar	Detroit Memorial
1949 Skip-a-long	Stan Dollar	Stan Dollar	Harmsworth Trophy
1949 Skip-a-long	Stan Dollar	Stan Dollar	Detroit Marathon
1950 Slo-mo-shun IV	Stan Sayres	Ted Jones	Gold Cup
1950 My Sweetie	Horace Dodge	Cantrell/Fageol	Detroit Memorial
1950 Slo-mo-shun IV	Stan Sayres	Lou Fageol	Harmsworth Trophy
1950 Such Crust I	Jack Schafer	Dan Foster	Silver Cup
1951 Miss Pepsi	Walter Dossin	Chuck Thompson	Detroit Memorial
1951 Miss Pepsi	Walter Dossin	Chuck Thompson	Silver Cup
1952 Miss Pepsi	Walter Dossin	Chuck Thompson	Detroit Memorial
1952 Gale II	Joe Schoenith	Dan Foster	Silver Cup
1953 Miss Great Lakes II	Al Fallon	Dan Foster	Detroit Memorial
1953 Gale II	Joe Schoenith	Dan Foster	Silver Cup
1954 Gale V	Joe Schoenith	Lee Schoenith	Detroit Memorial
1954 My Sweetie Dora	Horace Dodge	Jack Bartlow	Silver Cup
1955 Gale IV	Joe Schoenith	Bill Cantrell	Detroit Memorial
1955 Tempo VII	Guy Lombardo	Dan Foster	Silver Cup
1956 Miss U.S. II	George Simon	Don Wilson	Silver Cup
1956 Shanty I	William Waggoner	Russ Schleeh	Harmsworth Trophy
1956 Miss Thriftway	Willard Rhodes	Bill Muncey	Gold Cup
1957 Such Crust III	Jack Schafer	Fred Alter	Detroit Memorial
1957 Hawaii Kai III	Edgar Kaiser	Jack Regas	Silver Cup
1958 Miss Thriftway	Willard Rhodes	Bill Muncey	Detroit Memorial
1958 Maverick	William Waggoner	Bill Stead	Silver Cup
1959 Miss Supertest III	Jim Thompson	Bob Hayward	Detroit Memorial
1959 Maverick	William Waggoner	Bill Stead	Silver Cup
1960 Miss Thriftway	Willard Rhodes	Bill Muncey	Detroit Memorial
1960 Nitrogen Too	Sam DuPont	Ron Musson	Silver Cup
1961 Gale V	Joe Schoenith	Bill Cantrell	Detroit Memorial
1961 Miss Bardahl	Ole Bardahl	Ron Musson	Silver Cup
1962 Miss Century 21	Willard Rhodes	Bill Muncey	Spirit of Detroit
1963 Miss Bardahl	Ole Bardahl	Ron Musson	Gold Cup
1964 Miss Bardahl	Ole Bardahl	Ron Musson	Gold Cup
1964 Such Crust IV	Jack Schafer	Walt Kade	Spirit of Detroit
1965 Tahoe Miss	Bill Harrah	Chuck Thompson	Spirit of Detroit
1966 Miss Lapeer	Jim Herrington	Warner Gardner	Dodge Memorial
1966 Tahoe Miss	Bill Harrah	Mira Slovak	Gold Cup
1967 Miss Chrysler Crew	Bill Sterett	Bill Sterett	World Championship
1967 Miss Wickman	Ben Stormes	Red Loomis	Dodge Memorial
1968 Miss Bardahl	Ole Bardahl	Bill Schumacher	Gold Cup
1969 Miss U.S.	George Simon	Bill Muncey	World Champ.
1970 Myr's Sheet Metal	Joe Schoenith	Bill Muncey	Dodge Memorial
1971 Miss Budweiser	Bernie Little	Dean Chenoweth	Dodge Memorial
1972 Atlas Van Lines	Joe Schoenith	Bill Muncey	Gold Cup
1973 Miss Budweiser	Bernie Little	Dean Chenoweth	Gar Wood Memorial
1973 Miss Budweiser	Bernie Little	Dean Chenoweth	Nat. Champ. Regatta

Year	Boat	Owner	Driver	Trophy
1974	Miss Budweiser	Bernie Little	Howie Benns	Gar Wood Memorial
1975	Miss U.S.	George Simon	Tom D'Eath	Gar Wood Trophy
1976	Miss U.S.	George Simon	Tom D'Eath	Gold Cup
1977	Atlas Van Lines	Muncey Enterprises	Bill Muncey	Gold Cup
1978	Atlas Van Lines	Muncey Enterprises	Bill Muncey	Spirit of Detroit
1979	Atlas Van Lines	Muncey Enterprises	Bill Muncey	Spirit of Detroit
1980	Miss Budweiser	Bernie Little	Dean Chenoweth	Spirit of Detroit
1981	Miss Budweiser	Bernie Little	Dean Chenoweth	Stroh's Silver Cup
1982	Atlas Van Lines	Muncey Enterprises	Chip Hanauer	Gold Cup
1983	Atlas Van Lines	Muncey Enterprises	Chip Hanauer	Stroh's Thunderfest
1984	Miss Budweiser	Bernie Little	Jim Kropfeld	Stroh's Thunderfest
1985	Miller American	Fran Muncey	Chip Hanauer	Stroh's Thunderfest
1986	Miller American	Fran Muncey	Chip Hanauer	Gold Cup
1987	Mr. Pringles	Bill Wurster	Scott Pierce	Thunderboat Champ
1988	Miller High Life	Fran Muncey	Chip Hanauer	Thunderboat Champ
1989	Miss Circus Circus	Bill Bennett	Chip Hanauer	Spirit of Detroit
1990	Miss Budweiser	Bernie Little	Tom D'Eath	Gold Cup
1991	Winston Eagle	Steve Woomer	Mark Tate	Gold Cup
1992	Miss Budweiser	Bernie Little	Chip Hanauer	Gold Cup
1993	Miss Budweiser	Bernie Little	Chip Hanauer	Gold Cup
1994	Smokin' Joe's	Steve Woomer	Mark Tate	Gold Cup
1995	Miss Budweiser	Bernie Little	Chip Hanauer	Gold Cup
1996	PICO American Dream	Fred Leland	Dave Villwock	Gold Cup
1997	Miss Budweiser	Bernie Little	Dave Villwock	Gold Cup
1998	Miss Budweiser	Bernie Little	Dave Villwock	Gold Cup
1999	Miss Pico	Fred Leland	Chip Hanauer	Gold Cup
2000	Miss Budweiser	Bernie Little	Dave Villwock	Gold Cup
2001	Tubby's Grilled Subs	Mike Jones	Mike Hanson	Gold Cup
2002	Miss Budweiser	Bernie Little	Dave Villwock	Gold Cup
2003	Miss Fox Hills Chrysler/Jeep	Ed Cooper	Mitch Evans	Gold Cup
2004	Miss DYC	Kim Gregory	Nate Brown	Gold Cup
2005	Al Deeby Dodge	Dave Bartush	Terry Troxell	Gold Cup
2006	Miss Beacon Plumbing	Bill Schumacher	Jean Theoret	Gold Cup
2007	Miss E-lam Plus	Sven Ellstron	Dave Villwock	Gold Cup
2008	Race declared no contest			

NATIONAL CHAMPIONS (1946–2007)

Year	Boat	Owner	Driver
1946	Tempo VI	Guy Lombardo	Guy Lombardo
1947	Miss Peps V	Walt and Roy Dossin	Danny Foster
1948	Such Crust	Jack Schaefer	Dan Arena
1949	My Sweetie	Horace Dodge Jr.	Bill Cantrell
1950	My Sweetie	Horace Dodge Jr.	Bill Cantrell
1951	Miss Pepsi	Walt and Roy Dossin	Chuck Thompson
1952	Miss Pepsi	Walt and Roy Dossin	Chuck Thompson
1953	Gale II	Joe Schoenith	Lee Schoenith
1954	Gale V	Joe Schoenith	Lee Schoenith
1955	Gale V	Joe Schoenith	Lee Schoenith
1956	Shanty I	Bill Waggoner	Russ Schleeh
1957	Hawaii Kai III	Edgar Kaiser	Jack Regas
1958	Miss Bardahl	Ole Bardahl	Mira Slovak
1959	Maverick	Bill Waggoner	Bill Stead
1960	Miss Thriftway	Willard Rhodes	Bill Muncey
1961	Miss Century 21	Willard Rhodes	Bill Muncey

Year	Boat	Owner	Driver
1962	*Miss Century 21*	Willard Rhodes	Bill Muncey
1963	*Miss Bardahl*	Ole Bardahl	Ron Musson
1964	*Miss Bardahl*	Ole Bardahl	Ron Musson
1965	*Miss Bardahl*	Ole Bardahl	Ron Musson
1966	*Tahoe Miss*	Bill Harrah	Mira Slovak
1967	*Miss Bardahl*	Ole Bardahl	Bill Schumacher
1968	*Miss Bardahl*	Ole Bardahl	Bill Schumacher
1969	*Miss Budweiser*	B. Little/T. Friedkin	Bill Sterett
1970	*Miss Budweiser*	B. Little/T. Friedkin	Dean Chenoweth
1971	*Miss Budweiser*	B. Little/T. Friedkin	Dean Chenoweth
1972	*Atlas Van Lines*	Joe Schoenith	Bill Muncey
1973	*Pay N Pak*	Dave Heerensperger	Mickey Remund
1974	*Pay N Pak*	Dave Heerensperger	George Henley
1975	*Pay N Pak*	Dave Heerensperger	George Henley
1976	*Atlas Van Lines*	Muncey Enterprises	Bill Muncey
1977	*Miss Budweiser*	Bernie Little	Mickey Remund
1978	*Atlas Van Lines*	Muncey Enterprises	Bill Muncey
1979	*Atlas Van Lines*	Muncey Enterprises	Bill Muncey
1980	*Miss Budweiser*	Bernie Little	Dean Chenoweth
1981	*Miss Budweiser*	Bernie Little	Dean Chenoweth
1982	*Atlas Van Lines*	Muncey Enterprises	Chip Hanauer
1983	*Atlas Van Lines*	Muncey Enterprises	Chip Hanauer
1984	*Miss Budweiser*	Bernie Little	Jim Kropfeld
1985	*Miller American*	Fran Muncey	Chip Hanauer
1986	*Miss Budweiser*	Bernie Little	Jim Kropfeld
1987	*Miss Budweiser*	Bernie Little	Jim Kropfeld
1988	*Miss Budweiser*	Bernie Little	Tom D'Eath
1989*	*Miss Budweiser*	Bernie Little	Tom D'Eath
1990	*Miss Circus Circus*	Bill Bennett	Chip Hanauer
1991*	*Miss Budweiser*	Bernie Little	Scott Pierce
1992	*Miss Budweiser*	Bernie Little	Chip Hanauer
1993	*Miss Budweiser*	Bernie Little	Chip Hanauer
1994*	*Miss Budweiser*	Bernie Little	C. Hanauer/M. Hanson
1995*	*Miss Budweiser*	Bernie Little	C. Hanauer/Mark Evans
1996	*PICO American Dream*	Fred Leland	Dave Villwock
1997*	*Miss Budweiser*	Bernie Little	Dave Villwock/Mark Weber
1998	*Miss Budweiser*	Bernie Little	Dave Villwock
1999	*Miss Budweiser*	Bernie Little	Dave Villwock
2000	*Miss Budweiser*	Bernie Little	Dave Villwock
2001	*Miss Budweiser*	Bernie Little	Dave Villwock
2002	*Miss Budweiser*	Bernie Little	Dave Villwock
2003	*Miss Budweiser*	Joe Little	Dave Villwock
2004	*Miss Budweiser*	Joe Little	Dave Villwock
2005*	*Miss Elam Plus*	Ellstrom family	J. W. Myers/D.Villwock
2006*	*Formula Boats II*	Ted Porter	Mike Allen
2007	*Miss E-lam Plus*	Ellstrom family	Dave Villwock
2008	*Oh Boy Oberto*	City of Madison	Steve David

*There were a number of years when the national champion driver was not the driver of the national champion boat. In 1950, Danny Foster was the champion driver; in 1963, Bill Cantrell; in 1975, Billy Schumacher; in 1989, Chip Hanauer; in 1991, Mark Tate; and in 1994 and 1995, it was Mark Tate again. Tate won again in 1997. Steve David won in 2005 and 2006.

Across America, People are Discovering Something Wonderful. *Their Heritage.*

Arcadia Publishing is the leading local history publisher in the United States. With more than 3,000 titles in print and hundreds of new titles released every year, Arcadia has extensive specialized experience chronicling the history of communities and celebrating America's hidden stories, bringing to life the people, places, and events from the past. To discover the history of other communities across the nation, please visit:

www.arcadiapublishing.com

Customized search tools allow you to find regional history books about the town where you grew up, the cities where your friends and family live, the town where your parents met, or even that retirement spot you've been dreaming about.